РУССКАЯ И СОВЕТСКАЯ ЖИВОПИСЬ 1900-1930
RUSSIAN AND SOVIET PAINTINGS 1900-1930

SELECTIONS FROM THE
STATE TRETYAKOV GALLERY, MOSCOW
AND THE STATE RUSSIAN MUSEUM, LENINGRAD

Revised Edition

Supported by a grant from the Smithsonian Institution
Special Exhibition Fund

HIRSHHORN MUSEUM AND SCULPTURE GARDEN
SMITHSONIAN INSTITUTION
WASHINGTON, D.C., 1988

Distributed by Smithsonian Institution Press
Washington, D.C. 20560

Published on the occasion of an exhibition held at the
Hirshhorn Museum and Sculpture Garden, Smithsonian
Institution, Washington, D.C., July 12–September 25, 1988,
and organized by the Hirshhorn Museum and Sculpture
Garden with the State Tretyakov Gallery, Moscow, and the
State Russian Museum, Leningrad

Printed in the United States of America

Library of Congress Catalog Card Number: 88–61577

ISBN 0–87474–495–4

*Russian and Soviet Paintings, 1900–1930: Selections from the State
Tretyakov Gallery, Moscow, and the State Russian Museum, Leningrad* was
published by the Hirshhorn Museum and Sculpture Garden, Smithsonian
Institution, Washington, D.C.; translated by Nicholas D. Berkoff, Ilya Levin,
Paul D. Mitchell, Eugene Ostrovsky, and Alexei P. Tsvetkov; edited by
Kathleen Preciado; designed by Anne Masters Design; typeset in Melior,
electronic page composition by Patty Casey and Eddie O'Hare; and printed
on Warren Lustro Dull by W. M. Brown & Son.

CONTENTS

FOREWORD

Through the exhibition *Russian and Soviet Paintings, 1900–1930,* the two largest museums in the Soviet Union—the State Tretyakov Gallery in Moscow and the State Russian Museum in Leningrad, which possess the best collections of art of this era—continue to acquaint American viewers with selected works from their collections. The period of the realistic democratic painting of the Itinerants was the topic of the previous exhibition, *Russia, the Land, the People: Russian Painting, 1850–1910,* on view in 1986 and 1987.

One of the brightest periods in the history of Russian painting, 1900–1930 was a time of headlong development, striking diversity, and high creative achievements. It gave rise to an entire constellation of brilliant talents. Painting flourished along with poetry, music, theater, ballet, drawing, sculpture, and architecture. As the arts gravitated toward one another, they provided mutual creative impulses. The search for synthesis became a mark of the times, and artistic activity acquired traits of universality. Artists combined easel painting with the staging of theatrical presentations, design of new architectural interiors, and creation of striking books and textiles. American viewers will be able to acquaint themselves with the remarkable achievements and national distinctiveness of Russian painting, from Natalia Goncharova, Vasilii Kandinsky, Konstantin Korovin, Mikhail Larionov, Kazimir Malevich, and Liubov Popova to Mitrofan Grekov, Petr Konchalovsky, Alexandr Labas, and Yurii Pimenov.

The works in the exhibition were created in an era of sharp social conflict and radical breakdown of traditional views. In a short period of time three revolutions took place in Russia—that of 1905–7, the February Revolution in 1917, which overthrew the autocracy, and the great October 1917 Socialist Revolution. Russian art both absorbed and vividly expressed the atmosphere of this tempestuous time, with its tension, dynamism, and fervent search for new ways of life and creative orientations. For artists, this milieu helped create a powerful wave of Romantic sentiment, intense seeking of new forms in art, and innumerable aesthetic utopias that asserted the ability of the new art to transform the world. Konstantin Korovin aspired toward the beauty of the "delightful" in life; Kazimir Malevich was confident that art could express humanity's link with the infinity of the cosmos, with "world space"; Pavel Filonov

intended to show the propinquity of "world flowering," the path that is laid by the "knowing eye" of the artist; Mikhail Larionov and Natalia Goncharova—artists of exceptionally diverse stylistic range—attempted to link organically the expressive grotesque style of folk art with the refined culture of modern painting.

At this time Marc Chagall and Vasilii Kandinsky developed their own special version of Expressionism. *Window in a Dacha,* 1915, by Marc Chagall is a typical example of his bewitching lyricism. Behind the appearance of real life arises the music of an allegory about the magic of love. Vasilli Kandinsky is inseparable from the history of German Expressionism as well as from the quests for spiritual fulfillment and the "music" of painting, characteristic of Russian artistic culture. The works of Liubov Popova and Alexandra Exter indicate their Cubist aims.

Kuzma Petrov-Vodkin became one of the greatest artists of this time. His thorough mastery of the national traditions of the Russian icon, the art of the early Italian Renaissance, and the experience of European Symbolism as well as his own discoveries created the original fusion that distinguishes his style.

In the post-October period, the number and variety of associations, groups, declarations, and artistic manifestos grew with uncommon speed. Art strove to imprint the revolutionary advances and the beginning of the new life. Pavel Kuznetsov, Alexandr Kuprin, Ilia Mashkov, and others of the older generation of Russian artists found socially significant subjects, depicting the construction of the subway and new factories. The members of the Association of Artists of Revolutionary Russia continued in their art the traditions of the realistic painting of the second half of the nineteenth century. In their small-scale genre paintings they accurately documented the signs of the new living conditions of workers, peasants, and the Red Army; they also painted portraits of revolutionary figures and worker heroes. Boris Grigoriev, Evgenii Katsman, Efim Cheptsov, Mitrofan Grekov, and others belonged to this trend. The Society of Easel Artists ardently sought in their work to provide memorable depictions, not so much of everyday life as of the inimitable atmosphere of the revolution, the swift tempos of the new life and the dream of a wonderful future. Yurii Pimenov and Sergei Luchishkin were captivated by the miracles of technology, urbanization, and industrialization.

We hope that this exhibition offered to American art lovers will sufficiently represent Russian art of the first third of the twentieth century—the art of rebels and dreamers, revolutionary in spirit, reflecting one of the most vivid creative stages in the history of Russian and Soviet culture.

Genrikh P. Popov
Chief, Administration of Fine Arts
and Preservation of Monuments, Ministry of Culture
Union of Soviet Socialist Republics

PREFACE

In October 1986 the Smithsonian Institution proudly presented *Russia, the Land, the People: Russian Painting, 1850–1910,* an exhibition drawn from the internationally known collections of the State Tretyakov Gallery in Moscow and the State Russian Museum in Leningrad. In the catalog for that exhibition I pledged that the Smithsonian would "continue to seek new ways to share and communicate about the artistic and cultural resources of our two nations as steps toward mutual understanding."

The success of this effort has been enormously gratifying. Since 1986 the Smithsonian has organized an exchange exhibition entitled *New Horizons: American Painting, 1840–1910,* which traveled to the Soviet Union and was presented in Moscow, Leningrad, and Minsk. Now, in July 1988, we have reached a further stage in this still developing dialogue with the presentation in Washington, D.C., by the Hirshhorn Museum and Sculpture Garden of the exhibition *Russian and Soviet Paintings, 1900–1930: Selections from the State Tretyakov Gallery, Moscow, and the State Russian Museum, Leningrad.*

For the American public this exhibition should serve as both a revelation and a confirmation. It reveals how enormously rich and diverse were the sometimes overlapping, sometimes contrasting, styles and tendencies followed by the Russian and Soviet artists who worked during the first turbulent decades of this century. It confirms how very closely the experience of these artists paralleled that of American artists. Neither in their country nor ours did one particular style come wholly to dominate or neatly supplant another. Quite the contrary, it was a time of artistic ferment, a creative maelstrom. In both countries artists were driven by a variety of impulses—sometimes traditional or experimental, sometimes linked to international styles or rooted in local experience. It was a period that bequeathed us a precious aesthetic legacy, the full scope of which we are only now beginning to realize.

Our founding mandate at the Smithsonian was to be "an establishment for the increase and diffusion of knowledge." By giving our visitors what, for many, will be their first opportunity to view so vital a body of painting, the Hirshhorn Museum's presentation of the exhibition *Russian and Soviet Paintings, 1900–1930* permits us to carry out that mandate in a most exemplary way. That it may also lead us toward ever richer

exchanges and advance the ongoing dialogue between the peoples of two great countries—a dialogue that must surely deepen their understanding of one another—can only increase the immense pride we take in this occasion.

Robert McC. Adams
Secretary, Smithsonian Institution

ACKNOWLEDGMENTS

As in the West the first three decades of the present century in that vast Eurasian land mass once called Russia and now known as the Union of Soviet Socialist Republics were characterized by creative ferment, rapid change, and daring innovation in the visual arts. But to an extent unequaled elsewhere during that period, the country experienced a revolutionary transformation that left its mark on every aspect of life: political, economic, and cultural.

The Hirshhorn Museum and Sculpture Garden is privileged to present this introduction to an unusually rich, complex, and critical period in the country's artistic evolution. The medium of painting has traditionally long been favored by artists for ushering in a new formal vocabulary or for reflecting ideational and philosophical developments, and a conscious decision was made to focus on this facet of artistic creativity despite important occurrences in other media. In addition *Russian and Soviet Paintings, 1900–1930: Selections from the State Tretyakov Gallery, Moscow, and the State Russian Museum, Leningrad* is in some ways a continuation of the exhibition *Russia, the Land, the People: Russian Painting, 1850–1910,* which also was selected from the outstanding collections of the two museums noted above and which was presented by the Smithsonian Institution Traveling Exhibition Service (SITES) in 1986–87.

Exhibitions in the United States of Russian art of this century have tended to focus exclusively on the avant-garde, thereby transcending national boundaries and presenting the Russian experience in the context of other vanguard movements in the West. This exhibition, however, takes a more linear approach and places the avant-garde in the context of other manifestations of Russian and Soviet painting in the early part of the century. In this respect it perhaps affords the viewer a relatively more complete picture of what actually occurred.

We, of course, do not pretend to claim that the exhibition is comprehensive. Matters of condition and ever increasing commitments to other exhibitions have regrettably necessitated the omission of certain works and even of some major artists such as, for example, Vladimir Tatlin and Mikhail Vrubel. But we are gratified by what has so kindly been lent to us and what we are able to present.

The exhibition had its formal genesis in April 1987, when Robert McCormick Adams, Secretary of the Smithsonian Insti-

tution, and Genrikh P. Popov, Chief of the Fine Arts and Preservation of Monuments Administration, Ministry of Culture of the Soviet Union, signed a protocol in which, among other points of mutual interest, it was agreed that an exhibition of Russian and Soviet art from 1900 to 1930 would take place at the Hirshhorn Museum and Sculpture Garden in 1988.

It is with great pleasure and deep gratitude that we acknowledge those whose generous cooperation and support have culminated in this joint venture. In the Ministry of Culture of the Soviet Union we especially wish to extend our appreciation to Vasiliy Zakharov, Minister of Culture, and to M. A. Gribanov, Deputy Minister of Culture, for their endorsement of the cultural exchange program. Genrikh P. Popov has been extremely involved from the outset; we are grateful to him for his help and for the informative comments he has made in the foreword to this catalog. Also supportive of our efforts were Vladimir I. Litvinov, Chief, West European, American, and International Organizations Section; Irina Mikhyeva, Head of North American Relations; Natalya Volpina, Chief Expert, Department of Information; and Pavel Horoshilov, Director, All-Union Artistic Production Association Named after E. Vutshetich.

His Excellency Yuriy V. Dubinin, Soviet Ambassador to the United States, has been helpful throughout as has his staff at the Soviet embassy. Special thanks are extended to Aleksandr P. Potemkin, Counselor, for his patience and assistance as well as to Nikolai D. Smirnov, First Secretary of the Embassy, and Eduard R. Malayan, First Secretary, Department of the USA and Canada of the Ministry of Foreign Affairs.

The exhibition could not have been realized without the cooperation and assistance of our colleagues at the State Tretyakov Gallery in Moscow, directed by Juri K. Korolev, and at the State Russian Museum in Leningrad, directed by Vladimir A. Lenjashin. Our warm gratitude is extended to them and to their staffs: in Moscow to Aleksandr G. Halturin, Deputy General Director; Stanislav M. Ivanitskii, Soviet Painting Department Director; Ekaterina Selezneva, Chief of the Foreign Department; Natalya Karpinskaja, Expert of the Foreign Department; Vitold M. Petushenko, Academic Secretary; and Natalya Ponomareva; and in Leningrad to Evgenija N. Petrova, Vice Director; Vasiliy I. Moshkov, Assistant Director for External Relations; Dr. Nina Barbanova, Senior Research Curator; and

Elena Popova. To them, to those who have written for this publication, and to the many other persons who aided us in the Soviet Union we are most grateful.

Our sincere gratitude is extended to Ambassador Jack F. Matlock of the United States embassy in Moscow for his encouragement of our efforts, and in particular we wish to thank Philip Brown, Counselor for Press and Cultural Affairs; Mark Taplin, former Second Secretary; Rosemary Anne DiCarlo, Second Secretary and Assistant Cultural Affairs Officer; and Max Robinson, Office of Soviet Union Affairs, and Susan Robinson.

Closer to home, various persons have willingly shared information that has facilitated our efforts, and we are pleased to acknowledge them here: Kennedy B. Schmertz, Special Assistant to the Assistant Secretary for External Affairs; Peggy A. Loar, former Director of SITES; James H. Duff, Director, Brandywine River Museum; and Molly Raymond, Deputy Coordinator, President's US-USSR Soviet Exchange Initiative, USIA. Donald R. McClelland, SITES Exhibition Coordinator, also deserves special mention. Experts E. V. Basner of the State Russian Museum, A. P. Gusarova of the State Tretyakov Gallery, and John E. Bowlt of the University of Southern California have written introductory essays that provide useful information and perceptive insights into the art of the period. Catalog entries have been written by A. P. Gusarova and S. M. Ivanitskii of the State Tretyakov Gallery and by E. V. Basner, V. P. Kniazeva, G. K. Krechina, V. F. Kruglov, and O. N. Shikhireva of the State Russian Museum.

Although working under trying time restraints, the staff of the Hirshhorn Museum and Sculpture Garden has performed with diligence and efficiency. In particular I wish to acknowledge Ned Rifkin, Chief Curator for Exhibitions, who shared with me responsibilities for selecting the exhibition with our Soviet colleagues. With the help of his assistant Jennifer Loviglio he has also been responsible for coordinating the myriad aspects of the exhibition. My warm gratitude is extended to Deputy Director Stephen E. Weil, who provided his usual sound counsel throughout; and to Executive Officer Nancy Kirkpatrick; Registrar Douglas R. Robinson; Edward P. Schiesser, Supervisory Visual Information Specialist (Exhibits); and Public Affairs Officer Sidney S. Lawrence; and to the respective staffs for their invaluable assistance. Working under considerable pres-

sure to realize the publication of this catalog, Editor Barbara J. Bradley must be singled out for her perseverance and careful attention.

The Smithsonian Institution's charge "for the increase and diffusion of knowledge" is reflected in Secretary Adams's enthusiasm for cultural exchanges and for fostering international cooperation. To him and to Tom L. Freudenheim, Assistant Secretary for Museums, go our heartfelt thanks for their strong support of this project.

James T. Demetrion
Director, Hirshhorn Museum
and Sculpture Garden

INTRODUCTION

E. V. Basner, The State Russian Museum, Leningrad
A. P. Gusarova, The State Tretyakov Gallery, Moscow

In many ways the first three decades of the twentieth century constitute an autonomous stage in Russian history, which has as its center the October Revolution of 1917. Seeking to find their place in the growing political and social struggle, progressive artists of the time devoted their creative efforts to serving the cause of the revolution. With a heightened sensitivity to social issues, artists participated in the conflict, living in anticipation of what Symbolist poet Alexandr Blok heralded as "hitherto unseen changes," embodying in vivid myths the dream of a beautiful, harmonious world. In the aftermath of the revolution, artists continued, sometimes arduously, to define their relationship to the revolution.

Russian art, dance, literature, and music of the early twentieth century immeasurably contributed to the treasury of world culture. Merely to mention the creative giants of the period is to spark instantaneous recognition among all people worldwide: the writers Anton Chekhov, Maxim Gorky, Boris Pasternak; the dramatist Vladimir Maiakovsky; the directors Vsevolod Meierkhold and Konstantin Stanislavsky; choreographer Michel Fokine; operatic singer Fyodor Chaliapin; ballerina Anna Pavlova; composers Sergei Prokofiev, Alexandr Scriabin, and Igor Stravinsky; as well as that outstanding figure of Russian culture, Sergei Diaghilev, who introduced the world to the quintessence of Russian achievements in music, painting, and choreography. In the history of Russian painting this time period witnessed a creative revolution, replete with rebellious coups, daring experimentation, and fearless assaults into new territory. As a trailblazer of new directions in art, Russia gained universal recognition.

By the late nineteenth century artists were no longer interested in depicting bucolic genre scenes and romanticized dramas. The beginning of a new phase in Russian art had first emerged as early as the late 1880s and early 1890s. "Our love grew for another way of life, another art, other groups of people in our midst," wrote the Symbolist poet Andrei Bely. The first "bloodless rebels" in the fine arts were the young exponents of the Circle of the Itinerants: Konstantin Korovin, Mikhail Nesterov, and Valentin Serov, who assumed the roles of "adopted sons of the itinerant movement."

Korovin and Serov brought Impressionist devices to painting, Korovin becoming the foremost proponent of Russian Im-

pressionism. Many features of his work, which is distinguished by a predilection for silvery tones, were dictated by the unique atmosphere of the Russian north as well as the influence of Scandinavian Impressionists, particularly Anders Zorn. Only during the first ten years of the twentieth century did Korovin approach the French interpretation of Impressionism. In contradistinction to the elegance and discipline of French painting, Korovin's work is characterized by a bursting spontaneity, technical insouciance, and agitated brushwork. His long involvement with the opera colored his art with features of the dramatic and spectacular. "Konstantin rages in the blinding whirls of paints," Serov said of Korovin's stage sets.

Nesterov's work, although similar to the Itinerants' in its nationalistic folk spirit, was nonetheless perceived by them as rebellious since it contained a "harmful mysticism," which they considered to undermine rationalist norms. Committed to religious and symbolic themes, Nesterov created monumental church frescoes, landscapes, and portraits. His figures live in harmony with nature and are often found absorbed in prayerful contemplation. Nesterov's paintings mark the appearance of a new style, which in Russia was described as modernist. His work manifests itself in a free association of the real with the fantastic and an exalted spirituality, predicated on delicate hues and fragile rhythms.

Other artistic rebels were drawn together at the turn of the century by the slogans heralding "beauty" and "free expression" promulgated by supporters of the journal *World of Art*. This group, formally established in 1900, also sponsored exhibitions. Its founders were from Saint Petersburg and included Lev Bakst, Diaghilev, and Serov, who helped organize exhibitions and edit the journal. The association's many projects also succeeded because of the energy, will power, and extraordinary organizational talents of Diaghilev. Young Russian artists were drawn to the group because of its emphasis on their cultural heritage and the breadth of its artistic interests, spanning not only painting, sculpture, architecture, and the graphic arts but also literature, especially poetry, and the decorative as well as dramatic arts.

The World of Art awakened artists to the intrinsic possibilities of painting and the graphic arts. To quote one of its members, the group "served to wage the great artistic war and

reassess values." The journal *World of Art* disparaged the routine and defended the new. Finding common ground with other cultures, the World of Art promulgated its aesthetic philosophy against encroachments of any kind and promoted the development of a "new vision." To this end, for example, the group looked afresh at eighteenth- and early nineteenth-century themes and images, incorporating them in their own work. The imprint of the modernist style lay in the works of such leading members as Bakst, who manifested his great gift in designing stage sets. The greatest achievement of the World of Art group was in creating stylistic assemblages, primarily book designs and theatrical presentations. They received worldwide acclaim, especially in their contributions to the Ballets Russes, first organized in Paris by Diaghilev in 1909. His enterprises relied on the participation of both Russian and West European avant-garde artists: Natalia Goncharova and Mikhail Larionov (founder of Russian expressionist abstraction) as well as Pablo Picasso among others. These artists were not only painters and designers but also directors and critics, and with Fokine they reformed Russian ballet, thereby assuring it the universal recognition that continues to the present.

Exhibitions organized by members of the World of Art played an important role in Russian culture by stressing the importance of a synthesis of all art forms, including the decorative arts, and a reliance on international cooperation. Their exhibitions traveled abroad (the first, organized by Diaghilev, was of Russian and Finnish paintings). The artistic breadth of the group, moreover, prompted artists of diverse aesthetics to consider the organization as a safe haven. Exhibiting with the World of Art were such later Itinerants as Korovin, Nesterov, and Serov as well as two leading Russian Symbolists, Mikhail Vrubel, who used modernist language to convey his concepts, and Viktor Borisov-Musatov, who based his decorative experimentations on the methods of the Post-Impressionists. Russian "Cézannists" Petr Konchalovsky and Ilia Mashkov as well as the avant-garde artists Goncharova, Larionov, and Vasilii Kandinsky exhibited with the World of Art. The basic antagonism of these trends, however, would soon lead their adherents to part.

Russian Impressionists and Pleinairists in 1903 formed the Union of Russian Artists. The Moscow painters Abram Arkhipov and Korovin, among others, assumed leadership in the associa-

tion. Artists from Saint Petersburg joined the union as the World of Art began to fall apart in 1903. The Saint Petersburg artists, however, did not feel comfortable with the Muscovites, who in many ways continued the realist traditions of the Itinerants, and they quit the union in 1910 to regroup again under the name World of Art. Following their departure, the Moscow union gained a greater unity and integrity. The association devoted its talents to conveying the intrinsic qualities of the national spirit, evoked by the light and atmosphere of the Russian landscape and in the country's singular architecture and vibrant folk life—witnessed in artists' depictions of communal celebrations, colorful costumes, and festive bazaars and fairs. Others of this circle chose to describe with a lyric melancholy the spare landscapes of the north and abandoned estates of the gentry.

In 1907 Russian Symbolists established their own group. Associated with the journal the *Golden Fleece,* they mounted an exhibition entitled the *Blue Rose,* after which the group chose its name. Important Blue Rose artists Pavel Kuznetsov and Martiros Sarian, like Paul Gauguin, felt alienated from the banality of urban life, and they fled to the East in hope of finding a pristine integrity and strength. In the steppes beyond the Volga, Kuznetsov sought the "calm contemplative secret of the East." He painted pictures in which reality is transformed, cleansed of all that is incidental and hidebound. Kuznetsov's subtly decorative paintings drew on his impressions of the art of Gauguin and Henri Matisse as well as on his Russian heritage: Kuznetsov greatly admired Russian icons and frescoes. Sarian visited Egypt, Turkey, and Iran, acquiring a laconic, striking approach to composition and color. Blue Rose artists were the first to turn to Russian folk culture as a source for their work.

In 1910 another group was formed, the Jack of Diamonds. Important representatives of the "Jacks," as they called themselves, included Robert Falk, Konchalovsky, Alexandr Kuprin, Aristarkh Lentulov, Mashkov, and Vasilii Rozhdestvensky. They were, in the words of Konchalovsky, "united by a need to mount an attack against old art." They vehemently denied all preceding trends: the academism and Realism of the Itinerants; the retrospectivism and intimist qualities of the World of Art; the Symbolism and salon aestheticism of the Blue Rose. The Jacks plunged themselves into meeting the challenges of pure paint-

ing while maintaining sight of the object and retaining their painterly orientation. Their unbridled, colorful paintings drew equally from Matisse and the Fauves as well as from diverse Russian sources, including *lubki* (popular, brightly colored prints), icons, toys, and ancient architecture. Their art often combined folk humor and daringly barbaric arrays of color, describing somewhat crude and gaudy spectacles.

Konchalovsky typified the Jacks. He loved the material world and sought to unlock the secret of an art that had a willful pugnacity unrelated to Realism and Impressionism. He found in the work of the Itinerant Vasilii Surikov a vital force reflecting the Russian spirit. Despite his reliance on contemporary French painterly techniques, Konchalovsky remained a deeply nationalistic artist, who realized the exceptional originality of his own painting. He would say in jest that for the French he remained a "barbarian Slav."

To an even greater extent these so-called barbaric qualities are found in Mashkov's still-life paintings, which resemble billboards of exaggerated dimension and unnaturally bright colors. In his canvases every object shouts out as if it had been painted with the broad brushstrokes of a housepainter.

In contrast to these artistic enthusiasts, Falk and Kuprin were more restrained. Kuprin created spiritualist paintings that clearly evince his orientation toward ancient Russian art. A lyric perception of reality characterizes his work, which is multilayered, rich in tones, and illuminated by a translucent light. The Jacks before 1917 first became interested in gaining a mastery of nature, and after the revolution the cult of nature gradually conquered all other interests for them.

At the same time another direction—led by what has been termed "the Russian avant-garde"—gathered strength and energy. Although of diverse talents and temperaments, ideological convictions, and creative methods, avant-garde artists shared an interest in adapting their principles to finding new expressive means to bring down aesthetic canons that seemed to them obsolete and narrow. It would be incorrect to view the Russian avant-garde movement as a single, uniform phenomenon. Confrontation and competition were much more common than is indicated by the movement's collective statements against their predecessors and conservative opponents.

Early leaders of this movement were Goncharova and Lari-

onov. Inseparable in their life-long creative journey, they shared artistic aims and faced similar challenges. In their paintings they progressed through similar stages of development—from Post-Impressionism through Neoprimitivism (in many ways paralleling French Fauvism and German Expressionism) to their first experiments in nonobjective art. They exhibited together in the first Jack of Diamonds exhibition but later broke with the group, calling the members' orientation to the West futile and advising them to look instead to the East, the first source of the arts, and to develop a broad mastery of their own folk art.

Goncharova and Larionov were nonetheless different in their worldview, artistic temperament, and individual style. Larionov was given to the immediacy and organic quality of a purely painterly vision (which the artist Falk described as "absolute," comparing it to perfect pitch in music). Even in the most daring works Larionov never sacrificed his coloristic sophistication. The work of Goncharova is distinguished by a greater dynamism, expressiveness, and turbulent modeling. The Neoprimitivist period of their art (represented in this exhibition) also evinces opposing stylistic sources. This different tact is expressed by their reliance on individual subjects and themes: Larionov in urban folklore and use of the billboard; Goncharova in traditional peasant art. The art of Goncharova and Larionov forms a balance between the practical and theoretical. Their paintings matched their ideas fairly closely over time, and despite their intense political activity, they managed to avoid the temptation of empty theorizing.

The work of other masters of the Russian avant-garde—for example, David Burliuk and Nikolai Kulbin—also was oriented toward organizational and propagandistic activities. Although tirelessly championing new ideas, they painted canvases representative of a conservative expressionism (Burliuk) and *retardataire* pointillism (Kulbin). Their artistic activity nevertheless was a powerful, centrifugal force that ultimately led to a consolidation, albeit of short duration, of the avant-garde, culminating in 1910 in the emergence of the two largest art associations: the Jack of Diamonds in Moscow and the Union of Youth in Saint Petersburg.

Unlike the Jacks—for whom painting essentially became their sole avenue of artistic self-expression—members of the

Saint Petersburg avant-garde were drawn to other spheres of creative activity, including literature (poetry, in particular), music, drama, and philosophy. Thus Mikhail Matiushin, among the leaders of the Union of Youth, was not only a painter but a professional musician, composer, and outstanding aesthetician. He devoted many years to devising a theory of color perception that would yield a rationale for a new system of spatial relationships in painting. These theories were to provide the philosophical basis for his school of art. Maria Ender was among his students.

For most young painters the Jack of Diamonds and the Union of Youth were the starting blocks for further searches. These associations exhibited the work of Natan Altman, Marc Chagall, Alexandra Exter, and Olga Rozanova among other. A fascination with French Cubism and Italian Futurism—from which emerged a unique phenomenon, Russian Cubo-Futurism, which engaged virtually all young artists during the 1910s—neutralized the purely Saint Petersburg or Muscovite orientation of the two groups. Although systems of painting began to prevail over artistic individuality, the range of creative explorations continued to be all-inclusive.

For example, in the art of Chagall, French influences merged with the artist's strong and profound affiliation with Jewish culture. Altman and Yurii Annenkov embraced Cubism while maintaining an alliance with academic tradition. Exter incorporated in her early work analytical constructs that were further to define her later artistic evolution. Rozanova's artistic path is interesting: her unique gifts unfold in dense compositions and an assured handling of material. The work of Liubov Popova has as one source French Cubism and exhibits a confident handling of multidimensional structure and compositional unity. Although Pavel Filonov has traditionally been considered a leader of the Russian avant-garde as a member of the Union of Youth, his art is broader than any individual trend or movement. Much separates him from the artists here discussed. He never indulged in those elements of jest and irony that distinguished most avant-garde artists. Filonov was a deeply sensitive, tragic figure. Unlike most members of this circle (with the possible exception of Goncharova), Filonov was profoundly concerned with the way a work was made and emphasized the inseparability of form and content. Thus even his

abstracted works (such as *Formula for the Petrograd Proletariat*, 1920–21) are programmed.

Vasilii Kandinsky is an even more self-contained figure in the history of Russian art. His work belongs to two cultures, Russian and German. He was among the first to move toward improvisation and the nonobjective and away from rational analysis. In his journey into the realm of the intuitive and the subconscious, Kandinsky presumed no followers.

Most avant-garde artists sought to embody the objective essence of art, to discover forms independent of the vacillations of mood and temperament. This urge received its fullest embodiment in Suprematism, developed in the art and theory of Kazimir Malevich. According to Malevich, Suprematist compositions were to mirror "the artist's liberation from the imitative obedience to the immediate invention of creativity." A dynamic distribution of individual elements on the canvas plane and their rhythmical and colorful interaction serve in the artist's design to embody their own movement, their own energy and dynamics, overcoming generally accepted idioms that postulate the existence of matter and categories of space and time.

It is not surprising, therefore, that this idea of constructing one's own world, free of outmoded canons, accorded with the mind-set of artists who were creating innovative art forms before the revolution and during its aftermath. Among such artists is Ivan Kliun, a friend and committed follower of Malevich, although both later returned to figurative art.

The revolutionary events of 1917 brought to life a wave of creative enthusiasm, releasing an energetic charge that stimulated every sphere of society. During the first postrevolutionary years there emerged a new art of great power and expressiveness: agitational, propagandistic, art for the masses. Artists of different directions, both conservative and avant-garde—including Chagall, Boris Kustodiev, Kuprin, Malevich, and Kuzma Petrov-Vodkin—decorated streets and squares for revolutionary celebrations and rallies, created new cultural emblems, and painted impressive portrait images. They carried out Lenin's plan of bringing art closer to the people.

Artists understood the necessity to make the ideas of the revolution understandable to the Russian people, who at that time were largely illiterate. Art critic Yakov Turgendkhold vividly captured the atmosphere of those times:

Those were the years when, in a flush of ecstasy, a surge of young energy, it seemed that nothing would be easier than burning down the old bridges to the bourgeois culture and immediately erecting on the fragments of the past the building of the new culture—the proletarian culture. Those were the years when, despite poverty and hunger, it seemed that art could immediately set to the task of creating a new milieu, a new way of life. Those were the years when the revolutionary reappraisal of all values did not stop before tradition, when all aspects of artistic life—including museums and schools—underwent critical examination. Those were the years when, despite the new "accelerated" pace of life, people found time and energy to meet to discuss art and tackle the issue of whether art was to exist at all. Those were the years of declarations and decrees, ideological struggle and programs, of laying the foundation of the new art policy, the policy of the Soviet State.

The fundamental trends of the 1910s continued to develop after the October Revolution. The Impressionists and the Itinerants found a place in the Association of Artists of Revolutionary Russia (AKhRR). Members of the Blue Rose and World of Art groups merged into an association called the Four Arts Society, while the Jacks organized the Moscow Society of Artists. Art associations and manifestos appeared at an uncommon rate, and cultural activities throughout the country were lively and varied.

Progressive artists have always endeavored to register revolutionary change and bear witness to the building of new societies. To these ends, Nesterov painted portraits of contemporary leaders. Older artists, including Pavel Kuznetsov, Kuprin, and Mashkov, accepted socially purposeful assignments, depicting, for example, the building of new cities and the technological advances taking place throughout the country. At the same time they maintained the technical brilliance for which Russian easel painting was known.

Two especially noteworthy groups that addressed the significance of the revolution were the AKhRR and the Society of Easel Artists (OST). The AKhRR—including Efim Cheptsov, Mitrofan Grekov, Boris Grigoriev, and Evgenii Katsman—carried on the Realist traditions of late nineteenth-century art. Among the more typical examples of their painting is Chept-

sov's *A Meeting of a Village Cell*, 1924. He and other like-minded artists were interested in particularized settings and insightful psychological portraits. These artists ably captured the flavor of the period, and their art is especially significant as prized historical documents.

Unlike the AKhRR artists, with their interest in depicting scenes of everyday life, the OST painters were passionately committed to capturing the unique atmosphere of the revolution, its striking rhythms and sweeping tempos, the dream of a beautiful future. Artists Alexandr Deineka, Nikolai Denisov-sky, Sergei Luchishkin, and Yurii Pimenov were captivated by the marvels of technology, urbanization, and industrialization as well as the unprecedented possibilities available to the indi-vidual. The subject of much of their work is the athlete, who be-comes a vision of future possibilities, endowed with strength and character, living harmoniously in nature and society. Their cityscapes resemble the futuristic visions that fire the dreams of young architects. Such members of the OST as Alexandr Labas and, in some ways, David Shterenberg expressed their ideas about revolutionary transformations by manipulating color in new ways. The striking clarity and forcefulness of their work is uniquely expressive.

At the same time many avant-garde artists feverishly wel-comed the revolution, equating such revolutionary change with unfettered creativity and free experimentation in form, color, and material. For the vast majority the only means of embodying these ideas was abstract painting. They looked to nonobjective art as a measure of the artist's unshackled will. Nonobjective art re-created revolutionary symbols in timeless, cosmogonic compositions (Alexandr Rodchenko's works attest to this pursuit).

The correlations between the challenges of painting and revolutionary transformations, of finding harmony between individual goals and the needs of the historic moment, would lead many to renounce "pure" painting in favor of applied art and industrial design. One of the more distinct manifestations of this concept of bringing together the different arts—studio and applied—was Constructivism.

Unlike the Suprematists, who created their own worldview solely in painting and insisted on the primacy of color, the Constructivists absorbed themselves in the problems of exec-

tion and material, specifically in interaction with the applied arts. They moved away from solely concerning themselves with nonobjective art and took on concrete, clearly formulated projects. By focusing on execution the Constructivists introduced a new aesthetic and a keen awareness of materials. Their interest in the unprecedented challenges posed by science and technology meant that such concerns for the first time were to receive thoughtful consideration and become embodied in art.

BETWEEN EAST AND WEST:
RUSSIAN ART OF THE EARLY
TWENTIETH CENTURY

John E. Bowlt

The exhibition *Russian and Soviet Paintings, 1900–1930* brings to the American public more than fifty of Russia's most distinguished artists. Some, including Lev Bakst, Marc Chagall, Kazimir Malevich, and Alexandr Rodchenko, already enjoy universal acclaim; such others as Leonid Chupiatov, Alexandr Labas, and Vladimir Malagis are still unfamiliar. All neverthe-less belong to that mosaic of personalities and ideas that contributed to the extraordinary development of Russian modernism just before and after the October Revolution. From the latter-day Realism of Sergei Ivanov to the radical Con-structivism of the Stenberg brothers, from the Symbolist visions of Nicholas Roerich to the stark forms of Ivan Kliun's Suprema-tism, from the naïve Neoprimitivism of Natalia Goncharova and Mikhail Larionov to the chiseled forms of Natan Altman's neoclassicism—these are just a few of the aesthetic components of Russia's cultural renaissance that left such a deep imprint on the country's literature, music, and visual arts during the period 1900–1930. Unfortunately, because of the exigencies of trans-portation, international demand, and the condition of the works, certain artists—such as Vladimir Tatlin and Mikhail Vrubel—could not be included in the exhibition, so the survey is not comprehensive. Still to a large extent it provides an adequate idea of the genesis and evolution of one of the most dynamic periods in the history of Russian art.

One of the focal points of the exhibition is the avant-garde, a term that has almost become a household word thanks to the wide, current interest in the work of artists such as Pavel Filonov, Goncharova, Vasilii Kandinsky, Larionov, Malevich, Liubov Popova, Rodchenko, and Tatlin. This interest is, of course, justified and deserves to be expanded further as we come to recognize the fullness of the theory and practice of artists, critics, and patrons in Moscow, Saint Petersburg, Kiev, and Kharkov during the 1910s and 1920s. The rapid rehabili-tation of the avant-garde has also, however, prompted some misleading generalizations. For example, there was no single avant-garde, the term was never used by those artists to whom it is now applied, and it became a "movement" only retroac-tively, in the 1960s.[1] There was no harmonious intercourse between Larionov and Rodchenko, Chagall and Malevich, Popova and Varvara Stepanova; Filonov had no time for any-one; and the fistfight between Malevich and Tatlin at the 0.10

exhibition in Petrograd in 1915–16 is now legendary. Conse-
quently, in speaking of the avant-garde we should be aware of
these distinctions and as long as we take account of the hetero-
geneity of Russian modernism and of its many internal dissen-
sions and factions, we may avoid oversimplification.

Whichever category is used, the paintings of Malevich,
Popova, Rodchenko, and their colleagues are of major impor-
tance to the history of modern art, and they still amaze by their
predictions of American Abstract Expressionism and Minimal-
ism a quarter of a century later. The exhibition *Russian and
Soviet Paintings, 1900–1930* also provides us with a rare oppor-
tunity to place these radical artistic statements within the wider
context of late nineteenth-century Russian Realism (Ivanov),
the fin de siècle (Bakst, Mikhail Nesterov), and Heroic—or what
in 1932 would be called Socialist—Realism (Mitrofan Grekov,
Evgenii Katsman). Most artists here represented were intensely
patriotic, closely allying themselves with their domestic tradi-
tions, and to a considerable extent maintained rather than
destroyed the essential rituals and customs of their culture.

The remarkable upsurge of creativity, diversity of stylistic
precepts, and ambivalent attitude toward the West identifiable
with Russian modernism formed a combination of conditions
that was by no means new in the long history of Russian art. A
similar coincidence occurred during the late seventeenth cen-
tury in the Kremlin Workshops in Moscow, when Simon
Ushakov, the great modernizer of Russian icon painting, super-
vised the icon studios there. Like the Moscow School of Paint-
ing, Sculpture, and Architecture in the early 1900s (where
many of the avant-garde trained), the Kremlin Workshops of the
1660s and 1680s welcomed Ukrainian, Armenian, Greek, and
Polish as well as Russian students, exposed them to Western
styles, and produced an entire generation of nonconformists.
Just as Malevich and Tatlin revolutionized twentieth-century
Russian art and brought it on par with Western art, even
surpassing the achievements of Paris, Milan, and Munich, so
Ushakov and his colleagues also transformed the Russian icon
and brought it into the mainstream of Western culture, adjust-
ing its covert imitation of Italian styles to a formal and open
modus operandi while still adhering to the essential traditions
of the Russian school.

The issue of precedent, tradition, and foreign influence in

Russian culture is, of course, intricate, relating to many difficult questions—from the sharp polemic between the Slavophiles and Westernizers of the nineteenth century to the political debate of internationalism versus nationalism in the 1920s and 1930s. Modern Russian artists did not share a single response to the West and alternated between obsequious adulation and total rejection. Some such as Bakst, Chagall, and Kandinsky spent most of their lives outside Russia, others such as Filonov, Malevich, and Rodchenko made only brief trips abroad, but all were familiar with Western art through either direct confrontation in Europe or exposure to collections in Moscow, especially the Impressionist and Post-Impressionist paintings owned by Ivan Morozov and Sergei Shchukin.[2] It consequently is not surprising to find Russian paraphrases of French pictorial ideas—Pavel Kuznetsov, for example, in his *Still Life with Tapestry*, 1913, takes Henri Matisse as his inspiration; Goncharova transplants the feet of Paul Gauguin's Polynesian beauties to her Russian peasants; Georgii Yakulov's *Bar*, 1910, has an uncanny resemblance to Sonia Delaunay's Simultanist color discs; Robert Falk collapses Paul Cézanne and Pablo Picasso into his landscapes and portraits; Yurii Pimenov combines both Jean Metzinger and Otto Dix to produce his *Girls with a Ball*, 1929. These parallels are intriguing because they communicate much about the iconographic derivations of the Russian avant-garde and also touch on the broader question of the subsequent development of such artists.

Russian artists borrowed and reprocessed French, German, and Italian ideas, but they also blended them with local sources and exaggerated them out of all proportion. Such was the case with the move from Cubism and Futurism to Suprematism and then Constructivism. Russian artists, furthermore, often tried to extend what originated as an aesthetic or formal system to "life" or the "cosmos," to carry art into a public space and in-vest it with a utilitarian, sometimes messianic purpose. For example, Malevich and his followers applied geometric, abstract forms to functional ends in their designs for Suprematist porcelains, furniture, and fabrics.[3] In his *On the Spiritual in Art* (1911–12) Kandinsky used a theosophical argument to imply that art should express a higher consciousness.[4] Mikhail Matiushin and his students even believed that the visual apparatus itself could be expanded to 360 degrees and supple-

mented by the reactivation of dormant optical reflexes on the back of the neck and the soles of the feet—leading to their attempts at new spatial dimensions in the 1910s and 1920s.[5] The very ethos of Constructivism—using art to redesign every-day life (*byt*)—was a direct result of the same mentality. Whence came this enquiring intelligence and obdurate strength, this audacity to reduce art to its intrinsic elements on the one hand and then to justify these new arrangements by extrinsic application on the other? This question might be answered through reference to two particular movements: Symbolism and Neo-primitivism.

Opposing the Victorian, positivist worldview, the Symbol-ist poets and painters of the 1890s and early 1900s attempted to transcend concrete reality and reach the "ulterior" or "essen-tial." Viktor Borisov-Musatof, Kuzma Petrov-Vodkin, and their friends in the Moscow Blue Rose group (led by Kuznetsov) were fully representative of this eschatological mood, and their paintings—reminiscent of the disturbing harmonies of the Nabis—elicit misgivings about the solidity of the world of appearances. Instead of the affirmation of material objects, conveyed by such Realists as the great Ilia Repin and his pupil Filipp Maliavin, the Symbolists promoted less tangible values: individual interpretation, emotional expression, eccentric caprice. It was a philosophy preached by Sergei Diaghilev's World of Art group in Saint Petersburg supported by Bakst, Alexandre Benois, and Nicholas Roerich, who all later received fame as stage designers for the Ballets Russes. Disregarding socio-political reality, these artists evoked the heady perfumes of decadence, escaped into an artificial world of theatricalized gesture, or investigated ancient myth and legend. In many cases the artistic explorations of the Symbolists such as Vrubel were accompanied by deep philosophical concerns, and their formal discoveries thus were effects rather than primary goals, al-though their common doubt in physical absolutes obviously prompted them to attach increasingly less importance to objec-tive form. In Russia it was the Symbolists and not the Impres-sionists (despite the forceful presence of Igor Grabar and Kon-stantin Korovin, Russia did not have a strong Impressionist school) who foreshadowed what Malevich would advocate in 1915, the "creation as an end in itself and domination over the forms of nature."[6] Their perception of the "real" reality as a

form of movement, a primal music, for example, was a simple and potential idea that recurred in Suprematism and Constructivism. One of the Symbolist poets, Andrei Bely, even anticipated Malevich's assertions by arguing as early as 1907 that the logical development of art was toward "nonobjectivity [where] the method of creation becomes an *object in itself.*"[7]

The rejection of Realism and the Academy, the search for a more expressive and genuine artistic sensibility, and the conscious or unconscious move toward abstraction are elements identifiable with the aspirations of the major trend that replaced Symbolism—Neoprimitivism, led by Goncharova and Larionov about 1908 onward. In his Neoprimitivist manifesto of 1913, Alexandr Shevchenko (see his *Woman Ironing,* 1920) affirmed that the exuberance and vitality of the new art derived in part from indigenous and Eastern art forms: "Primitive art forms—icons, *lubki*, trays, signboards, fabrics of the East, etc.— these are specimens of authentic value and painterly beauty."[8] Many avant-garde artists—Chagall, Filonov, Petr Konchalovsky, Alexandr Kuprin, Malevich, Ilia Mashkov, Tatlin—shared this sentiment, flaunted their derision of the West, and issued xenophobic claims to the effect that the Russian *lubok* was part of an oriental tradition and that the Russian icon was more cubist than Picasso's Cubism. Such aesthetic Slavophilism found dramatic visual extensions in the paintings of Goncharova (*Washerwomen,* 1911) and Larionov (*Bathing Soldiers,* 1911). These artists often superimposed the bright colors, naive foreshortenings, and semantic perspectives of "native" art on the basic schemes of Gauguin and Matisse. Chagall did the same with his mixture of Jewish folklore and mild cubism, Kandinsky borrowed from the Russian icon subjects such as Saint George and the Dragon, and Konchalovsky, Kuprin, Aristarkh Lentulov, and Mashkov used local artifacts (trays, toys, embroideries, church architecture, loaves, and gingerbreads) as central images in their pictorial vocabulary, even though they never entirely forgot Cézanne.

The Neoprimitivists consolidated their ideological position through a series of exhibitions and various manifestos and declarations of intent. For example, Larionov and his colleagues were responsible for the establishment of the Jack of Diamonds group that ran exhibitions from 1910 through 1918. He also organized the Donkey's Tail and Target groups at which

he, Goncharova, and Malevich presented their newest extensions of the primitive aesthetic—culminating in the invention of Larionov's abstract system called Rayonism in 1912. Goncharova too did much to propagate her interpretation of Neoprimitivism, opening two enormous solo shows in Moscow and Saint Petersburg in 1913 and 1914 and proclaiming: "The West has shown me one thing: everything it has is from the East."[9]

Regarded in the context of Symbolism and then Neoprimitivism, the emergence of the more extreme movements of Cubo-Futurism about 1912 and Suprematism in 1915 seems consistent and direct. There are many cross-references and common concerns: artistic synthesism (one of the most exciting productions of the avant-garde was the Futurist opera *Victory over the Sun,* 1913),[10] dismissal of conventional systems and desanctification of grand art (Malevich crossed out a photograph of the *Mona Lisa* in one of his compositions of 1914),[11] extension of studio art into other media such as performance and body art (David Burliuk, for example, painted his face, dressed up in outlandish clothes, and walked around downtown Moscow),[12] and elaboration of new linguistic or communication systems (the *zaum* or transrational language of the poets Alexei Kruchenykh and Velimir Khlebnikov and the painters Filonov, Malevich, Rozanova, and Stepanova).[13] It might be argued, for example, that Kruchenykh's and Malevich's interest in "shift" or "displacement," evident in transrational paintings, derives in part from the Symbolists' attempt to flee the world of appearances. The Cubo-Futurists, especially Malevich, Puni, and Rozanova, broke semantic and formal sequences, often isolating the everyday object (a spoon, a piece of fabric, a photograph as in Rozanova's *Sideboard with Dishes,* 1915, or Puni's *Still Life with Letters,* 1919) so that the viewer perceived it outside its conventional context. The impression is magical, perplexing, almost Dada.

In December 1915 at the exhibition *0.10* in Petrograd, Malevich declared: "Through zero I have reached creativity, that is Suprematism, the new painterly realism—nonobjective creativity."[14] Puni and his wife, Kseniia Boguslavskaia, rejoined: "An object . . . freed from meaning disintegrates into real elements—the foundation of art."[15] Ivan Kliun concluded: "Only we have become fully aware of the principle: Art as an end in itself."[16] To illustrate their sentiments Kliun, Malevich,

and Puni presented nonobjective or abstract works dependent on the interplay of geometric forms for their pictorial effect (see Kliun's Suprematist paintings). Malevich affirmed that black and white were powerful sources of energy and that color contrast in size rather than in shape generated maximum movement. Malevich subsequently argued that the dynamism of Suprematist forms would one day have a practical application, contributing to a "new motor of an organism, without wheels, steam, or gasoline" that would join with the "space of the monolithic masses moving in the planet system."[17] Despite these visionary concepts, Malevich supported a strict and constant system that produced paintings to be hung on the wall, that always employed a white ground, and that thereby tended to follow the traditional perspectival sequence with its orthodox vanishing point. Kliun seemed to be alluding to this when, in 1919, he criticized Malevich for being passé: "The nature that was ornamented by the Neo-Realists and the Neo-Impressionists was torn to pieces by Futurism. Suprematism has carefully painted these benumbed forms with different colors and presents them as a new art."[18]

In this respect Tatlin with his three-dimensional experiments in abstract assemblages of materials must have seemed more radical than Malevich, and we can understand why artists such as Lev Bruni, Vladimir Lebedev, Popova, and Alexandr Vesnin paid particular attention to him. Tatlin wished to remove the artifact from the level of personal gratification, to replace the "astrology" of art with its "astronomy,"[19] and most of his activities in art—his paintings, stage designs, reliefs, his famous *Monument to the Third International* of 1919–20, and his glider design of 1929–32—represent a consistent extension of this endeavor to replace the individual by the universal. His very impetus away from the painted surface to public space is symptomatic, although, as the critic Nikolai Punin emphasized, Tatlin owed his constructive method to both icon painting and Cézanne.[20] As an associate of the Jack of Diamonds group in 1913, and, therefore, a colleague of the Russian Cézannists Falk, Kuprin, and Vasilii Rozhdestvensky, Tatlin favored the treatment of figures and objects not as a vehicle of psychological and anecdotal denotation but as an arrangement of colored planes that consolidated and reconstructed rather than deconstructed the visual image.

Tatlin's concern with the analytical and constructive aspects of Cézanne's painting was further stimulated by his direct acquaintance with Cubism in Paris in the summer of 1914 (not 1913 as is commonly supposed), specifically, by his examination of a "violin sawn up into pieces, hanging by threads on various planes" in Picasso's studio.[21] As often happens at moments of artistic revelation, Tatlin was affected not by what was of central significance to Picasso—reprocessing the likeness of the violin—but rather by an ancillary property—the estrangement of the recognizable form of the object from its normal medium and environment; and the history of Tatlin's experiments with the relief in 1914 onward is the history of his reversal of Picasso's priorities, his establishment of the primacy of material over illusionism.

It is interesting to remember that many of Tatlin's younger disciples in the mid-1910s such as Bruni and Lebedev had been students at the Saint Petersburg Academy of the Arts. They were master draftsmen, whose emphasis on technical prowess, formal precision, and composition paradoxically appealed to Tatlin and distinguished them immediately from the "rural" contingent of Cubo-Futurists led by Burliuk and Larionov. The Saint Petersburg neoclassicism of Altman, Yurii Annenkov, Isaak Brodsky, Boris Grigoriev, Lebedev, Petr Miturich, and even of the later Petrov-Vodkin and his pupil Chupiatov has direct links with the traditional academic method, an unexpected component of the avant-garde that has yet to be explored in detail. Suffice it to recall that the prismatic verse of Anna Akhmatova, Mikhail Kuzmin, and other Acmeists, their conscious rejection of "philosophy" and "admiration of a rose because it is beautiful, not because it is a symbol of mystical purity"[22] find immediate parallels in the paintings, drawings, and occasional reliefs of these artists. As Punin recalled of the year 1916: "We had all grown tired of the approximations and conventions of aestheticism, and we were no less tired of the trotting races of the Futurist derby. We were seeking a strong and simple art."[23]

Tatlin's reliefs, like Bruni's architectural renderings, Altman's *Material Assemblage,* 1920, and Lebedev's *Still Life with Palette,* 1919, seemed the perfect cure for this nostalgia for order and sobriety.

Nevertheless, Malevich and his Suprematism continued to

attract many gifted artists, old and young. Alexandra Exter, Popova, Rodchenko, Olga Rozanova, Nadezhda Udaltsova, and then, after the revolution, an entire generation at the Vitebsk Practical Art Institute (including El Lissitzky and Ilia Chashnik) experimented with the geometric possibilities of Suprematism, after their assimilation of Cubism and Futurism (see, for example, Exter's *Florence,* 1914–15, and Rozanova's *Metronome,* 1915). For some it was an interim measure, a stimulus to explore adjacent avenues of enquiry, but the emphatic squares, rectangles, triangles, and rhomboids of Malevich's abstract universe left an indelible impression. They can be seen in Exter's set and costume designs for Alexandr Tairov's productions at his Chamber Theater in Moscow in 1916–21, in Rozanova's collages illustrating the Kruchenykh/Rozanova album of 1916 *Vselenskaia voina (Universal War)*, and on all levels of Popova's work after 1916.

Indeed, in the progression from Suprematism to Constructivism Popova played a crucial role. Her apprenticeship in 1912–13 to Henri LeFauconnier and Jean Metzinger in Paris (evident from her *Two Figures,* 1913) gave her a discipline and logic that Malevich sometimes lacked, enabling her rationally and consistently to experiment with the organization of forms on the surface and with concepts such as weight, asymmetry, and rhythm. The result was her series of so-called architectonic paintings and reliefs of 1916 onward, such as *Dynamic Structure,* 1919, in which once again the kinetic or mobile component was regarded as the most decisive. As she stressed in her painterly formula in 1919: "Construction in painting = the sum of the energy of its parts. . . . Color participates in energics by its weight. Energics = direction of volumes + planes and lines or their vestiges + all colors."[24] Energy certainly was the striking feature of her functional designs after 1921: her sets and costumes for Vsevolod Meierkhold and her textiles and dresses of 1923–24. Her premature death in 1924, like Rozanova's in 1918, was a major loss to the avant-garde.

No less important than Exter, Popova, and Rozanova in the elaboration of geometric abstraction was Rodchenko, who in little more than a decade (1912–23) mastered the principles of Art Nouveau, Suprematism, freestanding construction, and photography. As early as 1915 Rodchenko created his first compass-and-ruler drawings, six of which he showed at Tatlin's

exhibition *The Store* in Moscow in 1916, and proceeded to paint an extraordinary series of abstract, "minimalist" paintings that, like Popova's, explored the intrinsic elements of linearity, texture, and direction. *Density and Weight,* 1919, is a superb example of Rodchenko's "laboratory," serving almost as the preparatory composition for one of his concurrent wood constructions.

Rodchenko, however, was never satisfied with a single style or discipline. Like Gustav Klutsis, he argued that the new, revolutionary society demanded not only new forms but also new media—a sentiment shared by many of the avant-garde in the early 1920s. Some such as Altman, Kandinsky, Malevich, and Popova tried their hand at porcelain design; Klutsis and Lissitzky looked to typography; Exter, Popova, Rodchenko, and Stepanova turned to scenography and textiles. After 1923 Rodchenko focused attention on photography, contending that with its mechanical precision, anonymity, factual verisimilitude, and infinite reproducibility, photography would replace the lyric delusion of painting. "Every modern man must wage war against art, as against opium. Photograph and be photographed!" he declared in 1928.[25] In concentrating on photography Rodchenko certainly felt that he was working with a "nonartistic," utilitarian medium, even though he continued to experiment with the purely formal—or "artistic"—aspects of his profession. Indeed, "Rodchenko perspective" and "Rodchenko foreshortening" became vogue terms in the 1920s, and there can be no question that his innovative arrangements of light and shadow exerted an appreciable influence on the filmmakers Sergei Eisenstein, Esfir Shub, and Dziga Vertov.

Rodchenko, perhaps more than any other artist of his generation, unhesitatingly responded to the political, social, and cultural demands of the new republic. The Bolshevik revolution exerted an immediate influence on artistic life in Russia. On the one hand the new government gave active support to avant-garde artists, providing them with pedagogical and administrative positions within the new agencies, especially within Anatolii Lunacharsky's Commissariat for Enlightenment (Narkompros). On the other hand Lenin, Lunacharsky, and their colleagues did not initially dictate an exclusive artistic policy and allowed artists of all persuasions to create and exhibit. Thanks to this liberal environment, many innova-

tive theoretical programs were compiled and propagated at the chief centers of the avant-garde: Free Art Studios (Svomas), Higher State Art-Technical Studios (Vkhutemas), Higher State Art-Technical Institute (Vkhutein), Institute of Artistic Culture (Inkhuk), and State Academy of Artistic Sciences (GAKhN).[26] A direct result of this wider dissemination of experimental ideas was the emergence of a younger generation of leftist artists such as Chashnik, Klutsis, Sergei Luchishkin, and Kliment Redko.

During the years immediately following the revolution much attention was given to the question of what the new proletarian art should be. Many answers were proposed, but one in particular directly related to the development of Constructivism and industrial design of the 1920s: that the revolutionary art should be oriented toward technology and the factory and that it must be an international, "anonymous" style identifiable with global communism and not just with the Soviet Union. Local, ethnic motifs were regarded as redundant and this argument, coupled with the idea that the traditional media had run their course, contributed at once to the formulation and practice of Constructivism in and after 1921. Utilitarian design—architecture, interior design, graphic design, furniture design, porcelain design, printmaking, textile design—soon became a primary area in which avant-garde artists concentrated their creative energies.

The Constructivists, led by Alexei Gan, Klutsis, Lissitzky, Popova, Rodchenko, the Stenberg brothers, and Stepanova, were a volatile and vociferous group whose numerous manifestos and ambitious theories made up for the sparsity of their actual productions. Most of their projects remained as blueprints, and those few schemes that were implemented hardly ever reached mass production. It is important to remember moreover that most experimental artists of the 1920s were not wholehearted supporters of Constructivism and that they continued to investigate studio painting and sculpture despite Gan's announcement, "Death to art!"[27] Filonov, for example, never doubted the vitality of figurative painting. His pictures, such as *Formula for the Petrograd Proletariat,* 1920–21, pulsate with a raw energy that brings to mind the highly charged landscapes and portraits of the German Expressionists. Indeed, Expressionism, the new Heroic Realism, and even Surrealism attracted in the 1920s many talented painters who diligently searched for a modern

method that could synthesize the formal achievements of Kandinsky, Malevich, and Tatlin while restoring an ideological commitment to art. Members of the Society of Easel Artists (OST) such as Alexandr Deineka, Yurii Pimenov, Labas, Luchishkin, David Shterenberg, and Konstantin Vialov proved that easel painting was alive and well and that it could interpret the new imagery of the civil war, industrialization, sports scenes, and even the New Economic Policy by still using experimental styles. They, in turn, were criticized by the rival group called the Association of Artists of Revolutionary Russia (AKhRR), who maintained: "Our civic duty . . . is to record, artistically and documentarily, the revolutionary impulse of this great moment of history. We will provide a true picture of events and not abstract concoctions discrediting our Revolution in the face of the international proletariat."[28]

Efim Cheptsov, Grekov, Katsman, Sergei Maliutin, Vasilii Meshkov, and Nikolai Terpsikhorov, all represented in the exhibition, supported this doctrine, and the precise, photographic style of their paintings, such as *Village Teacher,* 1925, by Katsman, is sufficient evidence to plea for the critical acknowledgment of a Russian Neue Sachlichkeit. Their paintings were obeisant to the pressing political dictates of that era, and Socialist Realism, formulated at the First All-Union Congress of Soviet Writers in Moscow in 1934, was a direct consequence of this closer alliance between aesthetics and ideology. Even Malevich, Rodchenko, and Tatlin returned to figurative easel painting as Soviet art came to deal with local issues in an accessible, if often rhetorical, manner. Stalin, collectivization, the Five Year Plans, the new waterways, the great exploits of engineering—these were themes that determined the subsequent course of Soviet painting. Curiously enough, Socialist Realism was also part of an international movement, just as the avant-garde had been, and often bore a curious resemblance to concurrent Western trends, including American Social Realism. Furthermore, it was still transformative and transcendental, it aspired to redesign human consciousness and maintained the traditional, didactic mission peculiar to the highest moments of Russian culture. In this respect Socialist Realism was perhaps the consolidation—and not the rejection—of the experimental movements of 1900–1930.

NOTES

1. See, especially, the pioneering monograph by Camilla Gray, *The Great Experiment: Russian Art, 1863–1922* (New York: Abrams, 1962 and later editions). For detailed information on the Russian avant-garde see *Russian Avant-garde Art: The George Costakis Collection,* ed. Angelica Zander Rudenstine (New York: Abrams, 1981).

2. For information on the holdings of these collections see the exhibition catalogs *Impressionist and Post-Impressionist Paintings from the USSR* (Washington, D.C.: National Gallery of Art, 1973); *Capolavori impressionisti e postimpressionisti dai musei sovietici* (Lugano: Collection Thyssen-Bornemisza, 1983). Also see Anna Barskaya, *French Painting, Second Half of the Nineteenth to the Early Twentieth Century: The Hermitage* (Leningrad: Aurora, 1975).

3. On Kazimir Malevich see Troels Andersen, *Kasimir Malevich,* exh. cat. (Amsterdam: Stedelijk Museum, 1970); Charlotte Douglas, *Swans of Other Worlds: Kazimir Malevich and the Origins of Abstraction* (Ann Arbor: UMI Press, 1986); Larissa A. Zhadova, *Malevich: Suprematism and Revolution in Russian Art, 1910–1930* (London: Thames & Hudson, 1982).

4. For an English translation of, and commentary on, Vasilii Kandinsky's treatise see *Kandinsky: Complete Writings on Art,* ed. Kenneth C. Lindsay and Peter Vergo (Boston: Hall, 1982), 1:119–219; also see John E. Bowlt and Rose-Carol Washton Long, *The Life of Vasilii Kandinsky in Russian Art: A Study of "On the Spiritual in Art"* (Newtonville, Mass.: Oriental Research Partners, 1980).

5. For a discussion of Mikhail Matiushin's ideas see Alla Povelikhina, "Matyushin's Spatial System," in *Die Kunstismen in Russland, 1907–30/The Isms of Art in Russia, 1907–30,* exh. cat., with introduction and biographies by John E. Bowlt (Cologne: Galerie Gmurzynska, 1977), pp. 27–41. The catalog also contains statements by Matiushin.

6. Kazimir Malevich, "From Cubism and Futurism to Suprematism (1915)," translated in *Malevich: Essays on Art,* ed. Troels Andersen (Copenhagen: Borgen, 1968), 1:19.

7. Andrei Bely, "Budushchee iskusstvo (1907)," in Andrei Bely, *Simvolizm* (Moscow: Musaget, 1910), p. 452.

8. Alexandr Shevchenko, *Neo-primitivizm* (Moscow, 1913), p. 10.

9. Natalia Goncharova, preface to catalog of her solo exhibition, *Vystavka kartin Natalii Sergeevny Goncharovoi, 1900–1913* (Moscow: Art Salon, 1913), p. 3.

10. For a discussion of *Victory over the Sun* see Douglas 1986, pp. 35–47.

11. Malevich's painting *Composition with Mona Lisa,* 1914, is reproduced in color in *Kasimir Malewitsch zum 100 Geburtstag,* exh. cat. (Cologne: Galerie Gmurzynska, 1978), p. 209.

12. On David Burliuk and his antics see "A Slap in the Face of Public Taste," *Canadian American Slavic Studies* 20, nos. 1–2 (1986), a special issue devoted to Burliuk and the Russian avant-garde.

13. On *zaum* see Vladimir Markov, *Russian Futurism: A History* (Berkeley: University of California Press, 1968); for contextual discussion

also see Gerald Janecek, *The Look of Russian Literature: Avant-garde Experiments, 1900–1930* (Princeton: Princeton University Press, 1984).

14. *Malevich* 1968, p. 19 (adapted).

15. Ivan Puni and Kseniia Boguslavskaia, untitled statement issued at the exhibition *0.10,* translated in *Russian Art of the Avant-garde: Theory and Criticism, 1902–1934,* ed. John E. Bowlt (New York: Viking, 1976), p. 112.

16. Ivan Kliun, untitled statement issued at the exhibition *0.10,* translated in *Russian Art* 1976, p. 114.

17. Kazimir Malevich, "Suprematism: Thirty-four Drawings," translated in Andersen 1970, 1:126.

18. Ivan Kliun, "Color Art," in the catalog of the exhibition *Tenth State Exhibition: Nonobjective Creation and Suprematism,* Moscow, 1919, translated in *Russian Art* 1976, p. 142.

19. Nikolai Tarabukin, *Ot molberta k mashine* (Moscow: Rabotnik prosveshcheniia, 1923), p. 42.

20. See Nikolai Punin, *Tatlin: Protiv kubimza* (Petrograd: NKP, 1921).

21. Vasilii Komardenkov, *Dni minuvshie* (Moscow: Sovetskii khudozhnik, 1973), p. 56.

22. As quoted in Dmitri Mirsky, *A History of Russian Literature* (New York: Knopf, 1960), p. 485.

23. Nikolai Punin, "Iskusstvo in revoliutsiia" (archive of Irina Punina, Leningrad), quoted in Vsevolod Petrov, introduction to *N. N. Punin: Russkoe i sovetskoe iskusstvo,* ed. Irina Punina (Moscow: Sovetskii khudozhnik, 1976), pp. 16–17.

24. Liubov Popova, statement in the catalog of the *Tenth State Exhibition,* translated in *Russian Art* 1976, p. 147.

25. Alexandr Rodchenko, "Protiv summirovannogo portreta, za monumentalnyi snimok," *Novyi lef* (New Left), no. 4 (1928): 16.

26. On Inkhuk, Vkhutemas, and other art organizations of the postrevolutionary period see Christina A. Lodder, *Russian Constructivism* (New Haven: Yale University, 1983).

27. Alexei Gan, *Konstruktivizm* (Tver: Tverskoe knizhnoe izdatelstvo, 1922), p. 17.

28. "Declaration of the Association of Artists of Revolutionary Russia (1922)," translated in *Russian Art* 1976, p. 266. For the OST and AKhRR see Hubertus Gassner and Gillen Eckhart, *Zwischen Revolutionskunst und sozialistischen Realismus: Dokumenta und Kommentare. Kunstdebatten in der Sowjetunion von 1917 bis 1934* (Cologne: DuMont, 1979), pp. 264–389. The return to a more figurative aesthetic is also discussed in Nicoletta Misler, *Pavel Florenskij: La prospettiva rovesciata e altri scritti* (Rome: Casa del libro, 1983).

CATALOG OF THE EXHIBITION

The transliteration system used in the text is a modified version of that of the Library of Congress. Conventional transliterations that vary from this system—for example, Marc Chagall, not Mark Shagal—have been used.

The present city of Leningrad is referred to as Saint Petersburg until 1914 and as Petrograd from 1914 to 1924.

In the text the following abbreviations are used:

AKhRR	Association of Artists of Revolutionary Russia
GAKhN	State Academy of Artistic Sciences, Moscow
Inkhuk	Institute of Artistic Culture, Moscow; affiliations in Petrograd and Vitebsk
OST	Society of Easel Artists
Pegoskhuma	Petrograd State Free Art Educational Studios
RAKhN	Russian Academy of Artistic Sciences, Moscow
Svomas	Free Art Studios
Vkhutein	Higher State Art-Technical Institute
Vkhutemas	Higher State Art-Technical Studios, Moscow

All works are lent by the State Tretyakov Gallery, Moscow, and the State Russian Museum, Leningrad. Dimensions are in inches and centimeters, height precedes width.

NATAN ISAEVICH ALTMAN

Born 1889 Vinnitsa—died 1970 Leningrad

Studied at Odessa Art School (1901–7) and Académie Russe de Marie Vasilieff (Paris, 1910–11). Worked in Odessa, Saint Petersburg, Paris (1909–12, 1928–35), Moscow (1921–28). Exhibited with the groups the Union of Youth (Saint Petersburg, 1913–14), World of Art (1913–16), Jack of Diamonds (Moscow, 1916) and at the Salon des Indépendants (Paris, 1914). Contributed to the exhibition *0.10* (Petrograd, 1915–16) and with Marc Chagall and David Shterenberg to the *Exhibition of the Three*. Taught with Mikhail Bernstein (Petrograd, 1915–17) and at Svomas (Petrograd, 1918–20). Prepared decorations for the first-anniversary celebration of the October Revolution (Petrograd, 1918). Member of the Visual Arts Department of the People's Commissariat for Enlightenment (1918–21) and Inkhuk (1923). Honored artist of the Russian Soviet Federated Socialist Republic. Painted genre scenes, landscapes, portraits, still lifes; designed books and stage sets; active as a sculptor.

Self-Portrait 1911

Tempera and paper on board

24 7/8 x 18 3/8 in.

63.0 x 46.5 cm

Signed and dated lower center: Natan Altman 1911

The State Russian Museum, Leningrad (Zh.B.-1314)

Acquired in 1920 from A. A. Korovin

Self-Portrait apparently was painted on Altman's return from Paris in 1911. The influence of the Paris school is witnessed by the energetic plastic stylizations, compositional clarity, and decorative contrasting colors, which intensify the psychological characterization of the image.

44

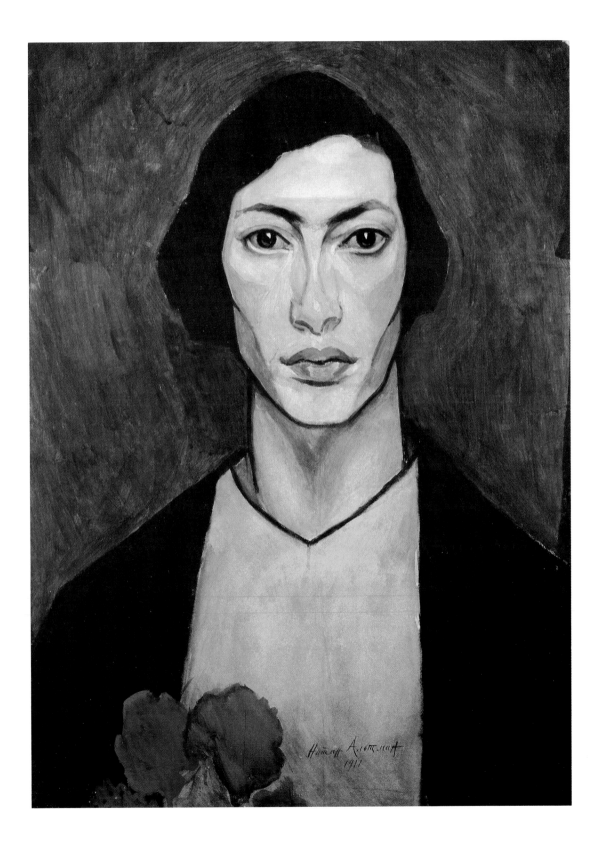

Enamel, glue, stucco, sawdust on canvas

32 3/4 x 25 7/8 in.

83.0 x 65.5 cm

Signed and dated lower left: Nat. Altman 920

The State Russian Museum, Leningrad (Zh.-8838)

Acquired in 1972 from I. V. Shchyogoleva, the artist's widow

Material Assemblage is one of Altman's few abstract works. Planes, lines, passages of color, and textures make up a plastic "formula," which becomes the subject of the picture. Altman amplifies the expressive effect of the painted surface by using various methods of brush application, mixing paint with such substances as stucco and sawdust. "Care for the character of the painting's surface, its texture, . . . is one of the liveliest means of expression and effect," wrote Altman, adding, "this is only a means to express reality."

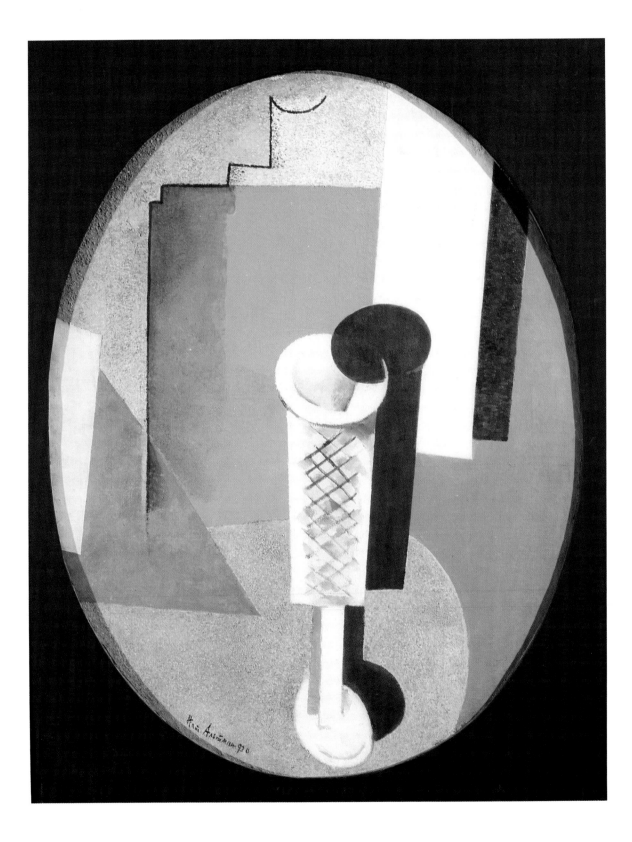

YURII PAVLOVICH ANNENKOV

Born 1889 Petropavlovsk-Kamchatski—died 1974 Paris

Expelled from school for contributing to an underground stu-
dent magazine during the first Russian revolution (1905). Stud-
ied at Saint Petersburg University (1908) and with Savelli Zei-
denberg and Yan Tsionglinsky (1909–10) and Maurice Denis
and Félix Vallotton (Paris, 1911–12). Visited Switzerland (1913).
Returned to Saint Petersburg. Illustrated various magazines
(1913–17). Worked regularly for the journal *Teatr i iskusstvo
(Theater and Art)*. With Mstislav Dobuzhinsky and Vladimir
Shchuko prepared sets for the spectacular dramas *Hymn to
Liberated Labor* and *Storming of the Winter Palace* (Petrograd,
1920). Exhibited with the group the World of Art (1922). Moved
to Paris (1924). Painted portraits; designed and illustrated books;
designed stage sets; active in film.

**Portrait of the
Artist-Photographer
Miron Abramovich Sherling** 1918

Oil on canvas

28 1/4 x 22 5/8 in.

71.5 x 57.5 cm

Signed and dated lower left:
Yu. Annenkov. 1918.

The State Russian Museum,
Leningrad (Zh.B.-1226)

Acquired in 1924 from the State
Museum Collection

Miron Sherling, called by contem-
porary journalists a "master of
artistic light-painting," photo-
graphed the foremost personalities
of his day, including the director
Vsevolod Meierkhold and operatic
singer Fyodor Chaliapin. The
creative nature of the photogra-
pher prompted Annenkov to
devise an artistic solution for his
portrait, stressing Sherling's
Europeanism. The sketchy
silhouette of the Eiffel Tower, a
house with garrets, and the word
hotel evoke images of Paris, the
city closely tied to a generation of
Russian artists, including Annen-
kov and his model.

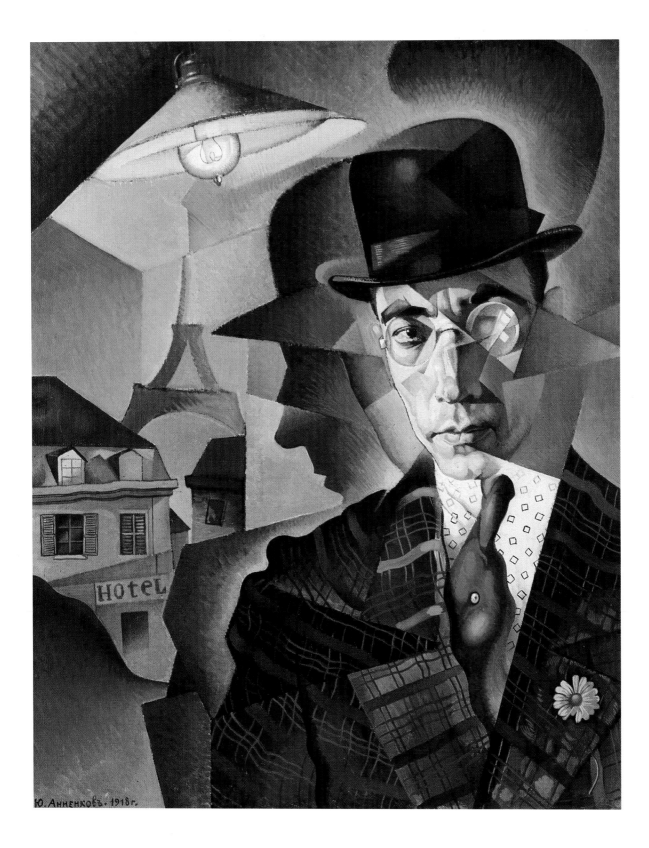

Ю. Анненковъ. 1918 г.

ABRAM EFIMOVICH ARKHIPOV

Born 1862 Yegorova—died 1930 Moscow

Studied at Moscow School of Painting, Sculpture, and Architecture (1877–88, intermittently) and Saint Petersburg Academy of the Arts (1884–86). Exhibited with the Circle of the Itinerants (1891), Union of Russian Artists (1903), AKhRR (1923–28). Taught at Moscow School (1894–1918) and Vkhutemas (1922–24). Academician of painting (1898) and full member of the Academy (1916). Painted genre scenes, interiors, landscapes, portraits.

Laundresses c. 1901

Oil on canvas

38 1/4 x 25 7/8 in.

97.0 x 65.5 cm

Signed lower right: A. Arkhipov

The State Russian Museum, Leningrad (Zh.-5629)

Acquired in 1930 from the State Tretyakov Gallery

As one of the younger members of the Circle of the Itinerants, Arkhipov inherited an interest in depicting scenes of social inequality, which he presented in emotionally intense narratives. *Laundresses,* with its evocative silvery grays, is one of the most famous of Arkhipov's works. Painted c. 1901, it is the first of two canvases depicting a similar scene (the other is in the State Tretyakov Gallery) and was inspired by the artist's visit to the laundry rooms of Smolensky Market in Moscow.

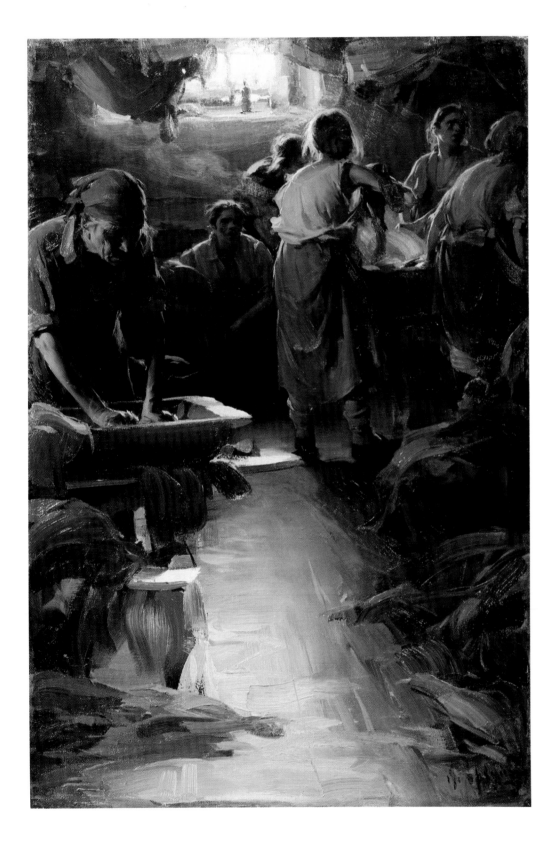

LEV SAMOILOVICH BAKST

Born 1866 Grodno—died 1924 Paris

Studied at the Saint Petersburg Academy of the Arts (1883–87); with Jean-Léon Gérôme; at the Académie Julien (Paris, 1893–96). Exhibited with the Society of Russian Watercolorists (1891–95, 1897), World of Art (1899–1903, 1906, 1913), Union of Russian Artists (1903) and at the Salon d'automne (Paris, 1906). Taught at the Zvantseva School of Art (Saint Petersburg, 1906–10). Moved to Paris (1910). Designed stage sets for Marinsky and Alexandr theaters (Saint Petersburg), Grand Opéra (Paris), Sergei Diaghilev's Ballets Russes (Paris). Painted landscapes and portraits; illustrated books.

Supper 1902

Oil on canvas

59 1/8 x 39 3/8 in.

150.0 x 100.0 cm

Signed upper right: L. Bakst

The State Russian Museum, Leningrad (Zh.-2118)

Acquired in 1920 from A. A. Korovin

First shown in 1903 at an exhibition sponsored by the group the World of Art, the painting received numerous reviews in the Russian press. One noted critic wrote:

A cat wearing a woman's dress and some sort of horned headgear is sitting at a table. Its face is shaped like a round plate. Its scrawny paws are stretched toward the table, yet it looks to the side as if the dishes that are offered are not to its taste and it wants to snatch something else.

Another critic suggested a different description: "A stylish fin-de-siècle *décadente*—black and white, thin, like an ermine, with a mysterious smile—is eating oranges."

Bakst, who used the wife of artist Alexandre Benois as his model, created a stylized portrait of a lady of the demimonde. The poignant characterization, expressive silhouette, flowing wide brushstrokes, and elongated proportions are typical of his modernist style.

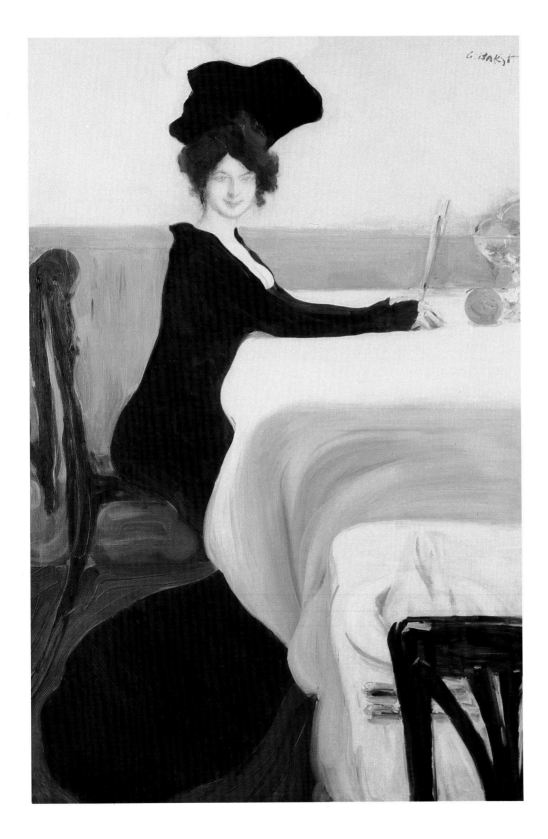

ALEXANDRE NIKOLAEVICH BENOIS

Born 1870 Saint Petersburg—died 1960 Paris

Studied at Saint Petersburg Academy of the Arts (1887–88). Exhibited with the Society of Russian Watercolorists (1893–96), World of Art (1898), Union of Russian Artists (1903–10) and at the Salon d'automne (Paris, 1906). Graduated from the Law School of Saint Petersburg University (1894). Curator of the State Hermitage Picture Gallery and member of the Commission for the Preservation of Monuments (1918–26). Moved to Paris (1926). Designed stage sets for Marinsky Theater (Saint Petersburg), Bolshoi Theater (Moscow), Sergei Diaghilev's Ballets Russes (Paris), Les Champs-Elysées Theater (Paris), Grand Opéra (Paris), La Scala (Milan). Painted landscapes, illustrated books, wrote art criticism.

Flora Fountain in Versailles 1905–6

Oil on canvas

20 7/8 x 25 5/8 in.

53.0 x 65.0 cm

The State Russian Museum, Leningrad (Zh.-2094)

Acquired in 1919 from L. P. Gritsenko

In his landscapes Benois preferred to depict ancient cities, historic sites, and parks. Versailles became one of his favorite "characters" and was the subject of two important painting series. For Benois, Versailles occupied a world of harmony, embodying the ideal unity of nature, art, and the individual, in antithesis to the emptiness of twentieth-century civilization. Benois believed that the work of art, in its unity with nature, could fulfill his dream of a harmonious existence.

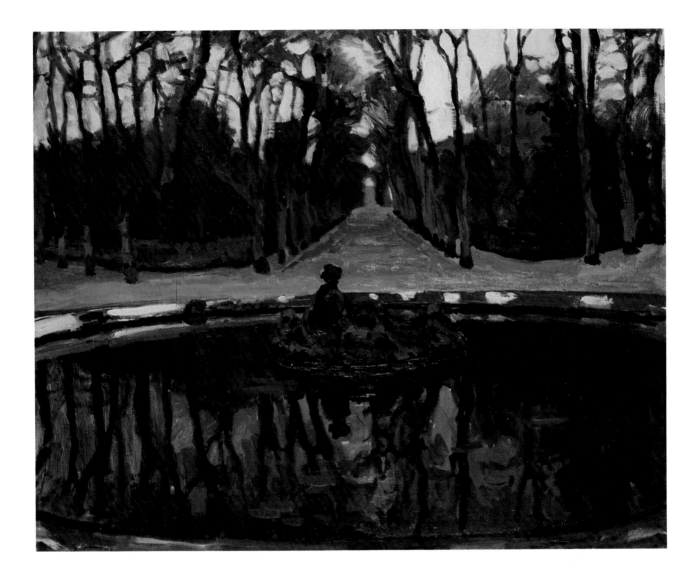

VIKTOR ELPIDIFOROVICH BORISOV-MUSATOV

Born Saratov 1870—died 1905 Tarusa

Studied at the School of the Saratov Society of Art Lovers; Moscow School of Painting, Sculpture, and Architecture (1890–91, 1893–95); Saint Petersburg Academy of the Arts (1891–93); with Ferdinand Cormon (Paris, 1895–98). Exhibited with the Society of Artists (Moscow, from 1899) and Union of Russian Artists (from 1904). Lived in Saratov (until 1903), Podolsk, Tarusa. Painted landscapes, portraits, genre scenes.

Embroidery 1901

Oil on canvas

27 x 22 7/8 in.

68.5 x 58.0 cm

Signed upper right:
V. Musatov. 1901

The State Russian Museum,
Leningrad (Zh.-2037)

For Musatov, the search for beauty and harmony lead to the creation of a ghostly dream world: "When life frightens me, I rest in art…. It sometimes seems to me that I am on some uninhabited island. And it is as though reality does not exist."

In this painting a woman is bent over her needlework. Time passes unhurriedly. Delicately painted in pale pink, light blue, and lilac, *Embroidery* is imbued with a poetic harmony.

56

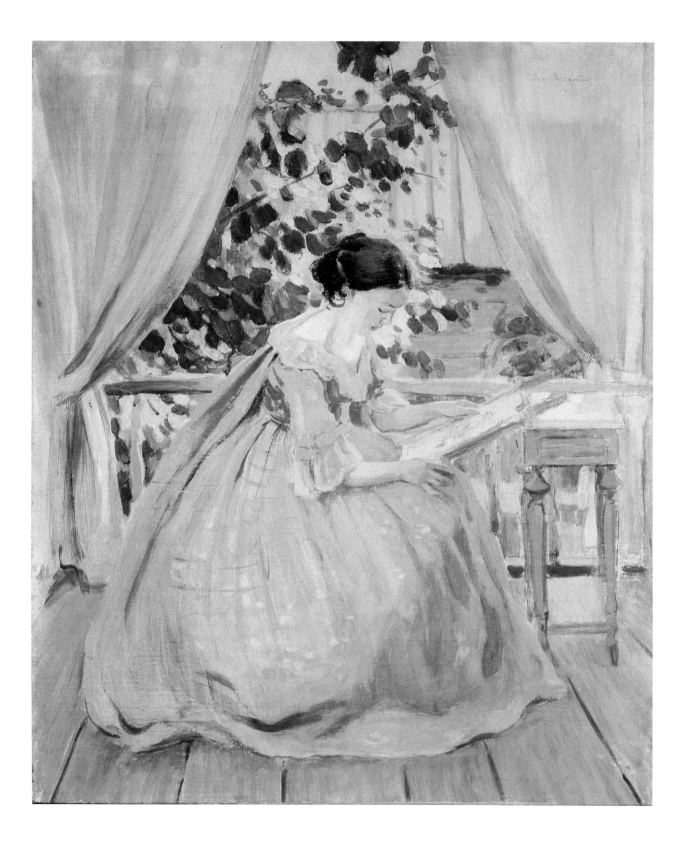

ISAAK IZRAILEVICH BRODSKY

Born 1884 Sofiyevka—died 1939 Leningrad

Studied at Odessa Art School and Saint Petersburg Academy of
the Arts with Ilia Repin (1896–1902). Exhibited with the groups
the World of Art (from 1904) and Association of Traveling Art
Exhibitions. Visited Austria, France, Germany, Greece, Italy,
Spain (1909–11). Member of the Union of Russian Artists,
AKhRR, Kuindzhi Society (president from 1930).

**Vladimir Ilich Lenin
in Smolnyi** 1930

Oil on canvas

74 7/8 x 113 in.

190.0 x 287.0 cm

Signed lower left:
I. Brodsky

Inscribed lower left:
Lenin in Smolnyi

The State Tretyakov Gallery,
Moscow (25467)

This painting is one of the most
important portraits of Vladimir
Ilich Lenin (1879–1924). Brodsky
was fortunate to have painted the
Communist leader from life and
thus was able to create a series of
authentic depictions, which he
produced over a number of years
for the Soviet government and
various social organizations. Of
this portrait, the artist wrote: "I
wanted to convey Vladimir Ilich
as he was, and this was most
difficult. Lenin does not require a
symbolic, heroic portrayal, or
deliberate monumental stature, or
special perspectives. He is great
in and of himself."

Aware of the memorial value of
the furnishings in Lenin's office at
Smolnyi Institute in Petrograd,
where Lenin lived and worked
until March 10, 1918, Brodsky
painted the few articles of the
modest room with meticulous
care and loving attention.

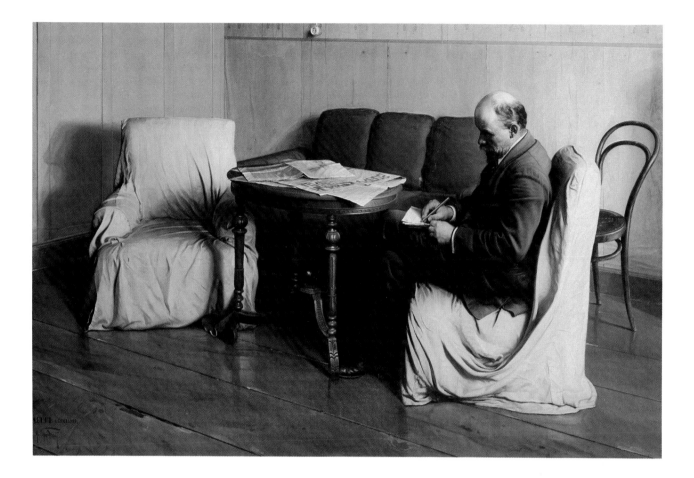

LEV ALEXANDROVICH BRUNI

Born 1894 Malaia Vishera—died 1948 Moscow

Studied at Saint Petersburg Academy of the Arts (1909–12) and Académie Julien (Paris, 1912). Exhibited with the groups the World of Art (1915), Four Arts Society (1925), Makovets (1926). Taught at the School of Industrial Drawing (Petrograd, 1920–21), Vkhutemas (1923–30), Moscow Textile Institute (1930–33), Moscow School of Arts (1931–38). Painted genre scenes, landscapes, portraits; illustrated books.

Section of a Mosque 1916

Oil on canvas

32 3/8 x 22 1/2 in.

82.0 x 57.0 cm

The State Russian Museum, Leningrad (Zh.B.-1620)

Acquired in 1926 from the Museum of Artistic Culture

Section of a Mosque is a work of the artist's early career, when he was especially fond of Suprematism. With flat geometric forms and a dense chiaroscuro, Bruni attempted to interpret "materials in space."

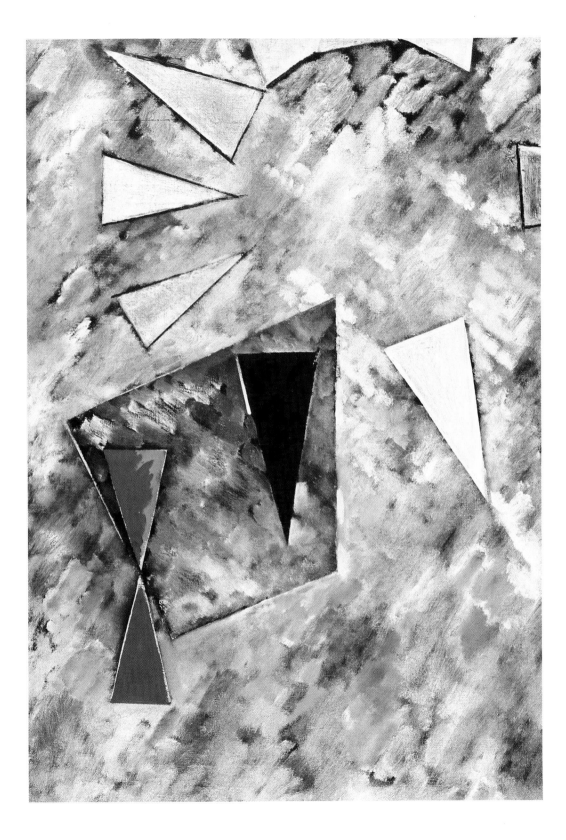

DAVID DAVIDOVICH BURLIUK

Born 1882 near Kharkov—died 1967 Long Island, New York

Studied in Kazan and Odessa (1898–1904, 1909–11); at the Munich Academy (1902–3); in Paris (1904); at Moscow School of Painting, Sculpture, and Architecture (1910–14). Expelled from the Moscow School with his friend the poet and playwright Vladimir Maiakovsky (1914). Exhibited with the Union of Russian Artists (1906–7), Wreath (1908), Jack of Diamonds (Moscow, 1910), Der Sturm (Berlin, 1910–14), Union of Youth (Saint Petersburg, 1911–12), Der Blaue Reiter (Munich, 1912). With Maiakovsky and Vasilii Kamensky toured Russia in performance, proclaiming the principles of Futurist art and poetry (1913). Lived in Saint Petersburg, Moscow, Iglino, Japan (1920), United States. Painted animal scenes and landscapes; widely known as a poet.

Horses
date unknown

Oil on canvas

17 x 20 3/4 in.

43.0 x 52.5 cm

Sticker on verso: "David Burliuk, Sketch of Horses"

The State Russian Museum, Leningrad (Zh.B.-1580)

Acquired in 1926 from the Museum of Artistic Culture

For the artist and poet members of the association Hylaea, founded on Burliuk's initiative, the image of a horse—that splendid, proud, freedom-loving animal—symbolized the primeval, liberated, Scythian force that they believed was destined to renew literature and the fine arts in Russia. Horses—"evening-maned, fierce-eyed"—prominently figure in the early work of the poet Velimir Khlebnikov, whose expressive poetry shares with this painting a similar mood.

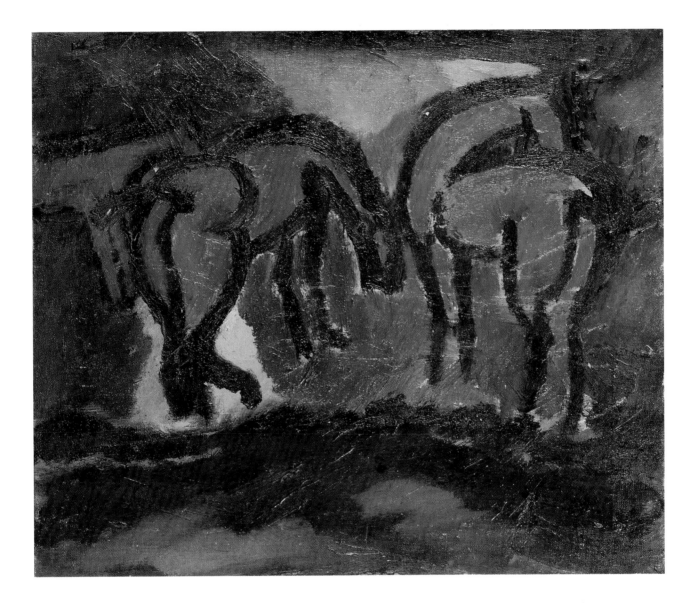

**Portrait of the Futurist
and Singer-Warrior
Vasilii Kamensky** 1916

Oil on canvas

38 1/4 x 25 3/4 in.

97.0 x 65.5 cm

The State Tretyakov Gallery,
Moscow

Acquired in 1927 by the
State Museum Fund from the
All-Russian Central Museum
Bureau, Visual Arts Department,
People's Commissariat for
Enlightenment

The Futurist poet Vasilii Vasil-
ievich Kamensky (1884–1961) was
among the leaders of the Russian
vanguard who shattered the
traditions of poetry and painting
and founded a new aesthetic. He
was also one of the first airplane
pilots in Russia. In portraying
Kamensky, Burliuk rejected
traditional perspectival considera-
tions and depicted the subject in a
deliberately simplified, primitive
composition with bright colors.
Above the poet a fleshy muse
carrying a trumpet soars heavily.
A toy-like locomotive, running
near a dark blue stream in which
one large fish can be seen, is
perceived not as an embodiment
of the Futurists' love of the
machine but rather as an organic
element of nature.

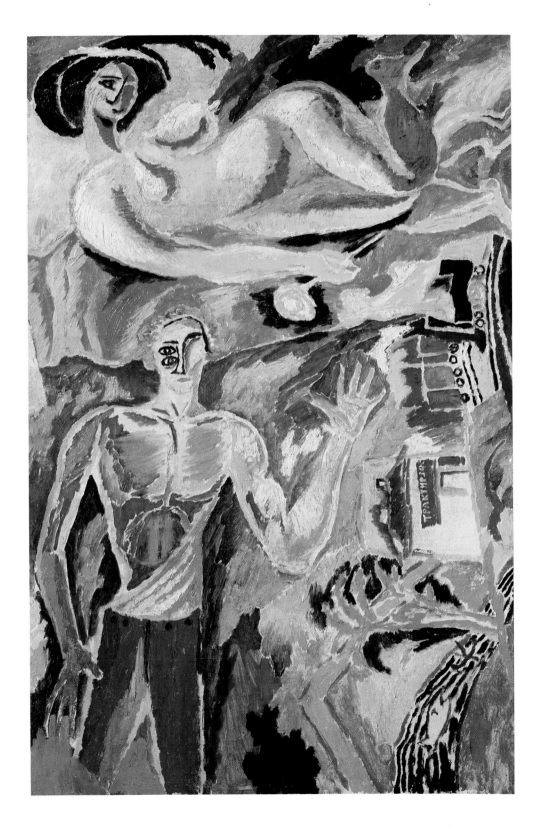

MARC ZAKHAROVICH CHAGALL

Born 1887 Vitebsk—died 1985 Vence, France

Studied with Jehuda Pen (Vitebsk, 1906); at the School of the Society for the Encouragement of the Arts with Nicolas Roerich (Saint Petersburg, 1906–7) and Zvantseva School of Art with Lev Bakst and Mstislav Dobuzhinsky (Saint Petersburg, 1908–9); in Paris (1910–14). Exhibited with the groups the Donkey's Tail (Moscow, 1912) and Jack of Diamonds (Moscow, 1916). Contributed to the exhibitions *The Target* (Moscow, 1913) and *Exhibition of Painting, 1915* (Petrograd, 1915); with Natan Altman and David Shterenberg to the *Exhibition of the Three.* Had solo exhibition at Galerie der Sturm (Berlin, 1914). Appointed commissar of art in Vitebsk region (1918). Founded and directed Vitebsk Practical Art Institute (1919). Resigned from school after disagreement with Suprematists (1920). Moved to France (1922).

The Red Jew 1915

Oil on board

39 3/8 x 31 3/4 in.

100.0 x 80.5 cm

Signed lower right: Chagall.

The State Russian Museum, Leningrad (Zh.B.-1708)

Acquired in 1926 from the Museum of Artistic Culture

In 1914–15, while living in Vitebsk, Chagall created a series of paintings with rather schematic titles—*Jew (Green), Jew with a Sack, Jew with a Fiddle*—which he exhibited in Saint Petersburg. In *The Red Jew* Chagall has transformed the figure of an old man into an epic image, complete with scriptural texts in the background.

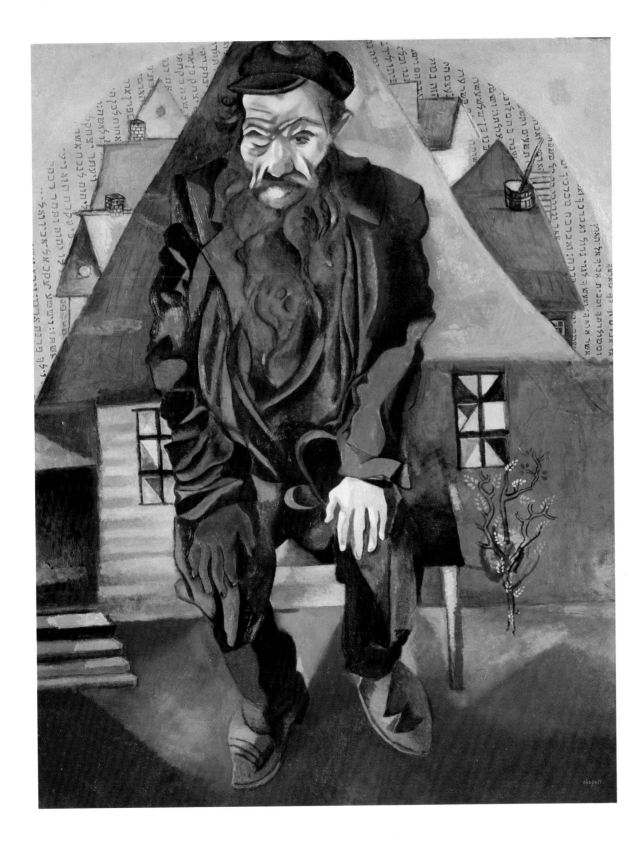

Window in a Dacha 1915

Oil and gouache on canvas

39 3/8 x 31 1/2 in.

100.0 x 80.0 cm

The State Tretyakov Gallery, Moscow (9196)

Acquired in 1927 by the State Museum Fund

Window in a Dacha was painted in a small town not far from Vitebsk, where Chagall and his wife, Bella Rosenberg, spent their honeymoon. The profiles of the newlyweds are simply depicted as in a child's drawing but with a sensitive lyricism. Gazing at the morning landscape, the figures experience the world side by side as a single being. The simplicity of dacha life is described with tenderness, and the view of the birch grove takes on a spiritual, elevated beauty in the presence of the loved one. It is precisely this beautiful, transformed world that stands before the viewer of Chagall's painting. The chaste purity of the white curtain, soft radiance of the tree trunks, and dull luminescence of the flowers among the green foliage form a poetic depiction of reality as well as an allegory about the magical power of love.

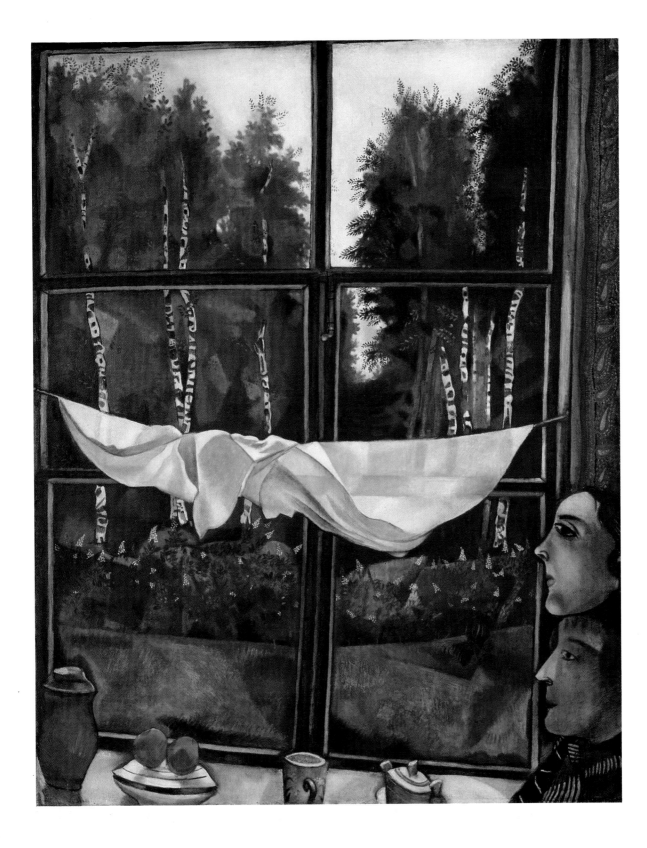

EFIM MIKHAILOVICH CHEPTSOV

Born 1875 Medvenka—died 1950 Moscow

Studied icon painting at Kiev-Pechersky Monastery and Saint Petersburg Academy of the Arts (1905–11). Joined AKhRR (1922) and the Kuindzhi Society. Taught at the Academy (from 1937) and Potemkin Pedagogical Institute (Moscow). Honored artist of the Russian Soviet Federated Socialist Republic.

A Meeting of a Village Cell 1924

Oil on canvas

23 1/8 x 30 1/8 in.

58.6 x 76.5 cm

The State Tretyakov Gallery, Moscow (27720)

Transferred in 1934 from the USSR Museum of the Revolution

Cheptsov ranks among the leading Soviet genre painters. *A Meeting of a Village Cell* depicts a group of party members who have come together to discuss community matters. Each figure portrays an actual person from Cheptsov's village of Medvenka in present-day Kurst Oblast.

70

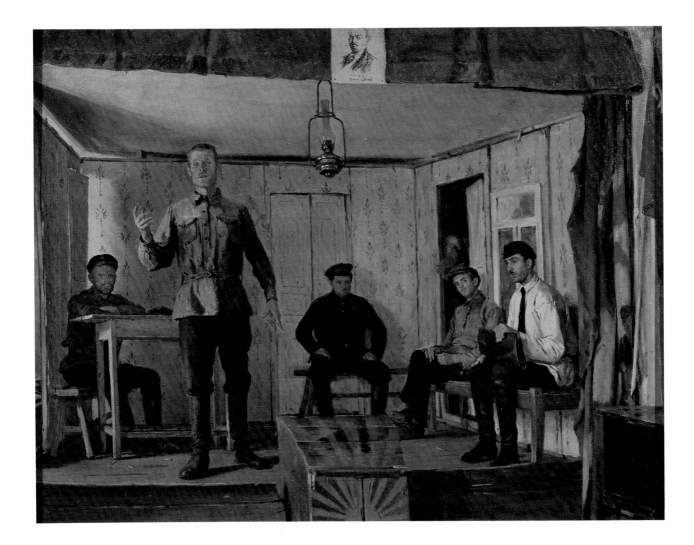

LEONID TERENTIEVICH CHUPIATOV

Born 1890 Saint Petersburg—died 1941 Leningrad

Studied with Mikhail Bernstein (Saint Petersburg/Petrograd, 1908–18) and at Pegoskhuma with Kuzma Petrov-Vodkin (1918–21). Lived and worked in Novgorod (1908, 1919–20), Kiev (1926–28?), Saint Petersburg. Exhibited with the groups the World of Art (1916–18), Society of Individualistic Artists (1922), Fire-Color (1924), Artists' Community (1925–27, 1929). Contributed to the *Exhibition of Pictures of Realistic Trends* (Moscow, 1922). Taught in Novgorod (1919–20), Kiev School of Art (1926–28), Vkhutein (Leningrad), Institute of Painting, Sculpture, and Architecture (Leningrad, 1929–33). Painted portraits and still lifes; designed stage sets.

Still Life with Apples and Lemon 1923

Oil on canvas

27 3/8 x 36 1/4 in.

69.5 x 92.0 cm

Signed and dated lower right: Chupiatov 19 II 23

The State Russian Museum, Leningrad (Zh.B.-1625)

Acquired in 1930 from the artist

As in other still lifes by Chupiatov the mundane is solemnly presented in a classical setting. The artist has masterfully rendered palpable forms and subtle nuances of color. The impressive tangibility of the scene is, however, disturbed by the appearance of a ball in the upper-left corner, which seems transported from a different dimension. Such an intrusive element recurs in Chupiatov's still lifes of the 1920s.

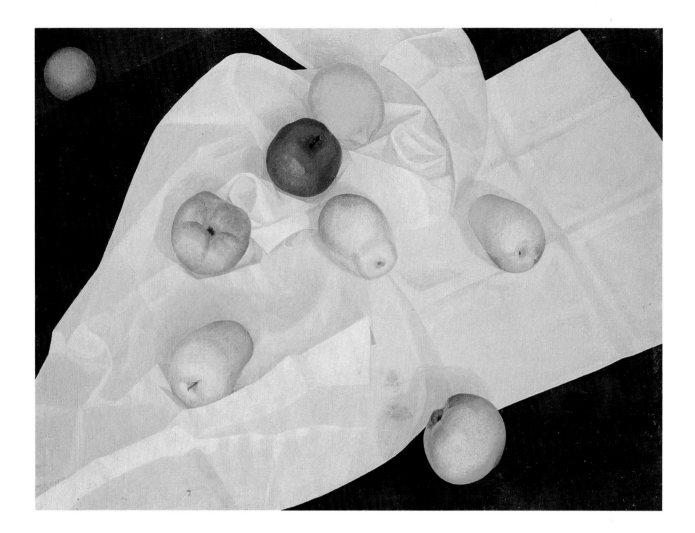

ALEXANDR ALEXANDROVICH DEINEKA

Born Kursk 1890—died 1969 Moscow

Studied at Kharkov Art School (1914–18) and Vkhutemas (1920–25). Taught at Vkhutein (Moscow, 1928–30), Polygraphic Institute (Moscow, 1928–34), Moscow Art Institute (1934–46), Moscow School of Applied and Decorative Art (1945–53), Moscow Architectural Institute (1953–57), V. I. Surikov Moscow State Art Institute (1957–64). Member of OST (1925–27), October (1928–30), Russian Association of Proletarian Artists (1931–32), USSR Academy of the Arts, German Democratic Republic Academy of the Arts. Honored artist of the Russian Soviet Federated Socialist Republic and Hero of Socialist Labor. Awarded the Lenin Prize.

Before Descending into the Mine 1925

Oil on canvas

97 1/4 x 82 5/8 in.

246.8 x 209.8 cm

The State Tretyakov Gallery, Moscow (20835)

As one of the founders of the Society of Easel Artists (OST), Deineka painted this work in his characteristically monumental, decorative style. The almost unfinished quality of the canvas reveals the vital truth of the image. The workers are portrayed with rough, brute strength. At the same time Deineka expresses the graphic beauty of industrial structures—a new subject for Soviet artists, which Deineka astutely mastered.

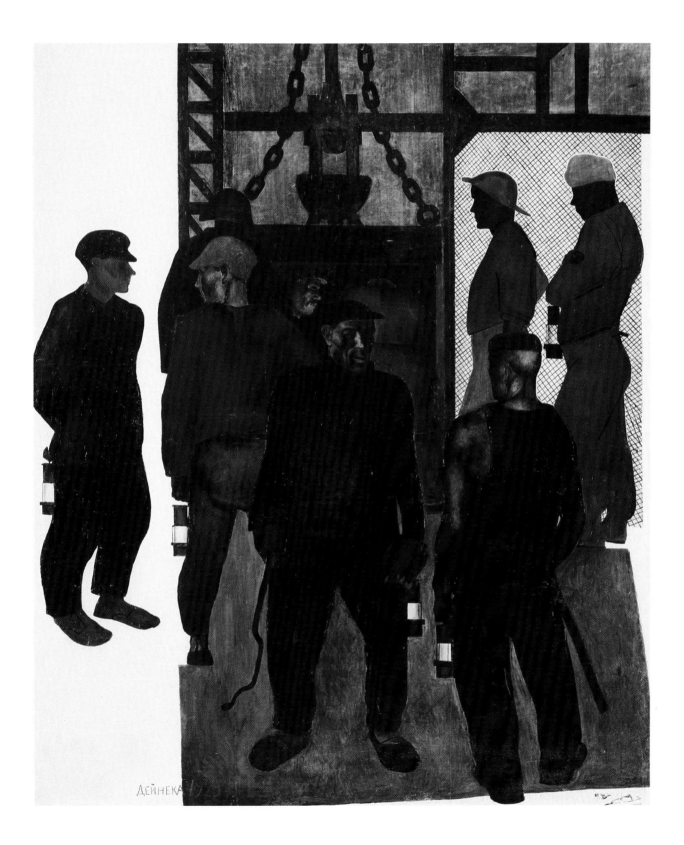

NIKOLAI FEDOROVICH DENISOVSKY

Born Moscow 1901—died 1981 Moscow

Studied at the Stroganov Art School (Moscow, 1911–17) and Svomas with Georgii Yakulov (1918–19). Exhibited with the Society of Young Artists (Moscow, 1920–21) and OST (1925–32). Taught at Vkhutemas (1929), Moscow Art Institute (1935–38), Moscow School of Applied and Decorative Art (1949–52), Mukhina Higher Art and Industry School (1952–55), Moscow Higher Art and Industry School (1955–56). Member of the Association of Revolutionary Placard Painters (1931–32).

Steel Plant: The Steel-Pouring Section 1930

Oil on canvas

34 1/4 x 47 5/8 in.

87.0 x 121.0 cm

Signed lower right: N

The State Tretyakov Gallery, Moscow (Zh.S.-750)

Acquired in 1934 from the artist

The energetic composition depicts the casting of steel in an old factory in Leningrad. The structured image appears as a cinematographic still frame, with space greatly foreshortened on the wide canvas so that the viewer can more intensely experience the dynamic scene in which labor is celebrated.

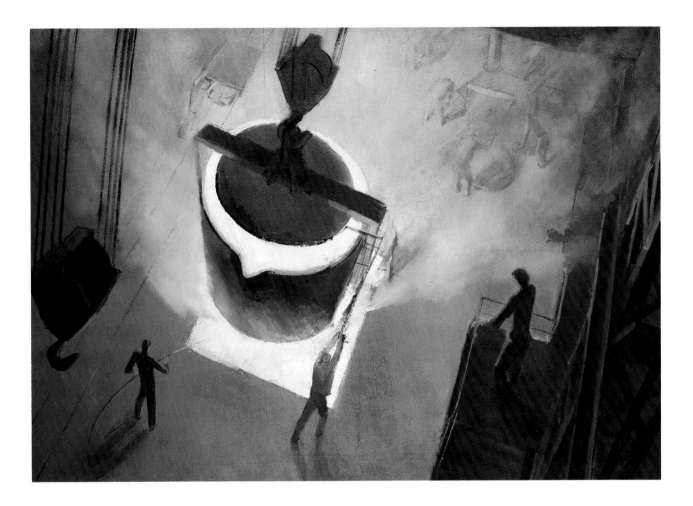

MARIA VLADIMIROVNA ENDER

Born 1897 Saint Petersburg—died 1942 Leningrad

Studied at the Language Department of the Pedagogical Institute (1915–18) and Pegoskhuma with Mikhail Matiushin (1918–22). Worked with Matiushin at the Research Department of Organic Culture at Inkhuk (Petrograd/Leningrad, 1923–26). Associate with the State Institute of Art History (from 1927). Taught at Vkhutein, Proletarian Arts Institute (Leningrad, 1929–32), Civil Aviation Institute (1930), Leningrad Institute of Civil Engineering, State Technical School of Art and Industry (1930). Helped prepare Matiushin's *The Rules of Variability of Color Combinations: A Color Primer* (1932). Implemented Matiushin's theories, primarily in design and applied arts.

Experiment with a New Spatial Dimension 1920

Oil on canvas

26 3/8 x 26 3/8 in.

67.0 x 67.0 cm

Signed and dated verso: M. Ender 1920

The State Russian Museum, Leningrad (Zh.B.-1368)

Acquired in 1926 from the Museum of Artistic Culture

The painting relates to Matiushin's pictorial experiments, and the title was derived from one of his articles published in 1930. *Experiment* is an abstract painting built around a maelstrom of abrupt brushstrokes, which lead the spectator's gaze into the canvas, beyond the picture plane.

ALEXANDRA ALEXANDROVNA EXTER

Born 1882 Belestok, near Kiev—died 1949 Paris

Studied at Kiev School of Art (1906) and Académie de la Grande Chaumière (Paris, 1908). Became acquainted with Guillaume Apollinaire, Georges Braque, Max Jacob, Pablo Picasso. Lived in Kiev, Moscow, and Paris. Visited Italy (1908–14, 1923) and France (1923). Joined the Constructivists. Taught privately (Kiev, 1918–20) and at Vkhutemas (1921–22). Began designing textiles (1921). Staged performances for the Chamber Theater (Moscow). Moved to France (1924). Taught privately and at the Fernand Léger Academy of Modern Art (from 1925). Reformed stage and costume design by introducing Cubist and Constructivist forms.

Still Life with Eggs
date unknown

Oil on canvas

34 5/8 x 27 5/8 in.

88.0 x 70.0 cm

Inscribed verso: Alexandra Exter. Still life.

The State Russian Museum, Leningrad (Zh.B.-1411)

Acquired in 1926 from the Museum of Artistic Culture

This beautiful composition characterizes work produced during Exter's Cubist period. Three-dimensional objects are set off by textural cross-sections, shifts of color planes, and Cyrillic letters, which have acquired a life of their own. The focal point of the painting—a tray with ornamental Easter eggs—evokes a feeling of repose and stability.

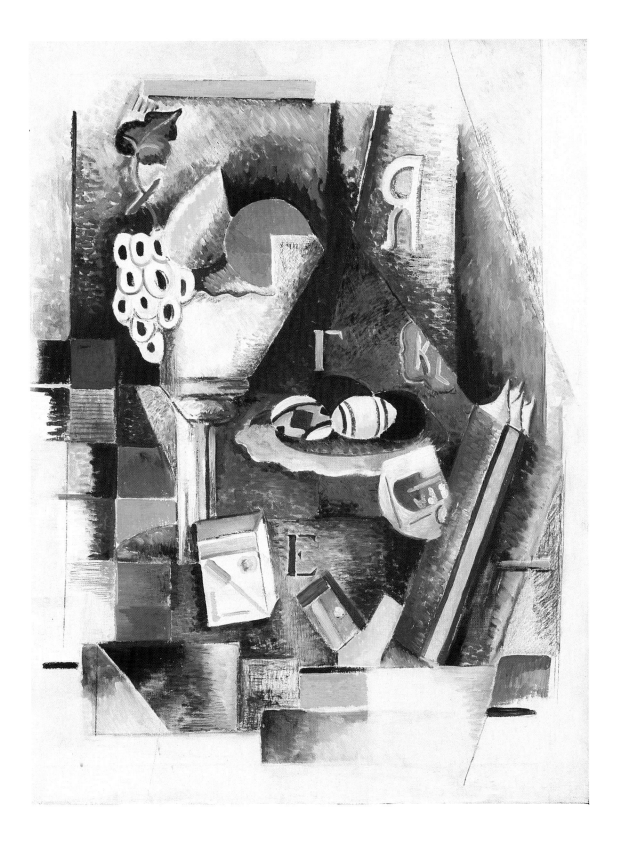

Florence 1914–15

Oil on canvas

43 x 57 1/8 in.

109.0 x 145.0 cm

The State Tretyakov Gallery, Moscow (46991)

Acquired in 1977 from George D. Costakis

By recomposing architectural elements into Cubist planes and skillfully manipulating contrasting colors, Exter created an expressively dynamic urban image.

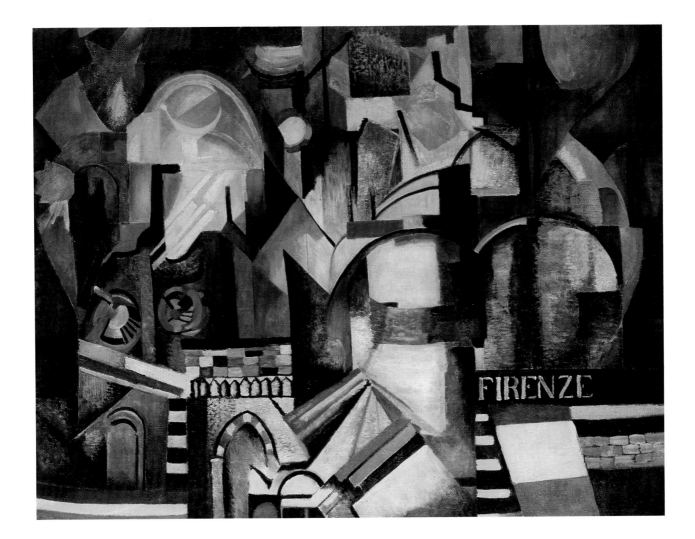

ROBERT RAFAILOVICH FALK

Born 1886 Moscow—died 1958 Moscow

Studied with Ilia Mashkov and Konstantin Yuon (Moscow, 1904–5) and at Moscow School of Painting, Sculpture, and Architecture with Konstantin Korovin and Valentin Serov (1905–12, intermittently). Exhibited with the groups the Golden Fleece (Moscow, 1909–10), Jack of Diamonds (Moscow, 1910–17), World of Art (1910, 1917, 1921–22), Moscow Painters Association (1925), AKhRR (1926–28), Society of Artists (Moscow, 1928) and at the Salon d'automne (Paris, 1928). Member of the Arts College, People's Commissariat for Enlightenment (1918–21), Inkhuk (1920). Taught at Svomas/Vkhutemas (1920–26/27), Vkhutein (1926/27–28), Moscow School of Applied and Decorative Art (1945–58). Contributed to the *Exposition internationale des arts décoratifs et industriels modernes* (Paris, 1925). Lived and worked in Paris (1928–37) and Moscow.

Portrait of an Unknown Man
1915–17 (?)

Oil on canvas

54 x 44 7/8 in.

137.0 x 114.0 cm

The State Russian Museum, Leningrad (Zh.B.-1505)

Acquired in 1926 from the Museum of Artistic Culture

The painting was apparently created during 1915–17, when, like other members of the Jack of Diamonds group, Falk emerged from the influence of Neoprimitivism and turned to Cubism. For him, compositional rhythm and the purity of texture and paint were a means for laying bare the spirituality of the individual.

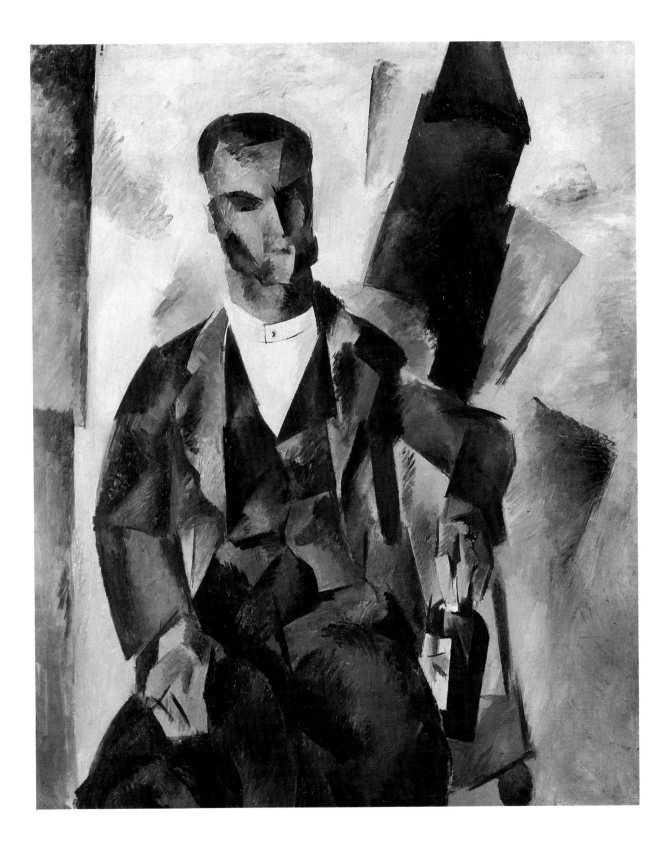

PAVEL NIKOLAEVICH FILONOV

Born 1883 Moscow—died 1941 Leningrad

Studied at the School of the Society for the Encouragement of the Arts (Saint Petersburg, 1898–1901) and Saint Petersburg Academy of the Arts (1908–10). Exhibited with the groups the Union of Youth (Saint Petersburg, 1910–14, 1917–19), Society of Artists without Party Affiliation (1913), Artists' Commune (1921–22, 1924). Designed stage sets for *Vladimir Maiakovsky: A Tragedy* (Saint Petersburg, 1913). Organized a studio for painters and graphic artists (1914). Served in the military (Rumanian front, 1916–18). Chaired the Divisional Committee and the Executive Committee of the Predanube Territory in Ismail. Official of the General Ideology Department at the Museum of Artistic Culture. Worked on the charter of the State Academy of Artistic Culture (1923). Founded the Collective of Masters of Analytical Art (1925). Active as a painter, graphic artist, composer, theorist.

The Rebirth of Man 1914–15

Oil on canvas

45 7/8 x 60 5/8 in.

116.5 x 154.0 cm

Inscribed verso, twice: Started July 17

The State Russian Museum, Leningrad (Zh.-8911)

Acquired in 1973 from E. I. Glebova, the artist's sister

Velimir Khlebnikov described the artist as "the beautiful, poignant Filonov, the little known bard of urban suffering." He was among the few avant-garde artists to portray the wretched of society with compassion and intensity.

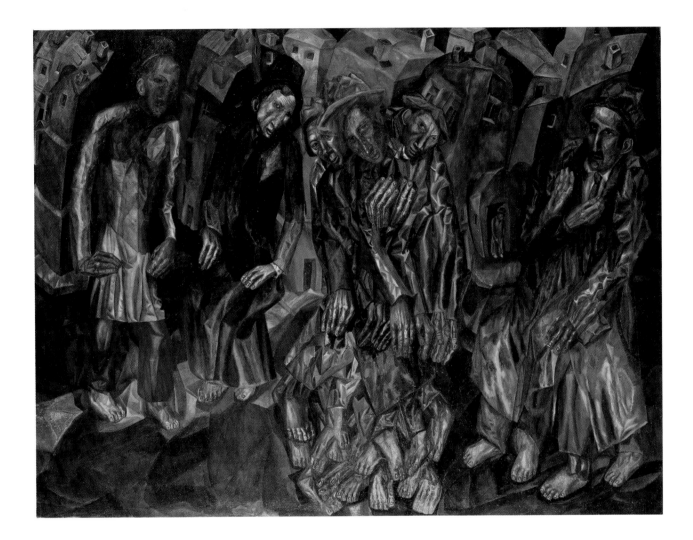

**Formula for the Petrograd
Proletariat** 1920–21

Oil on canvas

60 5/8 x 46 1/8 in.

154.0 x 117.0 cm

The State Russian Museum,
Leningrad (Zh.-9573)

Acquired in 1977 from E. I.
Glebova, the artist's sister

*Formula for the Petrograd Prole-
tariat* embodies Filonov's philoso-
phy of art whereby the world is
perceived as a process, an inces-
sant movement of good and evil,
birth and destruction. For Filo-
nov, the work of art "is a mental
process arrested," while "the truth
of art is the truth of analysis, . . .
the beauty of the merciless truth."
All his paintings bear the imprint
of the tumultuous age in which he
lived and of the revolutionary de-
struction of the old, guided by the
dream of a "universal flowering."

NATALIA SERGEEVNA GONCHAROVA

Born 1881 in present-day Tula Oblast—died 1962 Paris

Studied at Moscow School of Painting, Sculpture, and Architecture with Konstantin Korovin (1898–1902). Met Mikhail Larionov (1900). Invited by Sergei Diaghilev to contribute to an exhibition of Russian art at the Salon d'automne (Paris, 1906). Exhibited with the groups the Wreath (1907–8), Golden Fleece (Moscow, 1908–9), Union of Youth (Saint Petersburg, 1909–10, 1912–13), Jack of Diamonds (Moscow, 1910), Donkey's Tail (Moscow, 1912), World of Art (1916). With Larionov wrote the Rayonist manifesto (1913). Contributed to the exhibitions *The Target* (Moscow, 1913) and *No. 4* (Moscow, 1914). Lived in Moscow, Switzerland, Spain, Italy (from 1915). Moved to Paris (1919). Painted landscapes, portraits, still lifes; designed stage sets; illustrated books.

Washing Linen 1910

Oil on canvas

41 3/8 x 46 1/8 in.

105.0 x 117.0 cm

The State Tretyakov Gallery, Moscow (10317)

Acquired in 1927 from the Museum of Artistic Culture

One of the finest examples of Goncharova's Neoprimitivist interpretations, *Washing Linen* depicts lumbering peasant women in attitudes of calm expressiveness. Goncharova saw her Russian peasant heritage as a life-sustaining source of creative inspiration and sought to infuse her work with the energy of the primitive, to imbue the canvas with an impersonal, rough force.

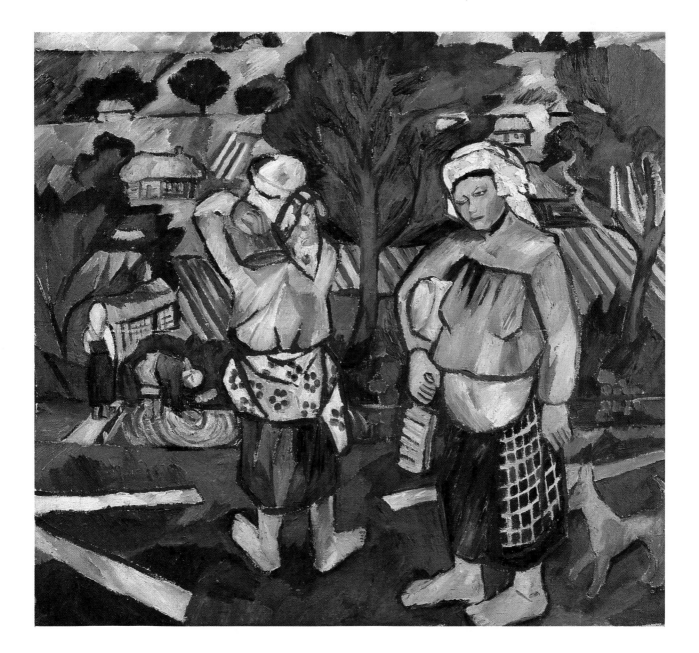

Peasants 1911

Oil on canvas

51 5/8 x 39 5/8 in.

131.0 x 100.5 cm

The State Russian Museum, Leningrad (Zh.B.-1592)

Acquired in 1926 from the Museum of Artistic Culture

This painting is part of an enormous nine-panel composition entitled *Harvest of Grapes,* created by Goncharova in 1911 and first publicly shown in its entirety at her solo exhibitions in Moscow and Saint Petersburg in 1913–14. Two panels (*Dancing Peasant Women* and *Peasants Drinking Wine*) are in Paris, one (*Peasant Women Carrying Grapes*) is in the National Art Gallery of New Zealand, Wellington, while the location of the others is unknown.

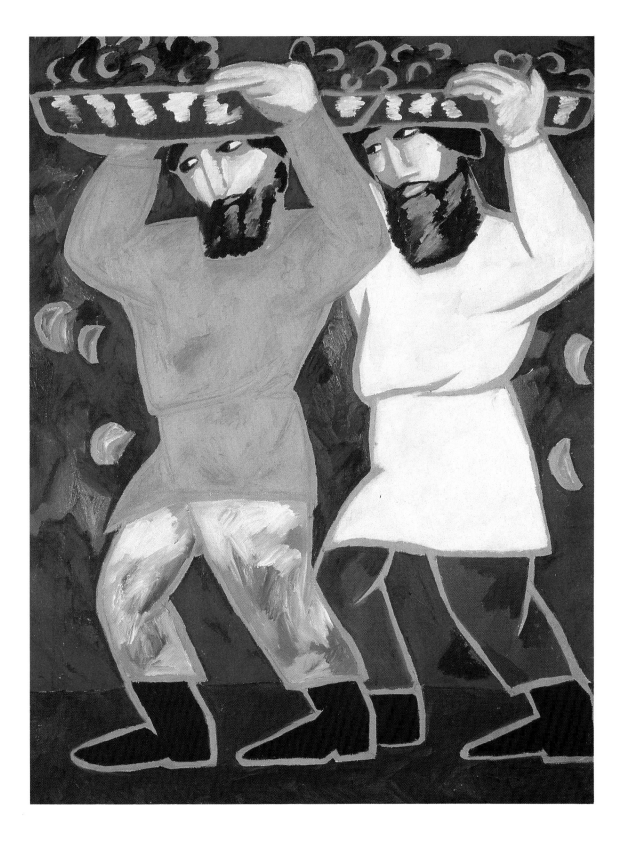

Washerwomen 1911

Oil on canvas

40 1/4 x 57 1/2 in.

102.0 x 146.0 cm

The State Russian Museum,
Leningrad (Zh.B.-1321)

Acquired in 1926 from the
Museum of Artistic Culture

In their dynamic expressiveness
Goncharova's works of 1911
occupy a special place in her
creative evolution. The coarse
gestures and stylized poses of
women hanging laundry recall
Scythian stone sculptures. The
intense color and quick, white
brushstrokes underscoring
movement evoke the influence
of ancient Russian icons.

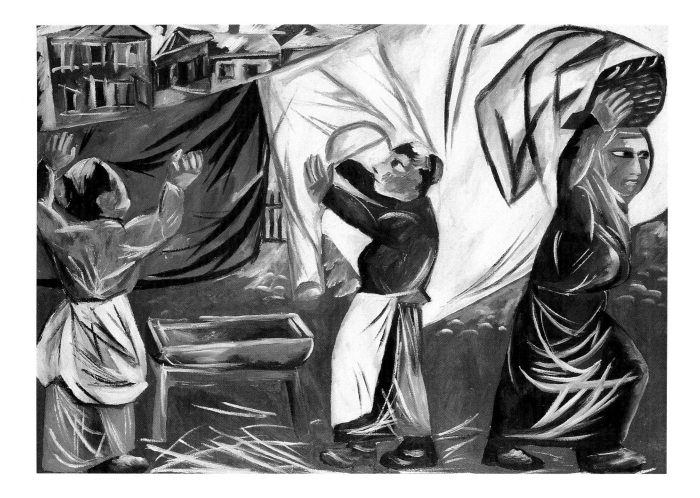

MITROFAN BORISOVICH GREKOV

Born 1882 Sharpaevsky (in present-day Rostov Oblast)—
died 1934 Sevastopol

Studied at Odessa Art School (1899–1903) and Saint Petersburg Academy of the Arts with Ilia Repin (1903–11). Exhibited with the Academy (1912–14, 1916), Society of Watercolor Artists (1912–17), Fraternity of Artists (1931). Served in the military (1912–17), in charge of student art classes in the Red Army (1920–27). Member of AKhRR (1925–32). Opened art gallery showing work made by Red Army soldiers (Moscow, 1953; now the Studio of the Military Artists).

Heading toward Budenny 1923

Oil on canvas

14 5/8 x 20 1/2 in.

37.0 x 52.0 cm

Signed and dated lower left:
M. Grekov 1923

The State Tretyakov Gallery,
Moscow (27755)

Acquired in 1934 from the artist

The painting depicts a peasant who will soon take part in the battles to establish Soviet power along the River Don. According to the famed Soviet military leader Semion Budenny (see his portrait by Vasilii Meshkov here illustrated), the painting is an artistically convincing "presentation of the entire political program and social orientation of the poorest of the Cossacks and peasants who lived near the River Don. The poor man firmly placed himself on the side of the revolutionary units that waged battles for land and freedom."

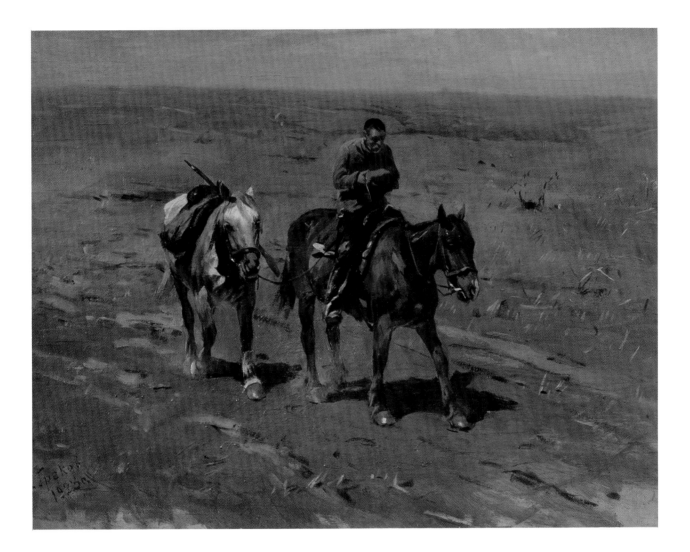

BORIS DMITRIEVICH GRIGORIEV

Born 1886 Rybinsk—died 1939 Cagnes-sur-Mer, France

Studied at the Stroganov Art School (Moscow, 1903–7) and Saint Petersburg Academy of the Arts (1907–12). Exhibited with the Impressionists (Paris, 1909) and Secessionists (Munich); with the group the World of Art (Moscow, 1913, 1915–18); at the Salon des Indépendants (Paris, 1912–13). Taught at the Stroganov Art School (Moscow, 1918). Lived in Petrograd (1919), Finland, Germany, France.

House under the Trees 1918

Oil on canvas

42 x 52 3/8 in.

106.5 x 133.0 cm

Signed and dated lower right: Boris Grigoriev 1918

The State Russian Museum, Leningrad (Zh.-11570)

Acquired in 1979 from I. S. Osipov

With a unique expressiveness and precise draftsmanship Grigoriev sensitively observed nature. His exaggerated forms reverberate with a vitalistic tension: the branches are living creatures, bending with resilience, their roots firmly gripping the soil. The color scheme and interplay of light and shadow suggest the presence of a submerged source of energy. The dynamic forms, precise lines, and sensitive palette express Grigoriev's artistic language and determine his poeticization of nature.

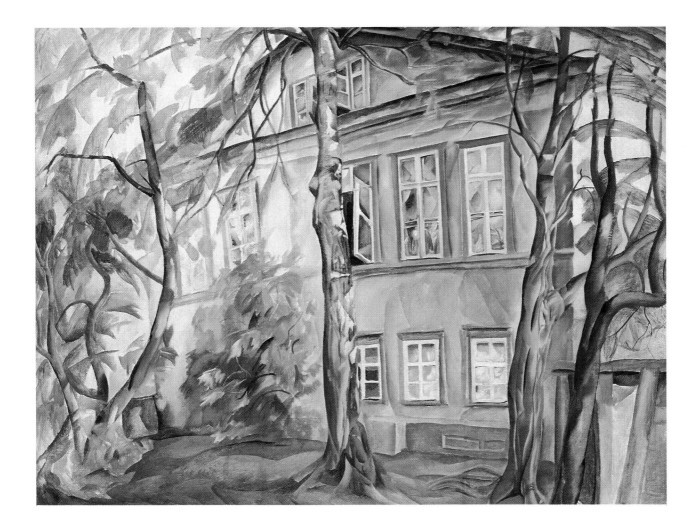

SERGEI VASILIEVICH IVANOV

Born 1864 Ruza—died 1910 Svistuha

Studied at Moscow School of Painting, Sculpture, and Architecture (1878–85, intermittently) and Saint Petersburg Academy of the Arts (1882–84). Exhibited with the Union of Russian Artists (1903) and Circle of the Itinerants (1889). Taught at the Stroganov Art School (Moscow, 1899–1906) and Moscow School (1900–1910). Painted genre scenes, historical subjects, landscapes; illustrated books.

"They're Coming!" The Punitive Expedition 1907

Oil on paper

18 3/4 x 29 3/8 in.

47.5 x 74.5 cm

Stamped lower right: S. Ivanov

The State Tretyakov Gallery, Moscow (24187)

Acquired in 1936

During the first Russian revolution of 1905 worker strikes and peasant disturbances flashed across the land. Ivanov's indignation was aroused by the cruel and merciless measures taken by the czarist government against the people. This dramatic scene depicts rebellious peasants awaiting the Cossacks, who approach on their horses in the distance.

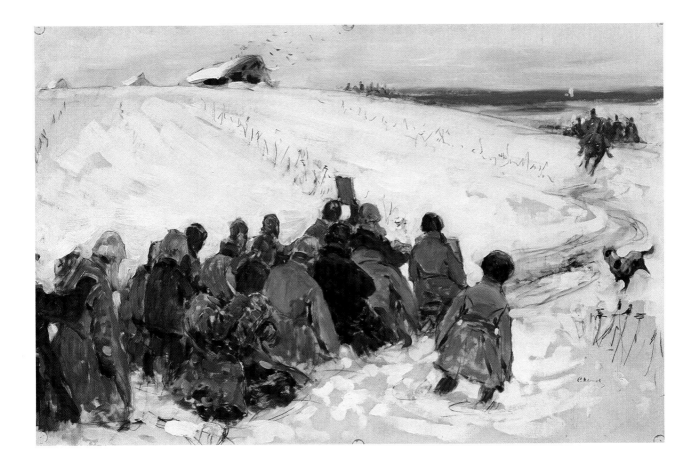

VASILII VASILIEVICH KANDINSKY

Born 1866 Moscow—died 1944 Paris

Studied with Anton Ažbé (Munich, 1897) and at the Munich Academy with Franz von Stuck (1900). Founded the Phalanx Society (1901). Lived in Munich and frequently visited Russia (1902–14). Cofounded Neue Künstlervereinigung (Munich, 1909) and Der Blaue Reiter (Munich, 1911). Exhibited with the group the Jack of Diamonds (Moscow, 1910). Wrote *On the Spiritual in Art* (1911–12). Member of the International Bureau of the Visual Arts Department of the People's Commissariat for Enlightenment (1918). Taught at Svomas/Vkhutemas (1918–21) and Moscow University (1920). Helped reorganize Russian museums. Directed the Museum of Artistic Culture (1919). Established programs for Inkhuk (1920). Vice president of RAKhN (1921). Sent to teach at the Bauhaus by the People's Commissariat for Enlightenment (1921). Taught at the Bauhaus (Weimar and Dessau, 1923–33). Moved to France (1933).

Improvisation #11 1910

Oil on canvas

38 3/8 x 42 in.

97.5 x 106.5 cm

Signed bottom right: Kandinsky 1910

The State Russian Museum, Leningrad (Zh.B.-1423)

Acquired in 1930 from the State Tretyakov Gallery

Improvisation #11, apparently painted in Munich, typifies Kandinsky's inquiries into "absolute painting" and his search of the subconscious for the knowable through intuition. A scene of war—with firing guns, soldiers, and departing vessel carrying people—can be distinguished. The broad, clashing colors used here are also found in Kandinsky's early Fauvist works.

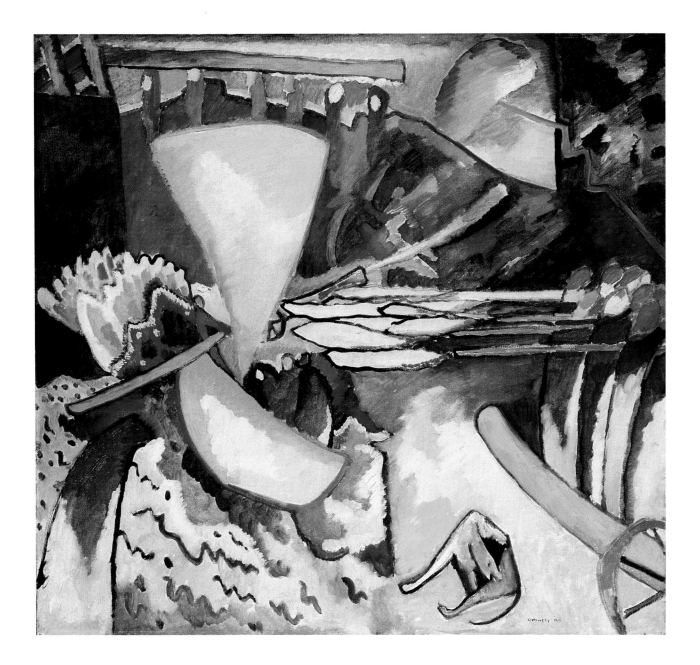

The Lake 1910

Oil on canvas

38 5/8 x 40 5/8 in.

98.0 x 103.0 cm

Signed and dated lower left: Kandinsky, 1910

The State Tretyakov Gallery, Moscow (4901)

Acquired in 1922 from the Main Directorate of Scientific Museums and Scientific-Artistic Institutions, People's Commissariat for Enlightenment

Painted in Germany, this canvas marks Kandinsky's transition from figurative to abstract painting. Barely distinguishable are mountains, a lake, and a castle, which emerge from a stormy phantasmagoria dominated by a whirlwind of color.

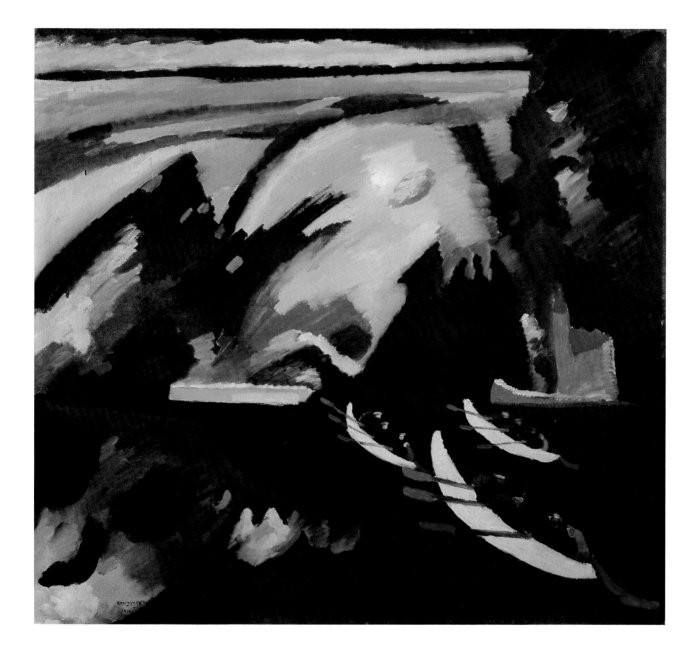

Composition #163 1913–14 (?)

Oil on paperboard

27 5/8 x 41 3/4 in.

70.0 x 106.0 cm

The State Russian Museum,
Leningrad (Zh.B.-1459)

Acquired in 1929 from the
State Tretyakov Gallery

For Kandinsky, freedom of plastic
expression was the only possible
method of transmitting spiritual
impulses. The artist compared
each element of a canvas to a
sound in a symphony of color and
line. His friendship with the
Austrian-born composer Arnold
Schönberg was very important to
him and greatly influenced the
formation of his theories about art.
In his search for the common roots
and fundamental elements of
imagery Kandinsky created his
own style and the pictorial music
of his time.

*N.B. The above title refers to a
number the artist assigned to this
work in a handwritten list of his
paintings. The painting is
identified as* Sketch II for Painting
with White Border (Moscow) *and
dated 1913 in the catalogue
raisonné compiled by Roethel and
Benjamin (see bibliography).*

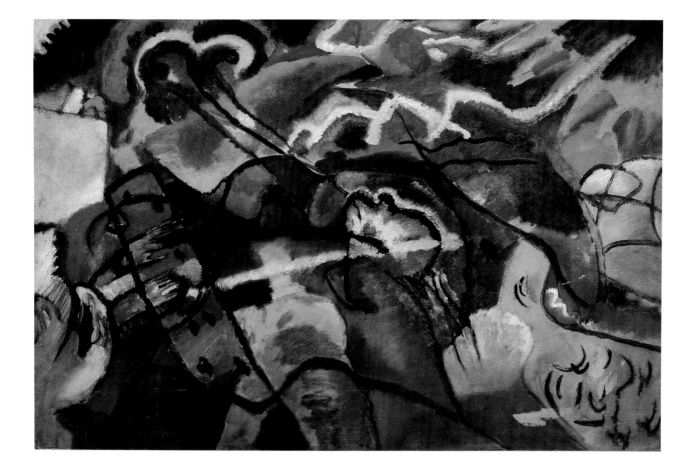

Twilight 1917

Oil on canvas

36 1/4 x 27 5/8 in.

92.0 x 70.0 cm

Signed and dated lower left: K 17

The State Russian Museum,
Leningrad (Zh.B.-1485)

Acquired in 1926 from the
Museum of Artistic Culture

Twilight was painted in Moscow,
after the artist's return from
Germany in 1914. Kandinsky
sought to discover the sources of
art exclusively in his own spiri-
tual insights. From the eccentric
play of lines, forms, and colors he
created in *Twilight* a captivating
world of fantasy and beauty.

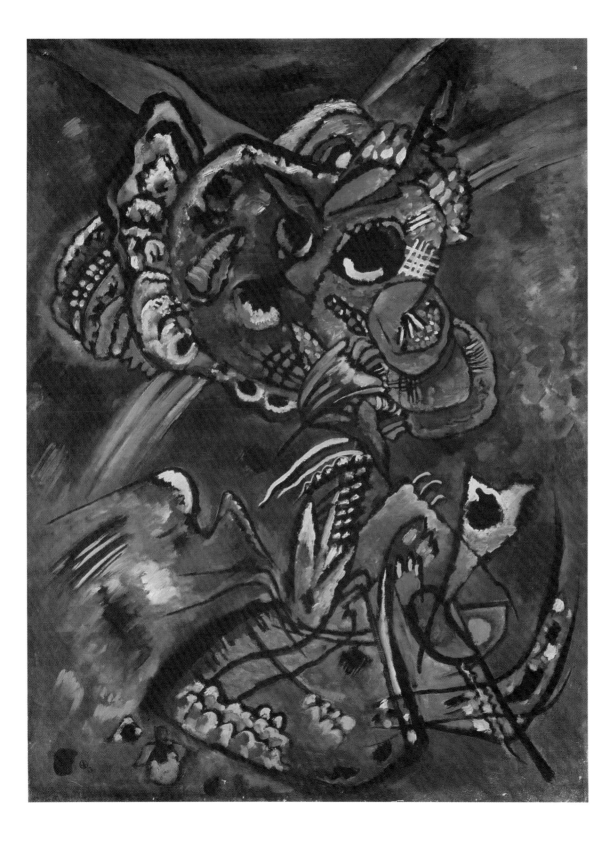

The White Oval 1919

Oil on canvas

31 1/2 x 36 5/8 in.

80.0 x 93.0 cm

Signed and dated lower left:
VK 19

The State Tretyakov Gallery,
Moscow (11924)

Acquired in 1929 from the
Museum of Artistic Culture

The canvas was painted in Russia
and is among Kandinsky's early
experiments in expressionistic
abstractionism.

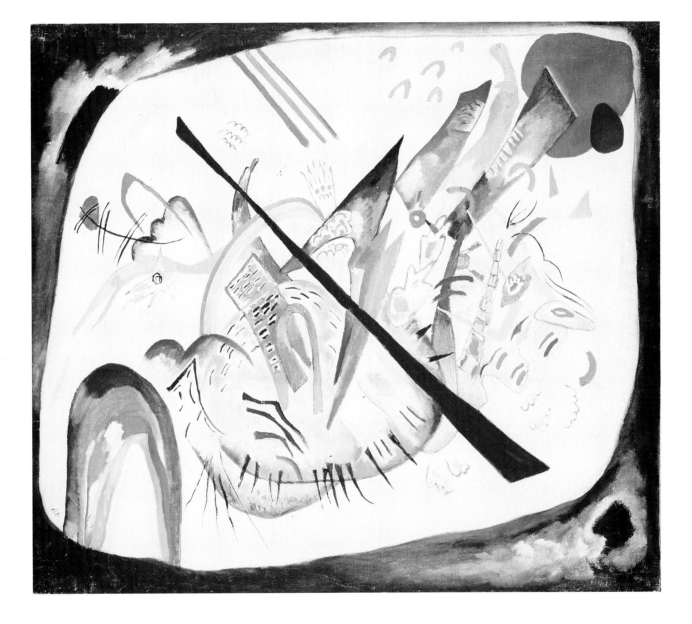

EVGENII ALEXANDROVICH KATSMAN

Born 1890 Kharkov—died 1976 Moscow

Studied in Saratov (1902–5) and at Moscow School of Painting, Sculpture, and Architecture with Abram Arkhipov, Konstantin Korovin, and Sergei Maliutin (1909–16). Taught at the Goldblat School of Art (Saint Petersburg, 1906–9). Member of AKhRR (1922–32). Honored artist of the Russian Soviet Federated Socialist Republic and corresponding member of the USSR Academy of Arts.

Village Teacher 1925

Oil on canvas

47 1/8 x 26 7/8 in.

119.6 x 68.0 cm

Signed and dated lower right:
Ev. Katsman Baranovka 1925.

The State Tretyakov Gallery,
Moscow (Zh.-550)

Acquired in 1963 from the artist

The October Revolution called huge masses of illiterate people to activity. Under these conditions the role of the teacher in introducing the populace to the message of the revolution was particularly important, especially for those working in villages.

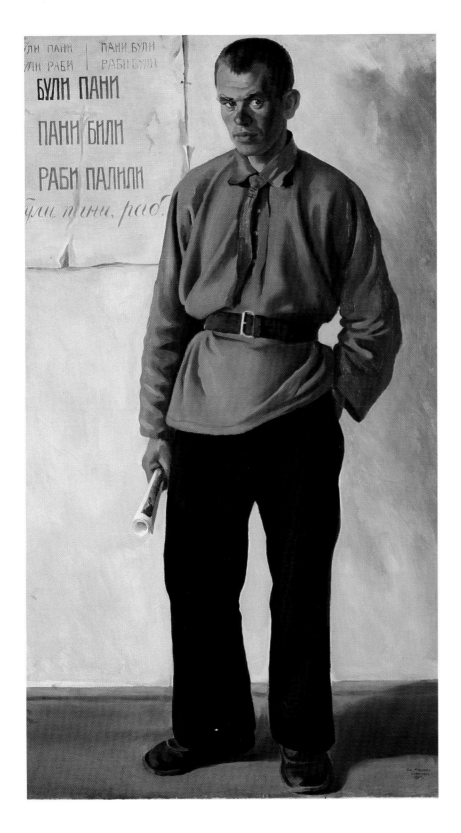

113

IVAN VASILIEVICH KLIUN

Born 1873 Bolshie Gorki—died 1943 Moscow

Studied in Warsaw (1890s) and with Fedor Rerberg and Ilia Mashkov (Moscow). With Kseniia Boguslavaskaia, Kazimir Malevich, Ivan Puni prepared Futurist manifesto (1915–16). Taught at Svomas/Vkhutemas (1918–21).

Suprematism 1915

Oil on canvas

25 1/2 x 21 1/8 in.

64.7 x 53.5 cm

The State Russian Museum, Leningrad (Zh.B.-1347)

Acquired in 1929 from the State Tretyakov Gallery

Despite his later declarations, Kliun often entered into polemical exchanges with Malevich, labeling Suprematism "a dead doctrine." In his easel paintings of the mid-1910s Kliun had, however, shown himself to be a dedicated Suprematist. In these paintings he was advancing the primacy of "pure painting" as postulated by Malevich. At that time Kliun declared, "Our color compositions are subject to the laws of color alone, not to the laws of nature."

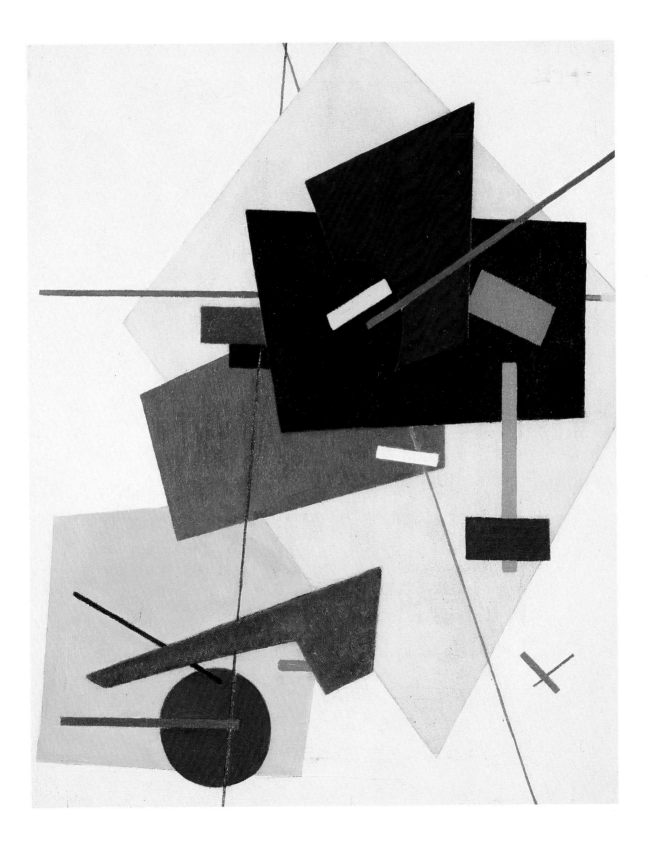

115

Self-Portrait with Saw 1917–22

Oil on canvas

26 1/4 x 20 7/8 in.

66.7 x 53.0 cm

Signed lower right: NK

The State Tretyakov Gallery, Moscow (P.-46708)

Acquired in 1977 from George D. Costakis as a gift to the USSR Picture Gallery

This work is characteristic of Kliun's Cubo-Futurist portraits.

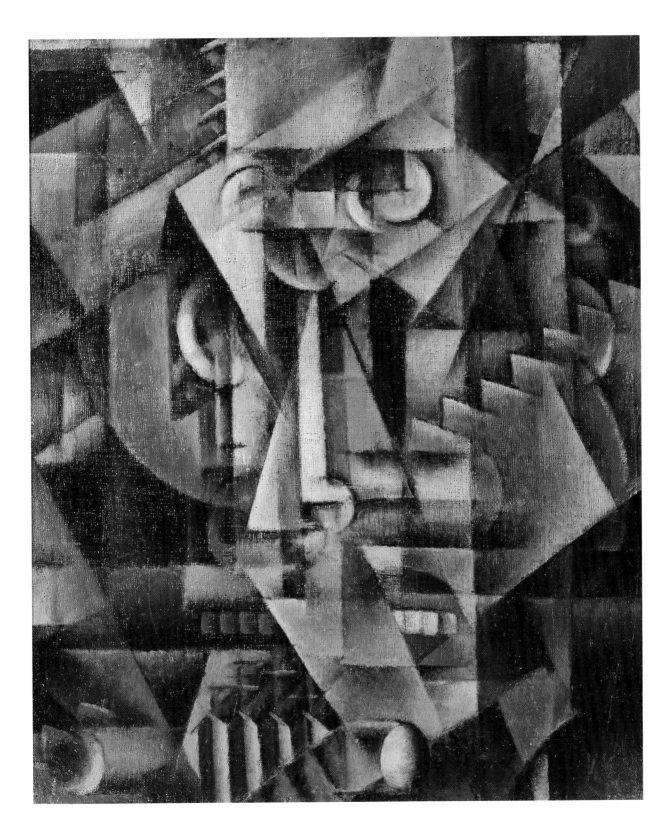

Suprematist Composition #6
1921

Oil on board mounted on wood

16 x 18 in.

40.5 x 50.6 cm

Signed upper left: I. Kliun

The State Tretyakov Gallery,
Moscow (P.-46705)

Acquired in 1977 from George D.
Costakis as a gift to the USSR
Picture Gallery

The geometric variety of abstract
art offered artists the opportunity
to concentrate on the interaction
of elementary forms and, in par-
ticular, the principles of a har-
monious, purposeful, and eco-
nomical planar and spatial
organization. These principles
later became aesthetic categories
in Constructivist theory.

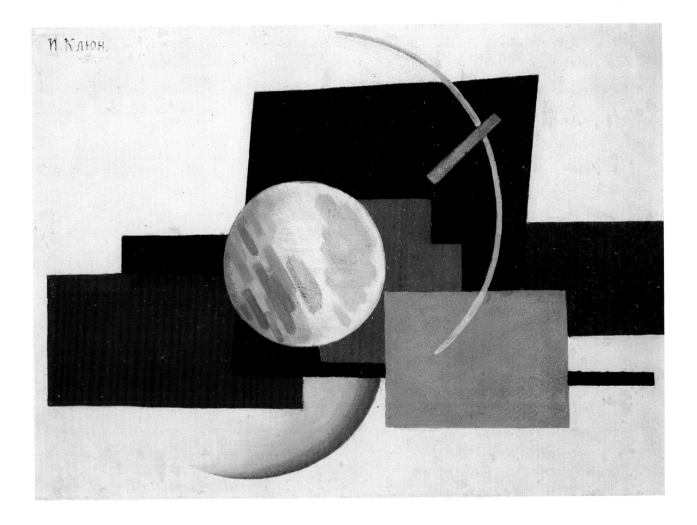

GUSTAV GUSTAVOVICH KLUTSIS

Born 1895 near Riga—died 1944

Studied in Riga (1913–15) and at Svomas with Konstantin Korovin and Kazimir Malevich (1918–20) and Vkhutemas (1920–21). Taught at Vkhutemas (1924–30) and Polygraphic Institute (Moscow, 1930). Cofounded the October group (1928). Member of the Association of Revolutionary Placard Painters (1929–32).

Axonometric Painting 1920

Oil and mixed media on canvas

37 7/8 x 22 1/2 in.

96.0 x 57.0 cm

Signed and dated lower left: Klutsis 1920

The State Tretyakov Gallery, Moscow (20844)

Acquired in 1930 from the artist

In creating *Axonometric Painting* Klutsis used oil paint as well as glass, metal shavings, and sand. He was interested in studying the capabilities of various media to transmit information about the nature of materials (in this example, iron, steel, and glass). Such studies would later influence the development of Productivist art.

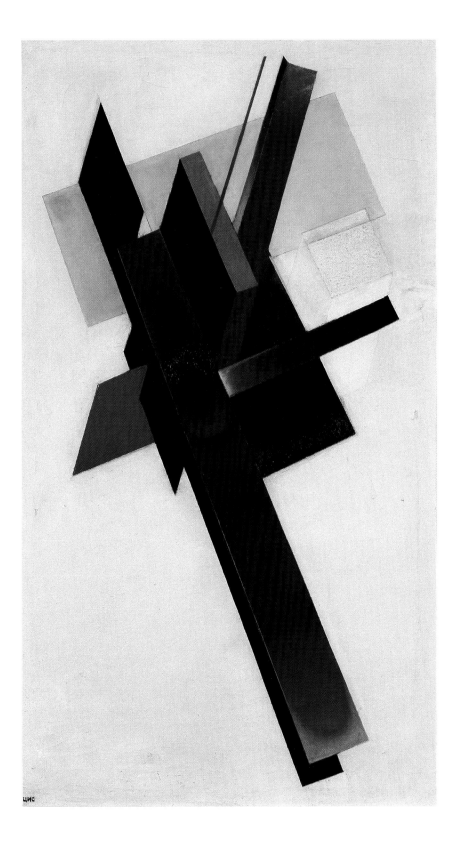

PETR PETROVICH KONCHALOVSKY

Born 1876 Slaviansk—died 1956 Moscow

Studied in Kharkov and at the Stroganov Art School (Moscow), Académie Julien (Paris, 1897–98), Saint Petersburg Academy of the Arts (1898–1905). Exhibited with the groups the Society of Artists (Moscow, 1900–1910), Jack of Diamonds (Moscow, 1910–18), Youth Alliance (1911–12), World of Art (1917, 1921–22), Being (1926–27), AKhRR. Taught at Vkhutein (1926–29). Honored artist of the Russian Soviet Federated Socialist Republic and corresponding member of the USSR Academy of Arts. Awarded USSR State Prize. Painted genre scenes, landscapes, portraits, still lifes.

Agave 1916

Oil on canvas

31 1/8 x 33 7/8 in.

79.0 x 86.0 cm

Signed and dated lower left:
P. Konchalovsky 1916

Inscribed verso: Agave 1916 224

The State Tretyakov Gallery, Moscow (8900)

Acquired in 1927 from the artist

Konchalovsky recalled the making of *Agave:*

Concern about texture can arise in the painter only when his manner of painting has already matured, and with me this did not take place until 1916. I prepared the canvas for Agave *with special care, and in the painting attempted to make the texture itself transmit the outward features of the articles: the dullness of a sheet of paper, the agave leaves filled with juice to the point of being elastic, the oiliness of polished wood. Even my painting technique was unusual. I painted on a semidry surface and resorted to glazings, using a great deal of varnish. But, already after* Agave *I was almost unable to get away from questions of texture, no matter what I painted, and concern about the canvas surface became of integral interest in my work.*

122

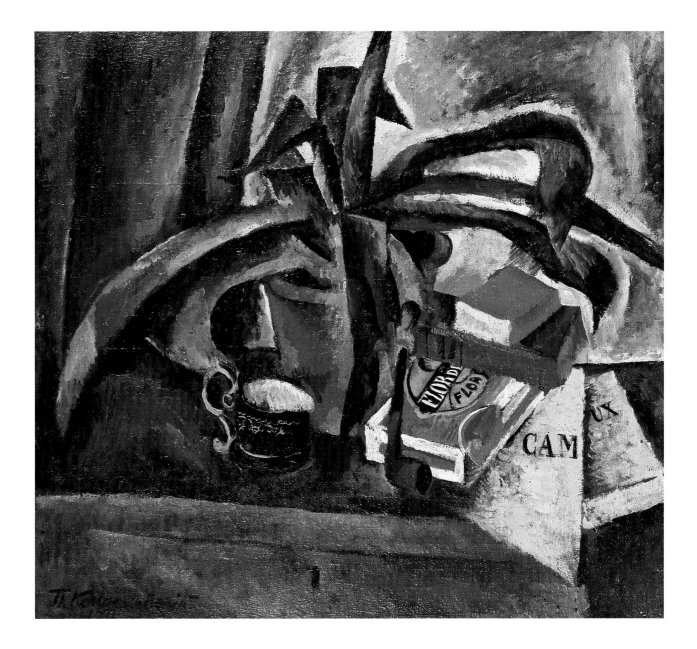

KONSTANTIN ALEXEEVICH KOROVIN

Born 1861 Moscow—died 1939 Paris

Studied at Moscow School of Painting, Sculpture, and Architecture (1875–86) and Saint Petersburg Academy of the Arts (1882). Exhibited with the groups the Circle of the Itinerants (1889–99), World of Art (1899–1903), Society of Artists (Moscow, 1889–1911), Thirty-six Artists (1901–2), Union of Russian Artists (1903–22). Awarded Légion d'honneur for creation of architectural designs and a series of decorative panels for the World's Fair (Paris, 1900). Taught at Moscow School (1901–18) and Svomas (1918–19). Designed stage sets for the Bolshoi Theater (Moscow) and Marinsky and Alexandr theaters (Saint Petersburg). Moved to Paris (1923). Painted genre scenes, landscapes, portraits, still lifes. Among the most brilliant representatives of Russian Impressionism.

Paris: Boulevard des Capucines
1911

Oil on canvas

25 5/8 x 31 7/8 in.

65.0 x 80.7 cm

The State Tretyakov Gallery, Moscow (9103)

Acquired in 1927 from the collection of Ivan Morozov at the State Museum of New Western Art

One of the best and most typical of Korovin's landscapes, *Paris: Boulevard des Capucines* was painted during 1910–20, a period when his creativity flourished. At that time his paintings became free and artistic, his palette enriched with vivid and pure colors. Korovin frequently painted scenes of Paris, which he visited almost every year beginning in 1900. In contrast to the French Impressionists, he loved depicting the city at night, the "fires of Paris." The influence of the theater is seen in his decorative landscapes.

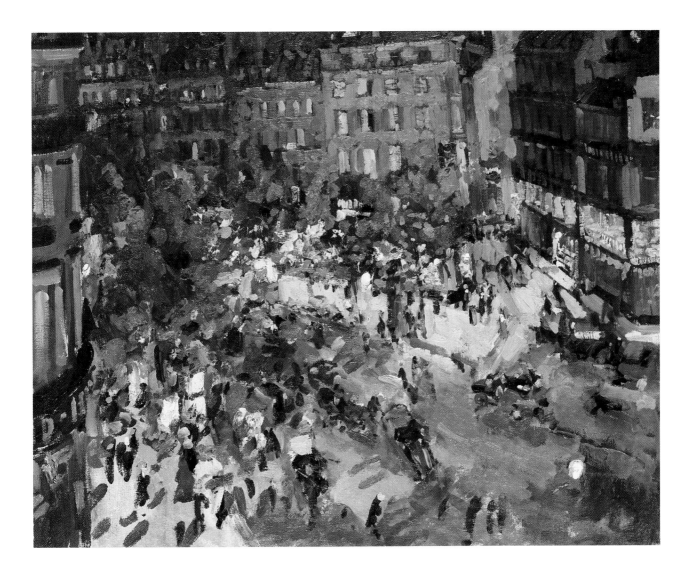

ALEXEI ILICH KRAVCHENKO

Born 1889 Pokrovskaya Sloboda (present-day Engels)—died 1940 Moscow

Studied at Moscow School of Painting, Sculpture, and Architecture with Abram Arkhipov, Konstantin Korovin, Valentin Serov (1904–10) and in Munich (1905–6). Exhibited at the Salon des Indepéndants (Paris, 1909) and with the groups the World of Art (1915–16), Circle of the Itinerants (Moscow), Society of Artists (Moscow, 1912–13), Four Arts Society (1925). Taught at the Saratov Svomas (1918–21) and Moscow Art Institute (1935–40).

Rainbow 1920

Oil on canvas on board

38 1/4 x 27 5/8 in.

97.0 x 70.0 cm

The State Tretyakov Gallery, Moscow (Zh.S.-2422)

Acquired in 1986 from N. A. Kravchenko

In the first decade after the October Revolution symbolic and allegorical depictions of contemporary themes were common in Soviet art. The image of the rainbow was often used to represent the birth out of chaos of a new and harmonious life; Kravchenko's landscape reflects this symbolism.

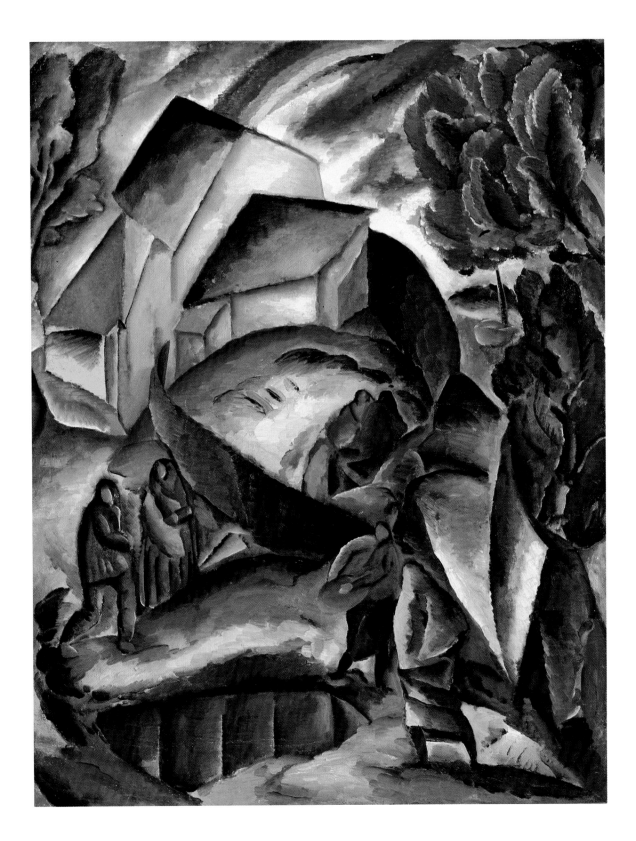

NIKOLAI IVANOVICH KULBIN

Born 1868 Saint Petersburg—died 1917 Petrograd

Self-taught. Graduated from Saint Petersburg Military Academy (1892); later taught there. Exhibited with the groups the Contemporary Movements in Art (1908), Triangle (1910), Jack of Diamonds (Moscow, 1912) and with the Impressionists (1909). Organized debates about Futurism. Decorated the artistic cabaret the Stray Dog (Saint Petersburg, 1911–15). Contributed to the *International Exhibition of Free Futurists* (Rome, 1914). Painted landscapes, portraits, symbolic images; illustrated books; designed stage sets; wrote articles on music, the fine arts, theater.

Tatar Section of Alushta 1916

Oil on canvas

22 7/8 x 35 7/8 in.

58.0 x 91.0 cm

The State Russian Museum, Leningrad (Zh.B.-1457)

Acquired in 1926 from the Museum of Artistic Culture

Alushta is a resort on the southern slopes of the Crimean mountains, near the Black Sea. In this painting Kulbin transformed one of the town's neighborhoods, depicting it as an image of poetic fancy.

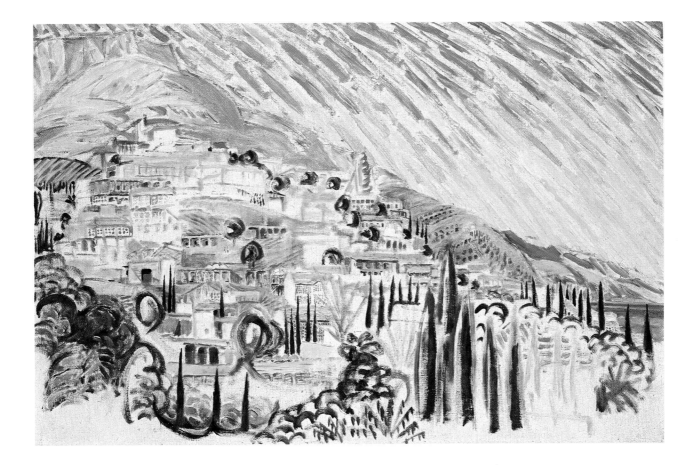

ALEXANDR VASILIEVICH KUPRIN

Born 1880 Borisoglebsk—died 1960 Moscow

Studied in Saint Petersburg (1902–4); with Konstantin Yuon (Moscow, 1904–6); at Moscow School of Painting, Sculpture, and Architecture with Abram Arkhipov and Konstantin Korovin (1906–10). Exhibited with the group the Jack of Diamonds (Moscow, 1910), Moscow Painters Association, Society of Artists (Moscow). Taught in Moscow and Nizhni Novgorod. Painted landscapes, portraits, still lifes.

Still Life with Gourd, Vase, and Brushes (Large Still Life)
1917

Oil on canvas

47 1/4 x 65 in.

120.0 x 165.0 cm

Signed and dated lower left:
A. Kuprin 1917

The State Tretyakov Gallery, Moscow (Zh.-676)

Acquired in 1968 from T. S. Kuprina-Anisimova, the artist's widow

More than any other artist in the Jack of Diamonds group, Kuprin displayed a keen interest in using line to delineate rhythmical patterns. In this still life centrifugal movement expresses agitation. The fragile and brittle forms have a nervous spirituality that recalls ancient Russian art forms.

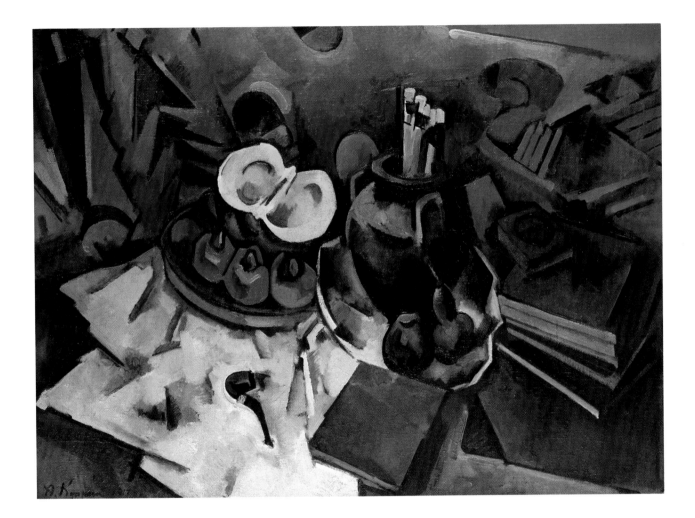

BORIS MIKHAILOVICH KUSTODIEV

Born 1878 Astrakhan—died 1927 Leningrad

Studied in Astrakhan and at Saint Petersburg Academy of the Arts with Ilia Repin (1896–1903). Pensioner of the Academy (1904). Exhibited with the New Society of Artists (1904), Union of Russian Artists (1907), World of Art (1910), AKhRR (1923). Taught at the New Art Studio (Saint Petersburg, 1913). Painted genre scenes, landscapes, portraits; designed and illustrated books; designed stage sets.

Merchant's Wife 1915

Oil on canvas

80 3/8 x 43 in.

204.0 x 109.0 cm

Signed and dated lower right: 1915 B. Kustodiev

The State Russian Museum, Leningrad (Zh.-1870)

Acquired in 1920 from A. A. Korovin

The Russia of the patriarch, peasant, and merchant is the primary subject of Kustodiev's work. With gentle irony he depicted scenes of popular celebration and entertainment. Relying on provincial art forms— including *lubki,* painted toys, and other handmade artifacts— Kustodiev forged his own inimitable style to create picturesque paintings.

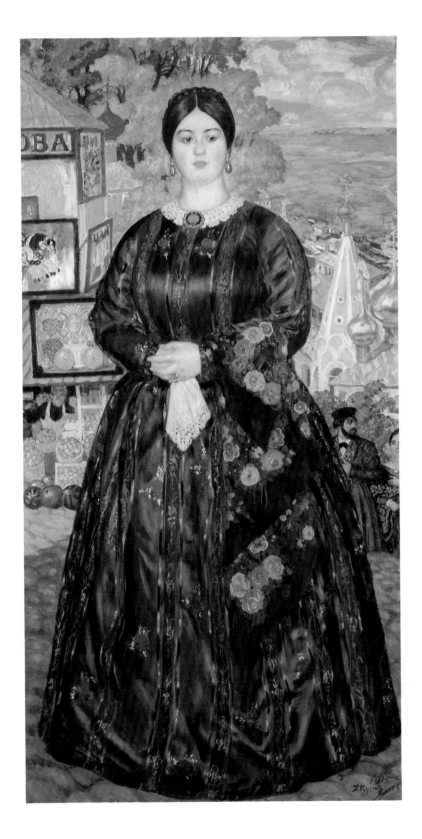

PAVEL VARFOLOMEEVICH KUZNETSOV

Born 1878 Saratov—died 1968 Moscow

Studied in Saratov (1891–96); at Moscow School of Painting, Sculpture, and Architecture with Konstantin Korovin and Valentin Serov (1897–1904); in Paris (1906). Exhibited with the groups the Blue Rose, World of Art (1902), Society of Artists (Moscow, 1905), Union of Russian Artists (1906) and at the Salon d'automne (Paris, 1906). Chairman of the Four Arts Society (1924–31). Headed the painting section of the Visual Arts Department of the People's Commissariat for Enlightenment. Taught at Moscow School and Vkhutein.

Still Life with Tapestry 1913

Oil on canvas

33 7/8 x 34 1/4 in.

86.0 x 87.0 cm

The State Tretyakov Gallery, Moscow (3835)

Acquired in 1913 from the artist

In his still lifes and portraits of Volga nomads Kuznetsov paid tribute to Russian orientalism. In this painting compositional elements dissolve in a radiant arabesque. The soft, rounded rhythms of yellow and blue create a decorative effect.

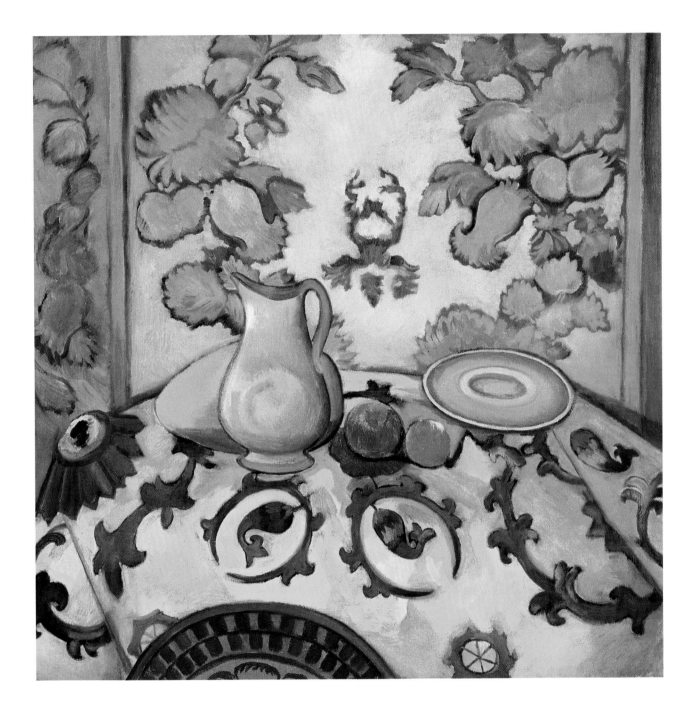

ALEXANDR ARKADIEVICH LABAS

Born 1900 Smolensk—died 1983 Moscow

Studied at the Stroganov Art School (Moscow, 1912–17), Svomas (1917–19), Vkhutemas. Taught at the Ekaterinburg Art Institute (1920–21) and Vkhutemas (1922–24). Cofounded OST (1925–32).

The First Steam Locomotive on the Turksib 1929

Oil on canvas

35 1/4 x 47 1/4 in.

89.5 x 120.0 cm

Signed lower right: A. Labas

The State Tretyakov Gallery, Moscow (Zh.S.-716)

Acquired in 1931 from the artist

In this painting Labas depicted a joyful event in the history of the Soviet Republic: the arrival of the steam locomotive on the Turkestan-Siberian Railroad, the first product of socialist construction in Central Asia.

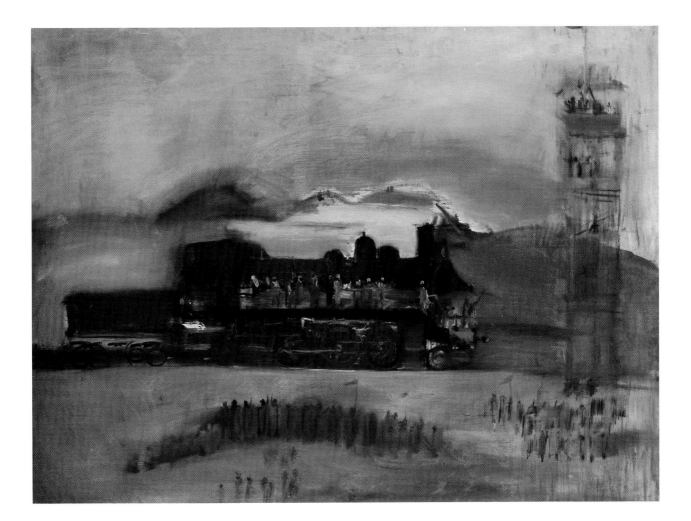

MIKHAIL FEDOROVICH LARIONOV

Born 1881 Tiraspol—died 1964 Fontenay-aux-Roses, France

Studied at Moscow School of Painting, Sculpture, and Architecture with Konstantin Korovin and Valentin Serov (1898–1908, intermittently). Met Natalia Goncharova (1900). Invited by Sergei Diaghilev to contribute to an exhibition of Russian art at the Salon d'automne (Paris, 1906). Exhibited with the group the Golden Fleece (Moscow). With David Burliuk organized the group the Wreath (1907). Coorganized the exhibitions *The Link* (1908) and *The Target* (Moscow, 1913). Cofounded the groups the Jack of Diamonds (Moscow, 1910) and Donkey's Tail (Moscow, 1912). With Goncharova wrote the Rayonist manifesto (1913). Organized the exhibition *No. 4* (Moscow, 1914). Designed sets for Diaghilev's Ballets Russes (Paris, 1914–29). Traveled abroad (1915). Moved to Paris (1917). Painted genre scenes, landscapes, portraits, still lifes; illustrated books.

Bathing Soldiers 1911

Oil on canvas

35 7/8 x 41 3/8 in.

91.0 x 105.0 cm

The State Tretyakov Gallery, Moscow (11952)

Acquired in 1929 from the Museum of Artistic Culture

Between 1910 and 1920 Larionov produced a series of genre scenes depicting military life. *Bathing Soldiers* is one of the most expressive paintings of the series. This vivid image is taken from life and evokes the spirit of *lubki* and Neoprimitivism. The restrained colors—drawn on the canvas with energetic brushstrokes—and simplified forms embody brutal, yet vibrant forces, which Larionov has described with good-natured irony.

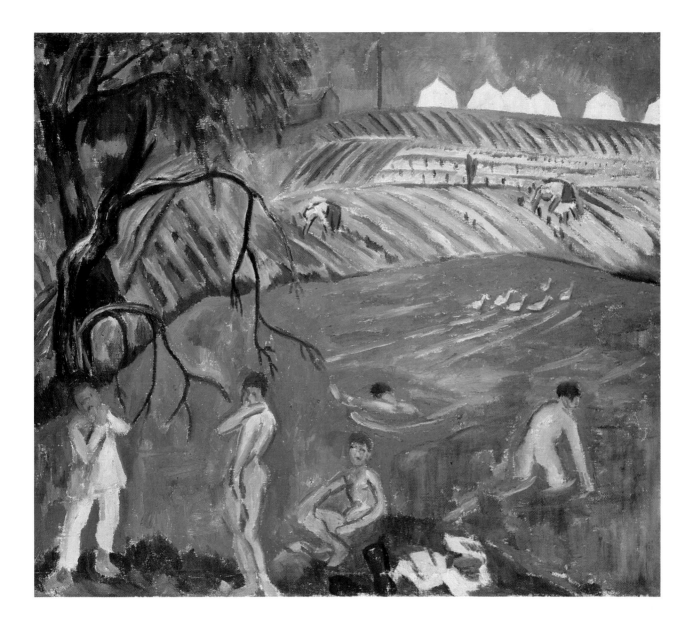

VLADIMIR VASILIEVICH LEBEDEV

Born 1891 Saint Petersburg—died 1967 Leningrad

Studied at the Saint Petersburg Academy of the Arts (1910–11), and with Mikhail Bernstein (Saint Petersburg, 1912). Worked for various art journals (1911–17). Exhibited with the Union of Youth (Saint Petersburg, 1913). Contributed to the exhibition *Union of New Trends in Art* (Petrograd, 1922) and a major exhibition of Russian and Soviet art (Berlin, 1922). Lived and worked in Saint Petersburg, Kirov (1941–42), Moscow (1942–50). Awarded silver medal at the exhibition *Art of Book Design* (Leipzig, 1954). Honored artist of the Russian Soviet Federated Socialist Republic (1966) and corresponding member of the USSR Academy of Arts (1967). Painted genre scenes, portraits, still lifes; illustrated books; designed posters and stage sets.

Still Life with Palette 1919

Oil on canvas

35 1/8 x 25 5/8 in.

89.0 x 65.0 cm

Signed and dated upper left:
V. Lebedev 1919

The State Russian Museum, Leningrad (Zh.B.-1435)

Acquired in 1926 from the Museum of Artistic Culture

For many years Lebedev devoted himself to painting still-life compositions. This painting dates to Lebedev's early Cubist period, and the influence of Cubism is apparent in the juxtaposition of contrasting forms and masses as well as interaction of surface and space. The objects in this painting—palette, sponge, frame, glass fragment, coat hanger, pot, brush—are presented with near illusory verisimilitude.

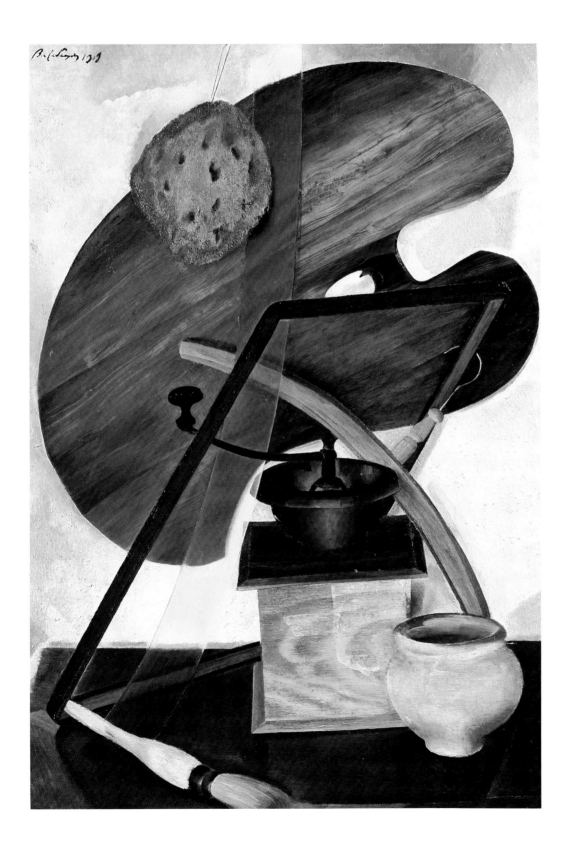

ARISTARKH VASILIEVICH LENTULOV

Born 1882 Veroha—died 1943 Moscow

Attended a religious school and seminary (Penza, 1889–98). Studied at the Seliverstov Art School (Penza, 1898–1900, 1905), Kiev School of Art (1900–1905), Jean Metzinger's studio La Palette with Henri LeFauconnier (Paris). Taught privately (Kiev, 1900–1905). Contributed to the exhibition *The Link* (1908). Exhibited with the groups the Wreath (1908), Society of Artists (Moscow, 1909–10), Union of Russian Artists (1910), Mir iskusstva (1911–12, intermittently). Lived and worked in Penza, Kiev, Saint Petersburg, Moscow (from 1909), Ulyanovsk (1941–42). Helped decorate the Café Pittoresque (Moscow, 1917) and Café of the Poets (1917). Board member of the Visual Arts Department of the People's Commissariat for Enlightenment (1918). Taught at Svomas, Moscow School of Pictorial Arts, Moscow School of Art (1918–43). Exhibited with the Society of Young Artists (Moscow, 1919–21), AKhRR (1926–28), Society of Artists (Moscow, 1928–32). Joined Inkhuk (1920). Awarded diploma from the *Exposition internationale des arts décoratifs et industriels modernes* (Paris, 1925) and first prize at the International Festival of Stage Design (Moscow, 1934). Painted landscapes, portraits, still lifes; designed stage sets.

Landscape with Monastery 1920

Oil on canvas

41 x 55 1/8 in.

104.0 x 140.0 cm

The State Russian Museum, Leningrad (Zh.-8280)

Acquired in 1967 from M. A. Lentulova, the artist's daughter

Landscape with Monastery is part of a painting series created by Lentulov at the Troitsko-Sergievskaya Monastery near Moscow in 1920–22. Nature and architecture are transformed into a schematic unity. The severe building contours are contrasted with the dynamic outlines of the bare tree branches, and the palette is constructed of muted color contrasts.

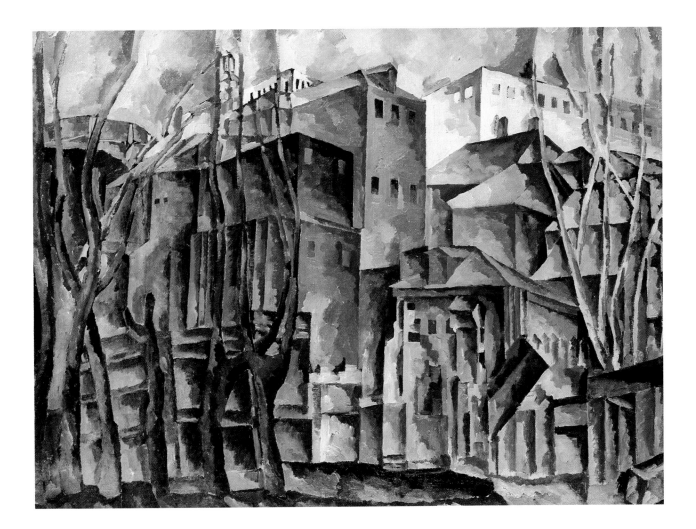

SERGEI ALEXEEVICH LUCHISHKIN

Born 1902 Moscow

Studied at Svomas with Abram Arkhipov (1919) and Vkhutemas with Alexandra Exter, Liubov Popova, Nadezhda Udaltsova (1919–24). Studied production and recitation at the Institute of the Word (1920–23). Active as a producer and artistic manager of the Projection Theater (Moscow, from 1923). Member of OST (1925–28).

**Book Festival,
Tverskoy Boulevard** 1927

Oil on canvas

62 7/8 x 43 3/4 in.

159.7 x 111.0 cm

The State Tretyakov Gallery, Moscow (Zh.S.-724)

In this painting Luchishkin depicted a holiday procession of book-publishing employees. A spirited feeling activates the scene and corresponds to the emotional tenor of the time.

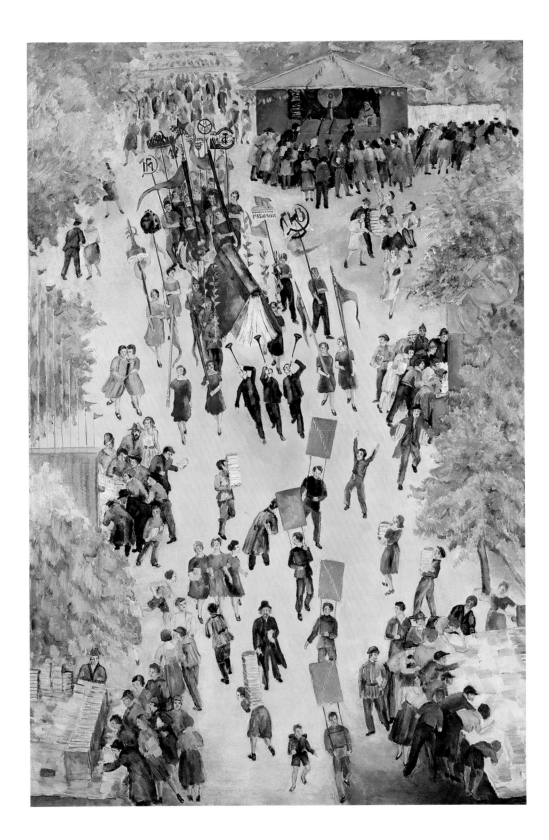

**Standing Guard over the
Collective Farm,
Peering into the Night** 1930

Oil on canvas

30 3/8 x 46 1/8 in.

77.0 x 117.0 cm

Signed and dated lower right:
S. Luchishkin 1930

The State Tretyakov Gallery,
Moscow (Zh.S.-754)

Acquired in 1931 from the artist

The painting was made at the time
of the country's first successes in
manufacturing farm machinery.
As did many Soviet artists
working during the 1920s,
Luchishkin created romanticized
technological images to stir pride
in the country's industrial and
agricultural achievements.

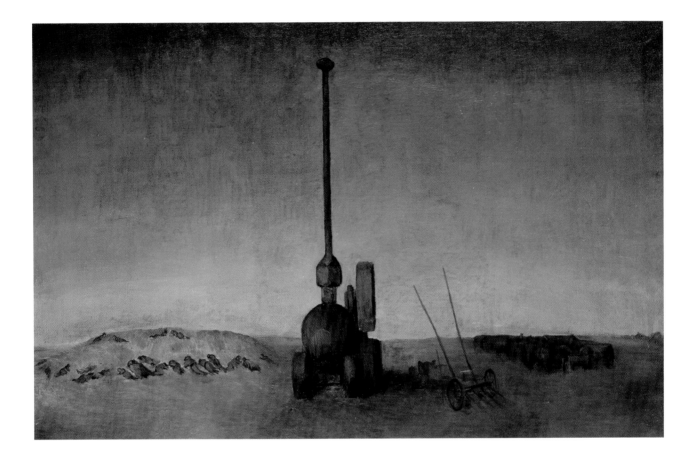

VLADIMIR ILICH MALAGIS

Born 1902 Griva—died 1974 Leningrad

Studied at the School of the Society for the Encouragement of the Arts (Petrograd); Pegoskhuma with Kuzma Petrov-Vodkin (Petrograd, 1918–24); Leningrad School of Painting, Sculpture, and Architecture; Repin Institute of Painting, Sculpture, and Architecture (1945–48). Exhibited with the groups the Artists' Circle (1926–29) and October (1930). Honored artist of the Russian Soviet Federated Socialist Republic.

Mourning (Still Life) 1924

Oil on canvas

29 1/4 x 29 1/4 in.

74.0 x 74.0 cm

Inscribed verso: Malagis V.I., Mourning (still life), oil on canvas 74 x 74 cm, 1924

The State Russian Museum, Leningrad (Zh.-9993)

Acquired in 1978 from E. V. Baikova, the artist's widow

Mourning was made in response to the tragic news of Lenin's death. The image is dominated by the front page of the newspaper *Leningradskaia Pravda,* which announces the leader's death, and the sheet music for the song "You Fell As Victims." The emotional intensity of the painting is heightened by Malagis's use of color in the cool green background and red-hemmed black tablecloth.

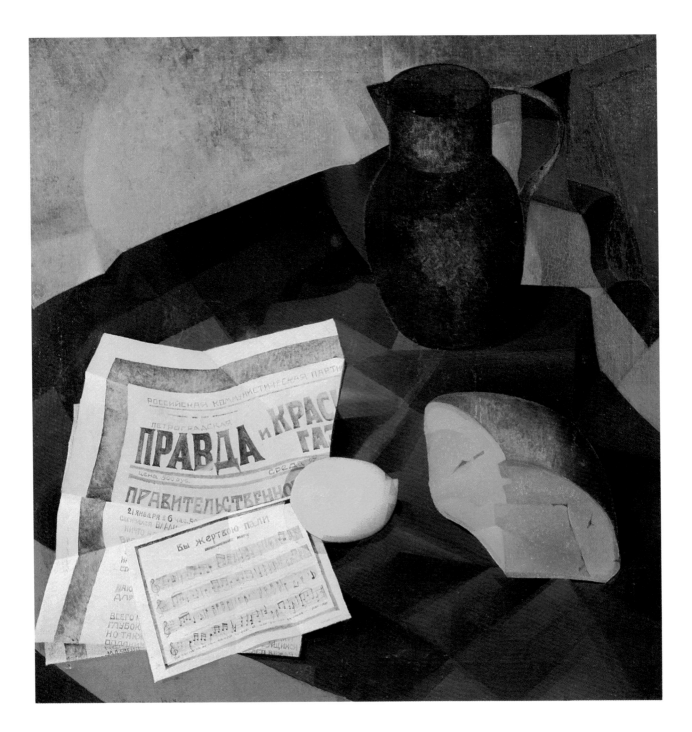

KAZIMIR SEVERINOVICH MALEVICH

Born 1878 near Kiev—died 1935 Leningrad

Studied at Kiev School of Art (1895–96) and Moscow School of Painting, Sculpture, and Architecture (1903). Exhibited with the groups the Jack of Diamonds (Moscow, 1910), Union of Youth (Saint Petersburg, 1910–13), Donkey's Tail (Moscow, 1912). Contributed to the exhibitions *The Target* (Moscow, 1913), *Tramway V* (Petrograd, 1915), *0.10* (Petrograd, 1915–16). Leader of the Suprematist art movement (from 1915). With Kseniia Boguslavskaia, Ivan Kliun, Ivan Puni prepared Futurist manifesto (1915–16). Taught at Svomas (1918) and Vitebsk Practical Art Institute (1919–22). Founded the organization the Affirmers of the New Art (Vitebsk, 1920). Taught at Inkhuk (Petrograd/Leningrad, 1923–27).

Suprematism 1916

Oil on canvas

34 1/2 x 28 3/8 in.

87.5 x 72.0 cm

The State Russian Museum, Leningrad (Zh.-1332)

Acquired in 1926 from the Museum of Artistic Culture

Suprematism developed during a critical period in the history of Russian art and was related to an attempt to grasp the "higher," suprapersonal essence of art, independent "of any aesthetic, feelings, or emotions." To many critics of the 1920s a Suprematist work of art, when considered apart from its context and ideology, seemed devoid of meaning and became a mere theoretical illustration. Supporters of Malevich, however, considered his paintings to be part of a continuous process, of what he defined as the "silent, dynamic construction of the universe."

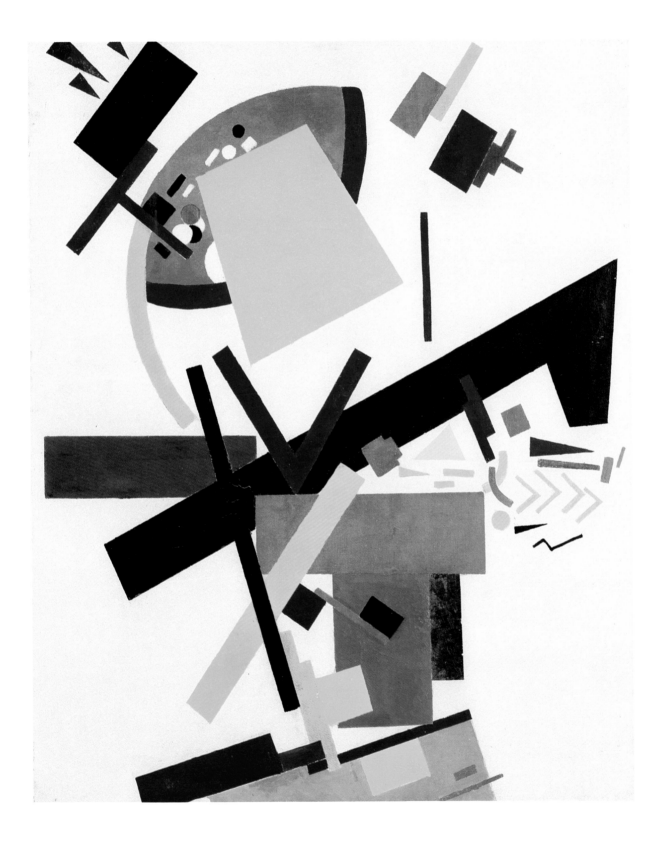

151

Carpenter 1928–32

Oil on plywood

28 x 17 3/8 in.

71.0 x 44.0 cm

Signed lower right: K Malevich

Inscribed verso: No 12 1910
Plotnik [Carpenter]

The State Russian Museum,
Leningrad (Zh.-9475)

Acquired in 1977 from the
Ministry of Culture of the USSR

The Neoprimitive canvases of
Malevich reflect the strong
influence of Russian folk art—
colorful paintings on wood,
embroideries, weavings—as well
as the metallic plasticism of
Fernand Léger. According to
scholars, *Carpenter* is a late work,
despite the early date assigned to
it by the artist.

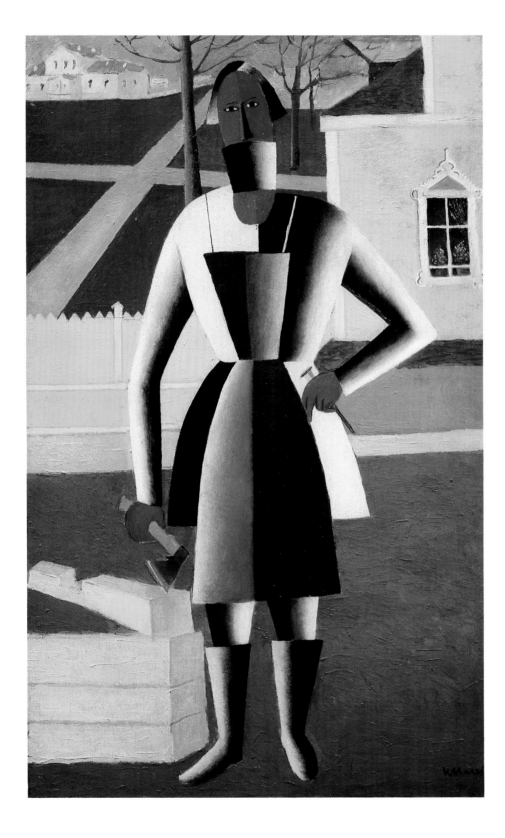

**Two Peasants against
Blue Background** 1928–32

Oil on canvas

39 x 29 1/4 in.

99.0 x 74.0 cm

Signed lower left: K Malevich
Dated lower right: 1913

The State Russian Museum,
Leningrad (Zh.-9436)

Acquired in 1977 from the
Ministry of Culture of the USSR

Like many others who allied
themselves with the Neoprimitiv-
ists during the 1900s and 1910s,
Malevich often turned to folk
motifs, interpreting traditional
Russian themes in his own way.
His interest in Suprematism is
here manifested in the composi-
tion and coloristic treatment of the
figures. Often, as in this painting,
Malevich assigned an early date to
those figurative paintings that he
had made after his discovery of
Suprematism.

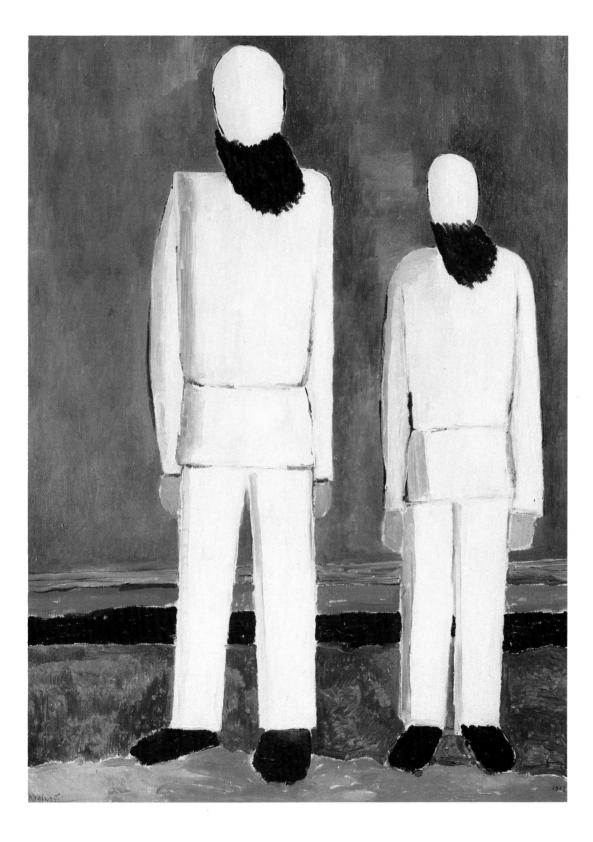

FILIPP ANDREEVICH MALIAVIN

Born 1869 Kazanka—died 1940 Nice, France

Studied icon painting at Saint Panteleymon Monastery (Mount Athos, Greece, 1885–91) and painting at Saint Petersburg Academy of the Arts with Ilia Repin (1892–99). Exhibited at the International Exposition (Paris, 1900); in Venice (1901, 1907) and Rome (1901); with AKhRR. Member of the Union of Russian Artists (from 1903). Academician of painting (1906). Moved to Paris (1922). Painted genre scenes and portraits.

Whirlwind 1905

Study for *Whirlwind,* 1905
(The State Tretyakov Gallery)

Oil on canvas

29 5/8 x 47 5/8 in.

75.3 x 121.0 cm

The State Tretyakov Gallery, Moscow

Acquired in 1925 by the State Museum Fund from the collection of I. A. Morozov

The monumental canvas *Whirlwind* occupies a special place in the oeuvre of Maliavin. The wild dance of the peasant women forms a whirlwind of color emblematic of a rebellious nationalism, and this painting is often associated with the Russian revolution of 1905. Repin called it "the most vivid painting of the revolutionary movement in Russia."

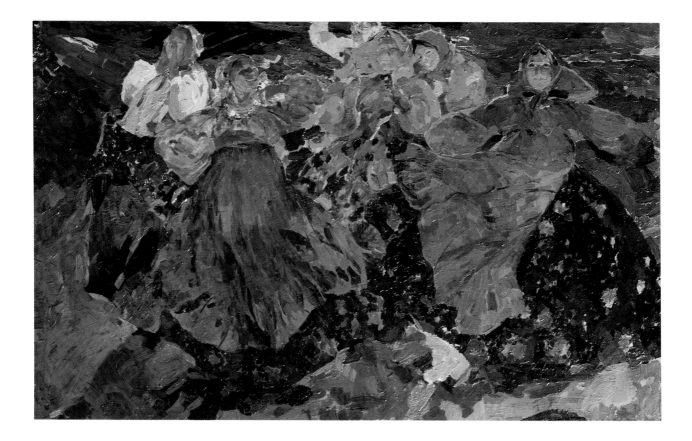

SERGEI VASILIEVICH MALIUTIN

Born 1859 Moscow—died 1937 Moscow

Studied at Moscow School of Painting, Sculpture, and Architecture (1883–86). Taught at Moscow School (1903–17) and Vkhutemas (1920–23). Exhibited with the groups the World of Art, Union of Russian Artists (1903), Circle of the Itinerants (1915), AKhRR (1922), Association of Realist Artists (1927). Worked in the Murava Potters' Studio. Honored artist of the Russian Soviet Federated Socialist Republic. Painted portraits; sculpted; designed architecture, furniture, interiors.

**Portrait of the Artist
Alexandr Vladimirovich
Grigoriev** 1923

Oil on canvas

27 1/4 x 31 1/2 in.

69.0 x 80.0 cm

Signed and dated upper left:
SM 1923

The State Tretyakov Gallery,
Moscow (Zh.S.-186)

Acquired in 1960 from the artist

This portrait of Alexandr Vladimirovich Grigoriev (1891–1961), first chairman of the Association of Artists of Revolutionary Russia (AKhRR), is part of Maliutin's series depicting leaders of Soviet art and culture.

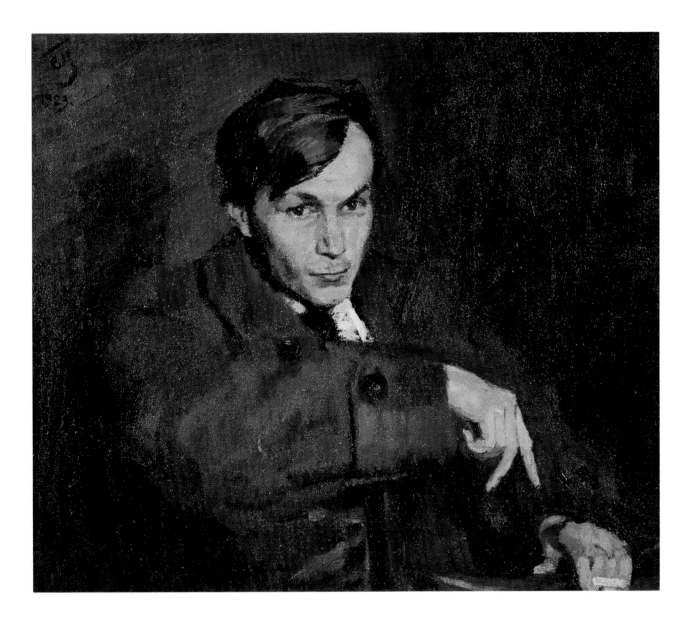

ILIA IVANOVICH MASHKOV

Born 1881 Mikhailovka—died 1944 Moscow

Studied at Moscow School of Painting, Sculpture, and Architecture with Abram Arkhipov, Konstantin Korovin, Valentin Serov (1900–1909). Taught privately (Moscow, 1904–17) and at Svomas and Vkhutein (1918–30). Exhibited with the group the Jack of Diamonds (Moscow, 1910) and Mir iskusstva (1911–17, intermittently). Joined AKhRR (1924). Headed the Central Studio of the AKhRR (1925–29). Honored artist of the Russian Soviet Federated Socialist Republic (1928). Painted landscapes, portraits, still lifes.

Portrait of a Boy in an Embroidered Shirt 1909

Oil on canvas

47 1/8 x 31 1/2 in.

119.5 x 80.0 cm

Signed upper left: Ilia Mashkov

The State Russian Museum, Leningrad (Zh.B.-1499)

Acquired in 1926 from the Museum of Artistic Culture

Like other members of the Jack of Diamonds group, Mashkov rarely turned to portraiture. This early painting is characterized by stylized imagery, exaggerated forms, and expressive colors. Extraordinarily bright hues arranged in contrasting clusters and broad brushstrokes are typical Jack of Diamond features, which are found in Mashkov's paintings.

160

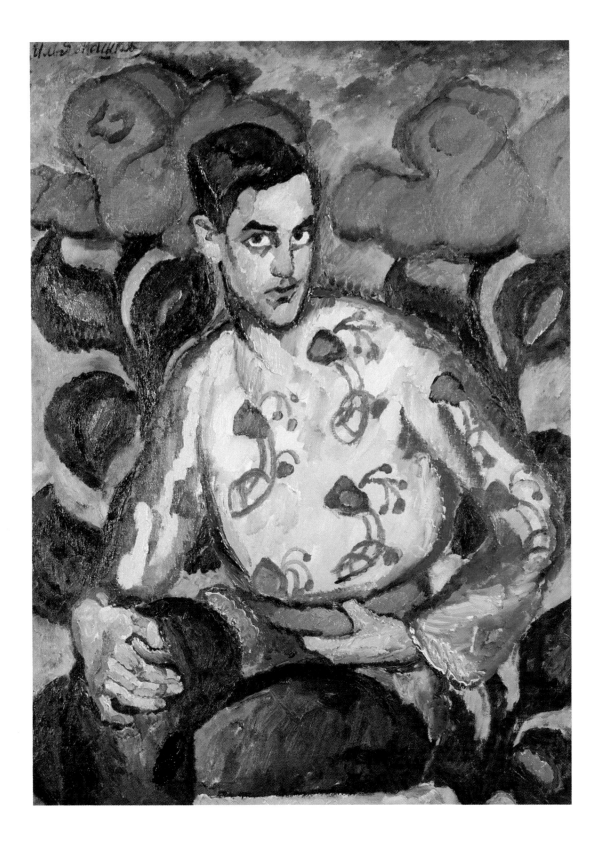

Still Life with Samovar 1919

Oil on canvas

56 x 70 7/8 in.

142.0 x 180.0 cm

The State Russian Museum, Leningrad (Zh.B.-1729)

Acquired in 1920 from the Visual Arts Department of the People's Commissariat for Enlightenment

Mashkov's creative aspirations found their fullest realization in the still-life genre. Although his early work is characterized by bold color juxtapositions and stylized forms, he would later turn to classical techniques, using minute, dense brushstrokes.

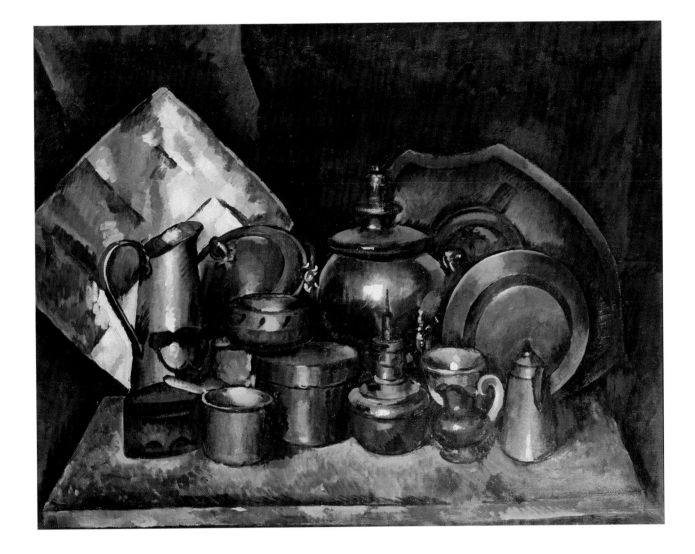

MIKHAIL VASILIEVICH MATIUSHIN

Born 1861 Nizhni Novgorod—died 1934 Leningrad

Attended Conservatory of Music (Moscow, 1876–81). Violinist with the Court Orchestra (Saint Petersburg, 1881–1913). Studied at the School of the Society for the Encouragement of the Arts (Saint Petersburg, 1914–18) and Zvantseva School of Art with Mstislav Dobuzhinsky and Lev Bakst (Saint Petersburg). Taught at Pegoskhuma and Vkhutein (1918–26). Headed Studio of Spatial Realism at Svomas (Petrograd). Exhibited with the Union of Youth (Saint Petersburg, 1910). Founded the group Zorved ("See-Know"; 1919–26). Lived in Finland (1913). Headed Research Department of Organic Culture at Inkhuk (Petrograd, from 1922). Wrote *The Rules and Variability of Color Combinations: A Color Primer* (1932). Active as a painter, graphic artist, composer, musician, critic, theorist.

Movement in Space 1922 (?)

Oil on canvas

48 7/8 x 66 1/4 in.

124.0 x 168.0 cm

Signed lower right: M.M.

The State Russian Museum, Leningrad (Zh.B.-996)

Acquired in 1926 from the Museum of Artistic Culture

The programmatic painting *Movement in Space* illustrates Matiushin's ideas about color perception. To arrive at his theories regarding the relationships between the environment and color, including the impact of sound on color perception, Matiushin constructed models based on geometry, mathematics, and organic chemistry.

164

VASILII NIKITICH MESHKOV

Born 1867 Ylets—died 1946 Moscow

Studied at Moscow School of Painting, Sculpture, and Architecture with Vasilii Polenov (1882–89). Taught in his own art school (from late 1880s). Exhibited with the Society of Art Lovers, Circle of the Itinerants (1892), AKhRR (1922). Honored artist of the Russian Soviet Federated Socialist Republic.

Portrait of Semion Mikhailovich Budenny 1927

Oil on canvas

53 5/8 x 38 5/8 in.

136.0 x 98.0 cm

Signed and dated lower right:
V. N. Meshkov. 1927

The State Tretyakov Gallery, Moscow (28039)

Acquired in 1937 from the artist

Semion Mikhailovich Budenny (1883–1973) was a Soviet military leader who commanded the First Cavalry during the civil war and would later command the southern front during World War II. In his left hand he holds a saber awarded to him in 1919 for combat against the White Guard.

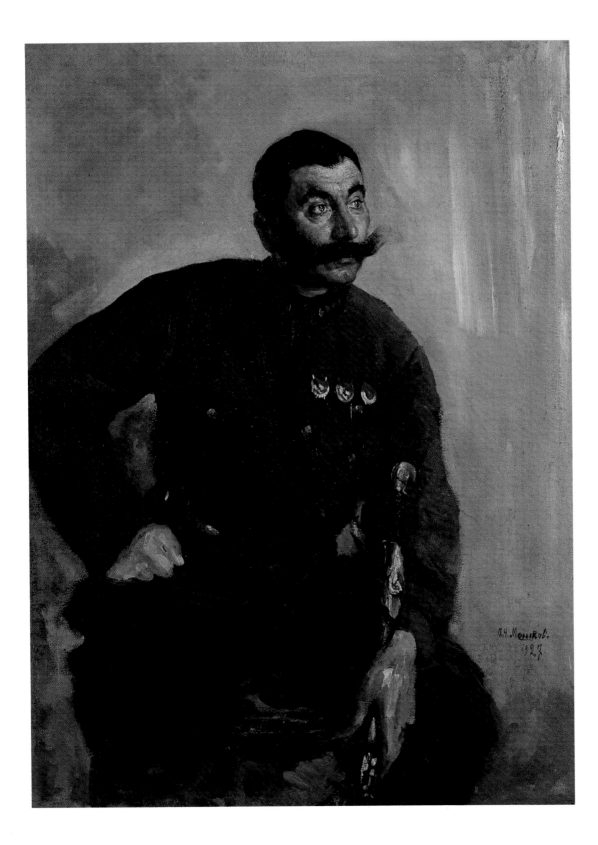

MIKHAIL VASILIEVICH NESTEROV

Born 1862 Ufa—died 1942 Moscow

Studied at Moscow School of Painting, Sculpture, and Architecture (1877–86, intermittently) and Saint Petersburg Academy of the Arts (1881–84). Lived in Kiev and Moscow. Exhibited with the Union of Russian Artists, Circle of the Itinerants (1896), World of Art (Moscow, 1899), Thirty-six Artists (1901). Honored artist of the Russian Soviet Federated Socialist Republic (1942). Painted genre scenes, landscapes, portraits.

Portrait of Ekaterina Petrovna Nesterova, Wife of the Artist 1905

Oil on canvas

56 1/8 x 42 1/2 in.

142.5 x 107.8 cm

Signed lower right:
Mikh. Nesterov. 1905

The State Tretyakov Gallery, Moscow (8870)

Acquired in 1927 from the artist

Nesterov began painting portraits in the mid-1900s, after long years of working on monumental church paintings. Here he portrayed his second wife in their Kiev apartment. In this painting Nesterov delighted in depicting domestic details: the vase of flowers, photographs on the table, and the painting *Sentimental Stroll* by Alexandre Benois.

168

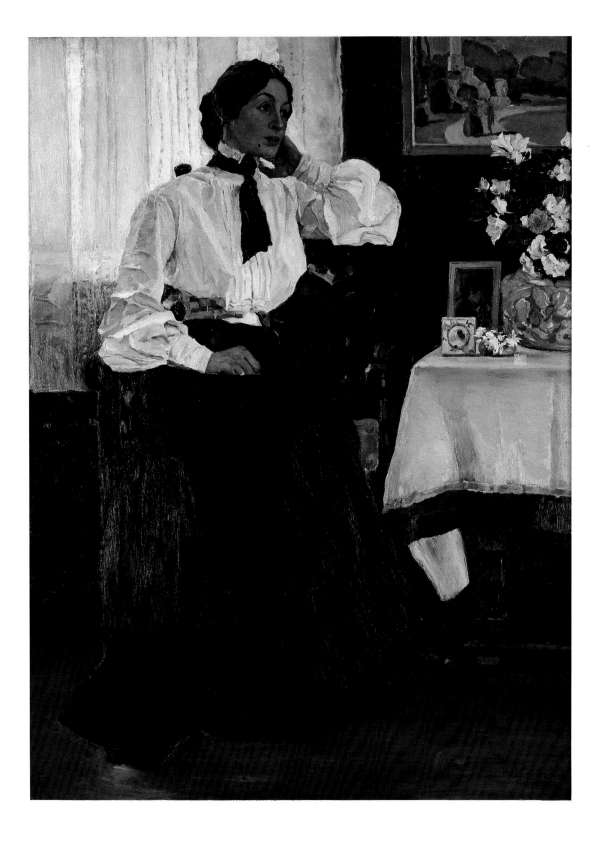

ALEXANDR ALEXANDROVICH OSMERKIN

Born 1892 Elisavetgrad (present-day Kirovograd)—died 1953 Moscow

Studied at Kiev School of Art (1909–11) and with Ilia Mashkov (Moscow, 1913–15). Exhibited with the groups the Jack of Diamonds (Moscow, 1914), Mir iskusstva (1917), Being (1926), Wing (1927). Taught at Svomas, Vkhutemas, Vkhutein (1918–30), All-Russian Academy of the Arts (Leningrad, 1932–47). Designed stage sets (Moscow and Leningrad). Painted landscapes, portraits, still lifes.

Lady with Lorgnette 1917

Oil on canvas

45 3/4 x 35 7/8 in.

116.0 x 91.0 cm

Signed and dated upper left:
A. Osmerkin, 917

The State Russian Museum, Leningrad (Zh.-8541)

Acquired in 1969 from N. G. Osmerkina

Osmerkin's creative evolution is to a large extent characteristic of the development of those of his generation who were developing a new language of painting. Emerging from the influence of Paul Cézanne and Cubism, Osmerkin sought to forge his own style.

Lady with Lorgnette is typical of his early work. It is a portrait of Ida Iakovlevna Khvas (1892–1945), a Moscow concert pianist and supporter of the Jack of Diamonds group.

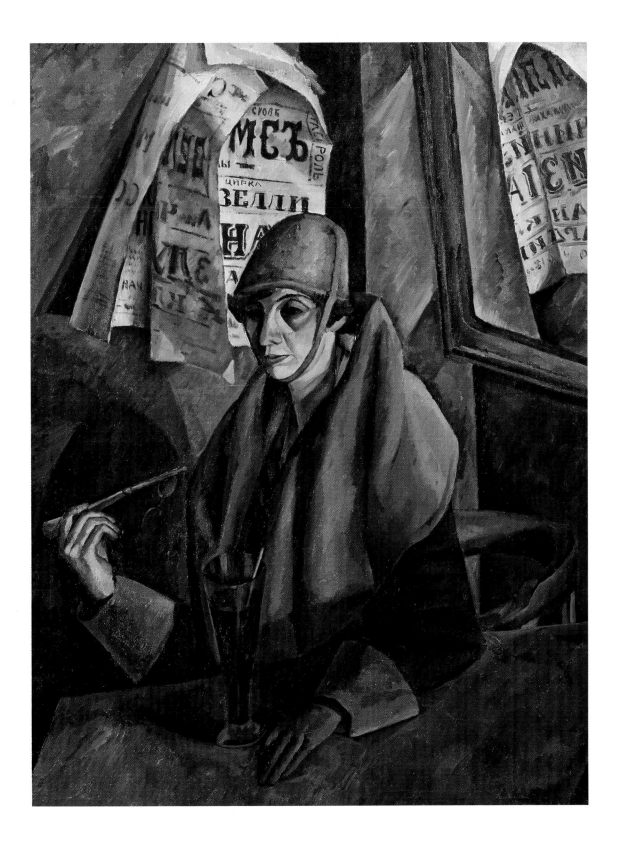

KUZMA SERGEEVICH PETROV-VODKIN

Born 1878 Khvalynsk—died 1939 Leningrad

Studied in Samara (1893–95) and Saint Petersburg (1895–97); at Moscow School of Painting, Sculpture, and Architecture with Abram Arkhipov and Valentin Serov (1897–1905); with Anton Ažbé (Munich, 1901); privately (Paris, 1906–8). Exhibited with the Union of Russian Artists (1909–10), Golden Fleece (1909–10), World of Art (1911–24), AKhRR (1923, 1928), Four Arts Society (1925–29) and in solo exhibitions (Saint Petersburg/Leningrad, 1909, 1936–37, 1947, 1966, 1978; Moscow, 1937, 1966; Prague, Bucharest, Sofia, 1967; Warsaw and Budapest, 1971). Taught at Zvantseva School of Art (Saint Petersburg, 1910–15), Svomas (Petrograd, 1918–21), All-Russian Academy of the Arts (Leningrad, 1921–38). First chairman of the board of the Leningrad Department, USSR Artists Union. Honored artist of the Russian Soviet Federated Socialist Republic. Painted historical and revolutionary scenes, portraits, still lifes, landscapes.

The Shore 1908

Oil on canvas

50 1/2 x 62 5/8 in.

128.0 x 159.0 cm

Signed bottom left:
Petroff-Vodkine 1908

The State Russian Museum, Leningrad (Zh.B.-1249)

Acquired in 1934 from
E. L. Bazilevich

The Shore was painted in Paris. Characterized by a strict rhythmic composition, precise design, and monumentality, it is typical of Petrov-Vodkin's early Symbolist works. During the first years of his career his interest in the art of the early Renaissance was combined with a preoccupation with the paintings of Puvis de Chavannes.

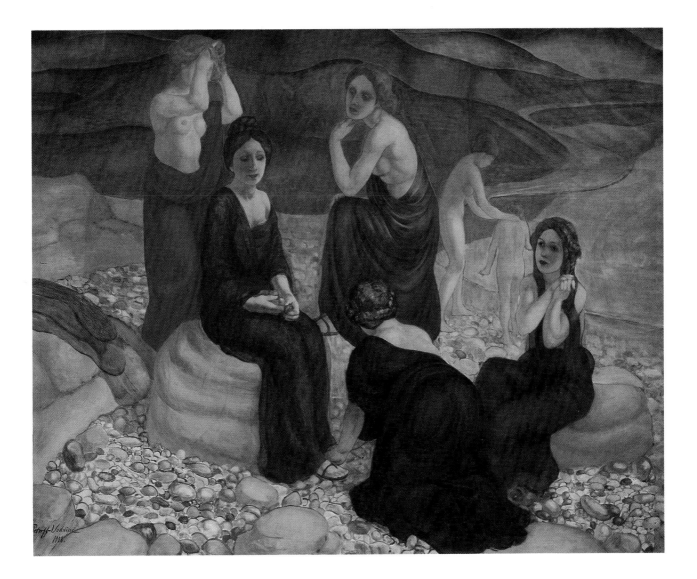

YURII IVANOVICH PIMENOV

Born 1903 Moscow—died 1977 Moscow

Studied at Vkhutemas with Sergei Maliutin (1920–25). Exhibited with OST (1925) and Arts Brigade (1931). Honored artist of the Russian Soviet Federated Socialist Republic and active member of the USSR Academy of Arts. Awarded the Lenin Prize and USSR State Prize.

Girls with a Ball 1929

Oil on canvas

62 5/8 x 40 1/4 in.

159.0 x 102.0 cm

Signed and dated: P. Yu. Moscow 1929

The State Tretyakov Gallery, Moscow (22572)

Acquired in 1932 from the artist

Images of athletes were among the most popular subjects for members of the Society of Easel Painters (OST).

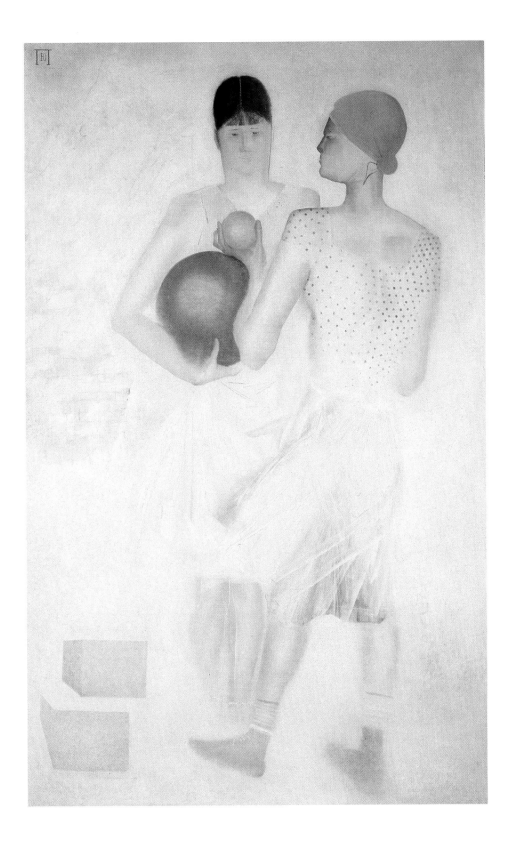

NIKOLAI ASLANOVICH PIROSMANASHVILI (Niko Pirosmani)

Born 1862 Mirzani—died 1918 Tbilisi

Self-taught. Lived in Tbilisi. Contributed to the exhibition *The Target* (Moscow, 1913). Worked for small shopkeepers and tavern owners, decorating walls and painting signs. Painted animal scenes, landscapes, still lifes.

Prince with Drinking Horn 1909

Oil on canvas

45 3/4 x 37 in.

116.0 x 94.0 cm

The State Russian Museum, Leningrad (Zh.B.-1605)

Acquired in 1930 from the State Tretyakov Gallery

Pirosmanashvili's unified painterly system is original, unlike the detailed, realistic paintings of most naive artists. Usually prepared on black oilcloth, Pirosmani's compositions are static and monumental, the colors laconic and precise in accordance with the artist's lofty ideals regarding the world and society. *Prince with Drinking Horn* as well as his other paintings displays the strong influence of contemporary photography.

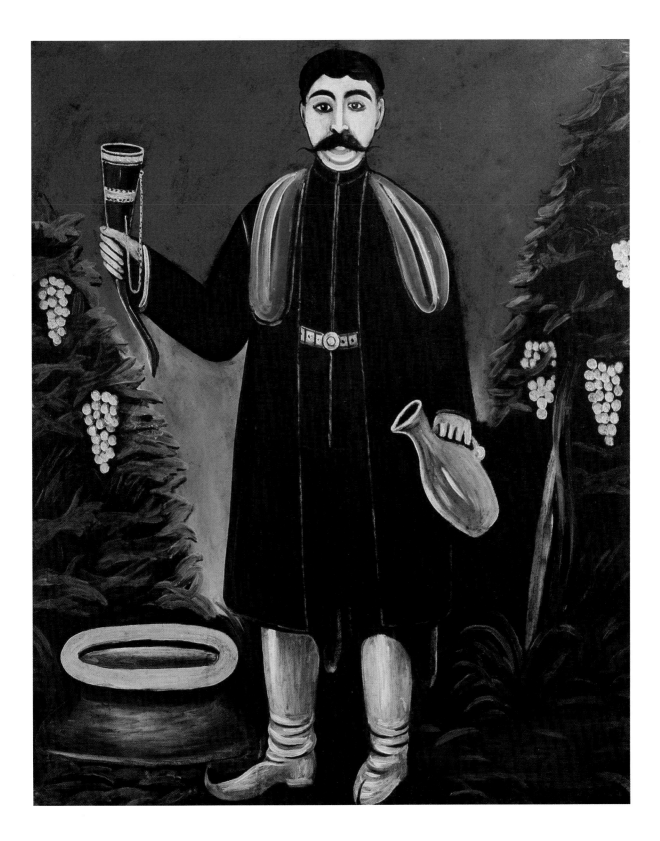

LIUBOV SERGEEVNA POPOVA

Born 1889 Ivanovskoye—died 1924 Moscow

Studied with Stanslav Zhukovsky and Konstantin Yuon (Moscow, 1907–8) and at Jean Metzinger's studio La Palette with Henri LeFauconnier (Paris, 1912–13). Visited Italy; greatly impressed by Giotto frescoes (1910). Worked with Vladimir Tatlin, Viktor Bart, Kirill Zdanevich (1912). Visited France and Italy (1914). Exhibited with the group the Jack of Diamonds (Moscow, 1915). Taught at Svomas (1918) and Vkhutemas (from 1921). Member of the Visual Arts Department of the People's Commissariat for Enlightenment (1918) and Inkhuk (1920). Signed a declaration with other artists rejecting easel painting and embracing Industrial Constructivism (1921).

Two Figures 1913

Oil on canvas

63 1/2 x 48 1/2 in.

161.0 x 123.0 cm

The State Tretyakov Gallery, Moscow (P.-46734)

Acquired in 1977 from George D. Costakis as a gift to the USSR Picture Gallery

This work characterizes the closeness of Russian and French Cubist painting and particularly reflects the influence of Albert Gleizes and Jean Metzinger. In the movement of the geometrized shapes male and female forms can be discerned as well as certain still-life details.

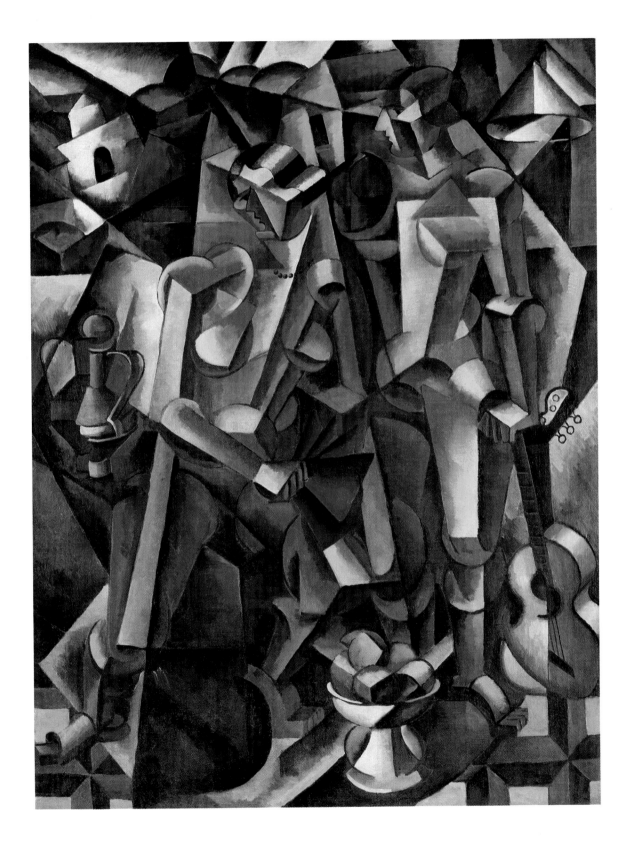

Objects 1915

Oil on canvas

24 x 17 1/2 in.

61.0 x 44.5 cm

Signed and inscribed on subframe:
L. Popova "Predmety" [Objects]
1915 Novinskii b. 117

The State Russian Museum,
Leningrad (Zh.B.-1636)

Acquired in 1926 from the
Museum of Artistic Culture

The artist's paintings from
1914–16 are classic examples of
Russian Cubo-Futurism, which
arose from the blending of two
essentially hostile trends: French
Cubism and Italian Futurism. In
this painting Popova's choice of
objects is significant. Among
them can be distinguished a gui-
tar, a favorite element in modern-
ist French painting and often
found in the early Cubist works of
Braque and Picasso, who exerted a
strong influence on Popova.

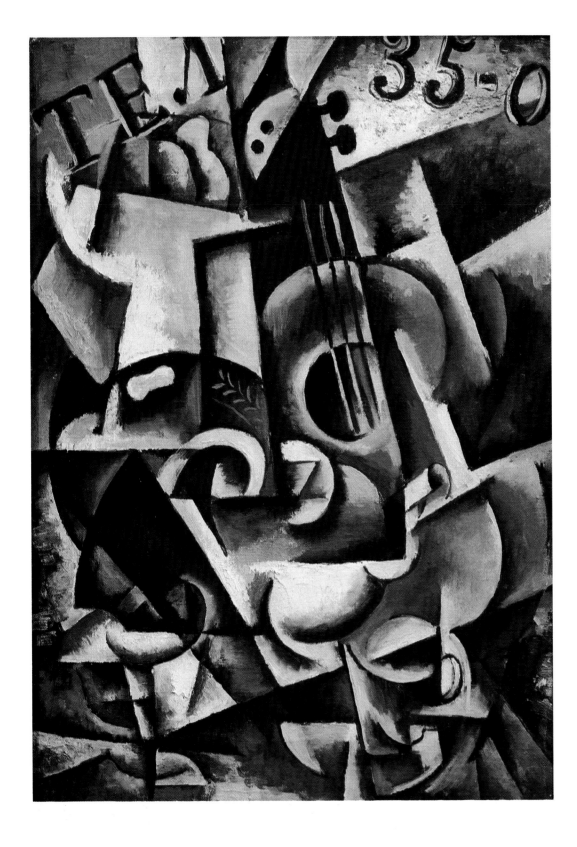

Dynamic Structure 1919

Recto and verso illustrated
Recto

Oil on canvas

62 5/8 x 48 7/8 in.

159.0 x 124.0 cm

The State Tretyakov Gallery,
Moscow (P.-46735)

Acquired in 1977 from George D.
Costakis as a gift to the USSR
Picture Gallery

While her early Cubist works
retain a link to pictorial realism,
by 1915–16, influenced by
Kazimir Malevich, Popova turned
to nonobjective art. Her absorp-
tion in purely artistic experiments
is reflected in the titles of her
paintings: *Artistic Structural
Design, Dynamic Structure, Power
Structure, Space.*

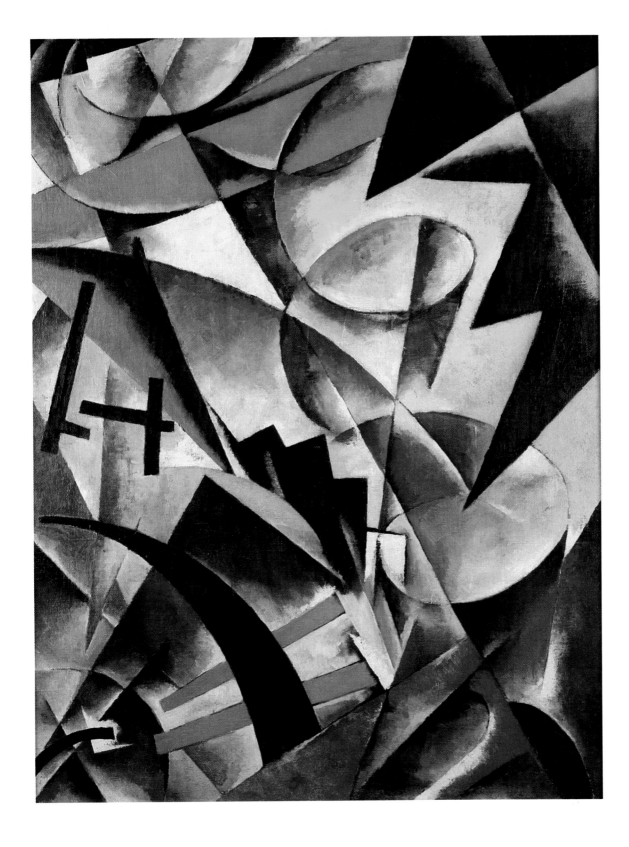

Dynamic Structure 1919

Verso

Oil on canvas

62 5/8 x 48 7/8 in.

159.0 x 124.0 cm

The State Tretyakov Gallery,
Moscow (P.-46735)

Acquired in 1977 from George D.
Costakis as a gift to the USSR
Picture Gallery

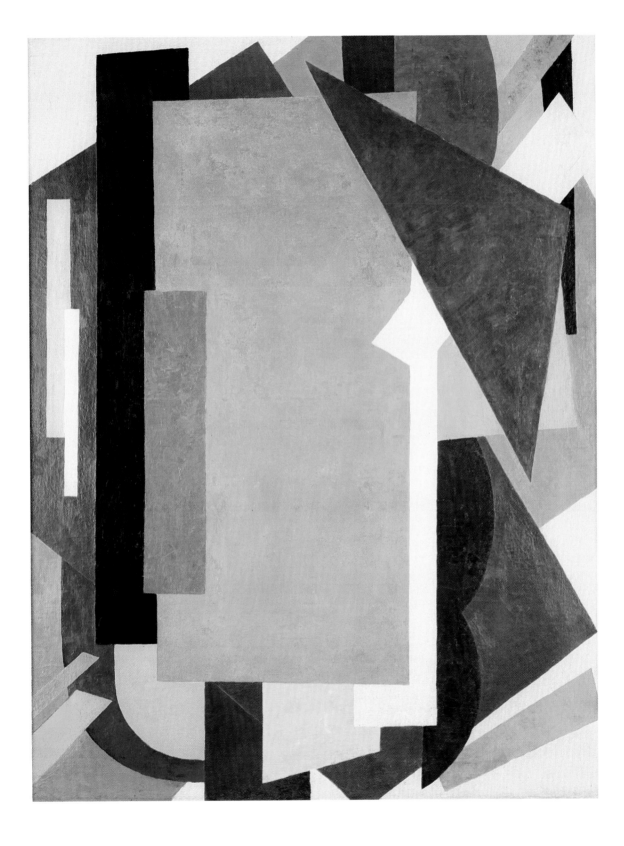

IVAN ALBERTOVICH PUNI (Jean Pougny)

Born 1894 Finland—died 1956 Paris

Studied with Ilia Repin and at the Académie Julien (Paris, 1909–10). Taught at Pegoskhuma (1918) and Vitebsk Practical Art Institute with Marc Chagall. Exhibited with the groups the Union of Youth (Saint Petersburg, 1912–13), Jack of Diamonds (Moscow, 1916–17), Four Arts Society (1928) and at the Salon des Indépendants (Paris, 1913–14). Coorganized the exhibitions *Tramway V* (Petrograd, 1915) and *0.10* (Petrograd, 1915–16). With Kazimir Malevich, Ivan Kliun, and Kseniia Boguslavskaia prepared Futurist manifesto (1915–16). Organized decorations for the first-anniversary celebration of the October Revolution (Petrograd, 1918). Lived and worked in Saint Petersburg, Vitebsk (1919), Finland (1919–20), Berlin (1920–23), Paris (from 1923). Painted nonobjective compositions, portraits, still lifes.

Still Life with Bottle and Red Book 1914–15

Oil on canvas

26 7/8 x 21 1/4 in.

68.0 x 54.0 cm

Signed and dated lower right: 1912 Iv. Puni

The State Russian Museum, Leningrad (Zh.B.1644)

Acquired in 1920 from the artist

This still life combines the direct vividness of works produced by the Jack of Diamonds group with the characteristic Cubo-Futurist fragmentation of forms and shifted object contours.

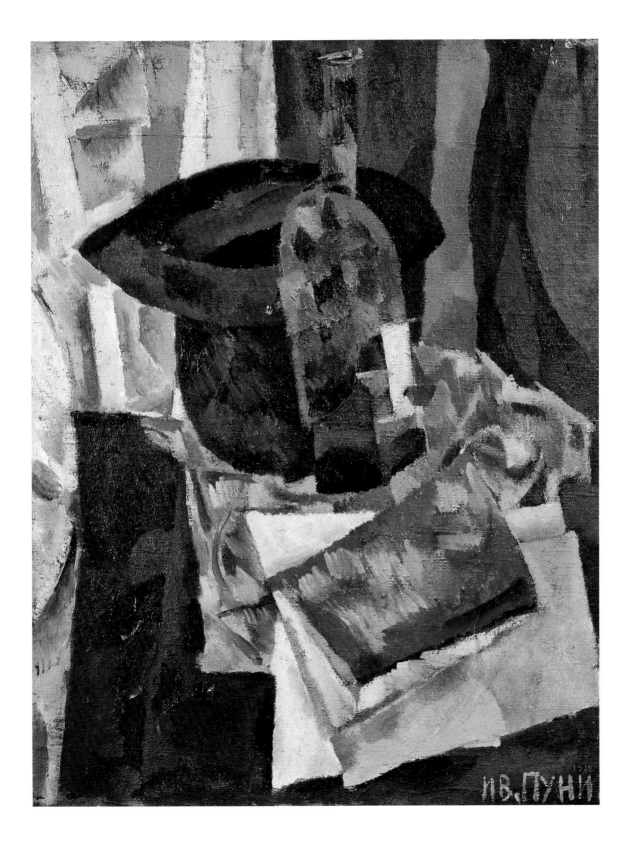

**Still Life with Letters
(Spectrum Flight)** 1919

Oil on canvas

50 x 48 7/8 in.

127.0 x 124.0 cm

Signed and dated lower right:
I [?]. Puni 1919 [?]

The State Russian Museum,
Leningrad (Zh.B.-2074)

Acquired in 1926 from the
Museum of Artistic Culture

The expressive lettering of this
image reveals the relationship
between the meaning of a word
and its plastic metaphor. For
example, in the word *flight* the
letters chaotically fly across the
canvas surface, while in the word
spectrum the letters grow out of
the painting like a widening
stream of light.

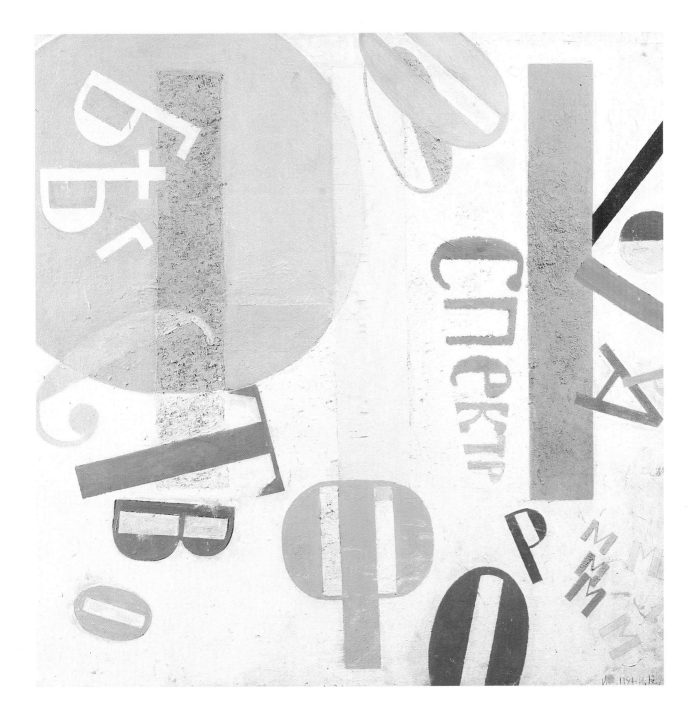

KLIMENT NIKOLAEVICH REDKO

Born 1897 Chelm, Poland—died 1965 Moscow

Studied icon painting at Kiev-Pechersky Monastery (1910–14), School of the Society for the Encouragement of the Arts (Petrograd, 1914–19), Pegoskhuma (1920–22). Sent to France by the People's Commissariat for Enlightenment (1926–36). Taught at the USSR Academy of Architecture (1950).

Husband and Wife 1922

Oil on canvas

26 3/4 x 12 7/8 in.

67.7 x 32.6 cm

The State Tretyakov Gallery, Moscow (P.-46851)

Acquired in 1977 from George D. Costakis as a gift to the USSR Picture Gallery

Redko was interested in depicting scenes from everyday life. In this painting he presents a prismatic image of a married couple.

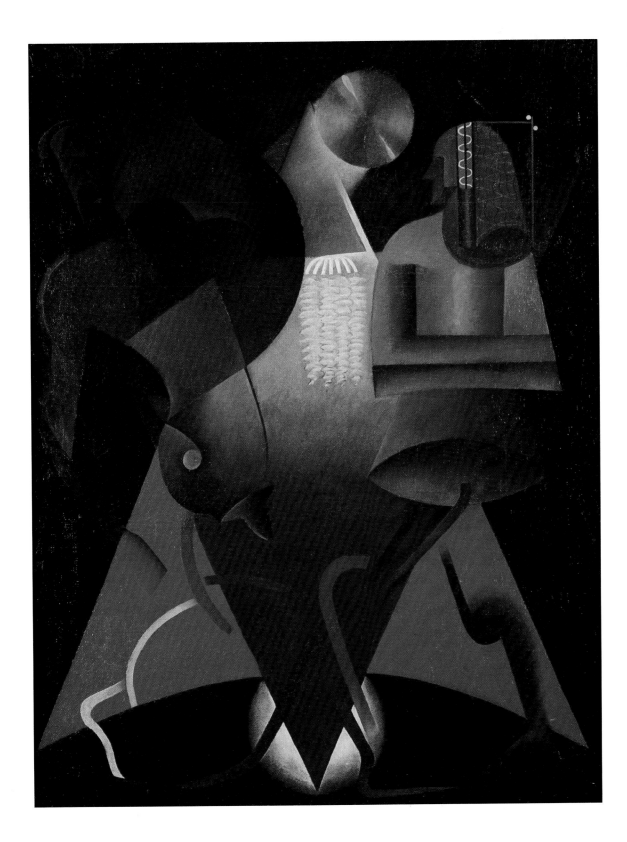

ALEXANDR MIKHAILOVICH RODCHENKO

Born 1891 Saint Petersburg—died 1956 Moscow

Studied at Kazan Art School with Nikolai Feshin (1910–14) and Stroganov Art School (Moscow, 1914–17). Contributed to Vladimir Tatlin's exhibition *The Store* (Moscow, 1916) and the exhibitions *5 x 5 = 25* (Moscow, 1921), *Exposition internationale des arts décoratifs et industriels modernes* (Paris, 1925), *Ten Years of Soviet Photography* (1928). Member of the Visual Arts Department of the People's Commissariat for Enlightenment. Headed the Museum Bureau and Museum of Artistic Culture (Moscow, 1917–18). Taught at Moscow Proletkult (1918), Vkhutemas, Vkhutein (painting, wood- and metalwork; 1920–30); Polygraphic Institute (photography; Moscow, 1932). Exhibited with the Society of Young Artists (Moscow, 1920–21) and October Photographic Association. Member of the Initiative Group involved in organizing Inkhuk (1920–24). Board member of the Association of Photojournalists (1928). Designed sets for Vsevolod Meierkhold's staging of Vladimir Maiakovsky's play *The Bedbug* (1929). Lived and worked in Saint Petersburg, Kazan, Ocher, Perm (1941–42), Moscow. Active as a photographer, painter, designer.

Nonobjective 1918

Oil on canvas

28 x 20 1/2 in.

71.0 x 52.0 cm

Signed and dated verso: Rodchenko 1918

The State Russian Museum, Leningrad (Zh.B.-1376)

Acquired in 1926 from the Museum of Artistic Culture

This work is a striking example of Rodchenko's experimental painting. His innovative spatial interpretations would later influence the development of modern design and architecture. Exploring the limits of the painterly medium, Rodchenko sought to arrive at an abstract interpretation, irrelevant of space, texture, and color.

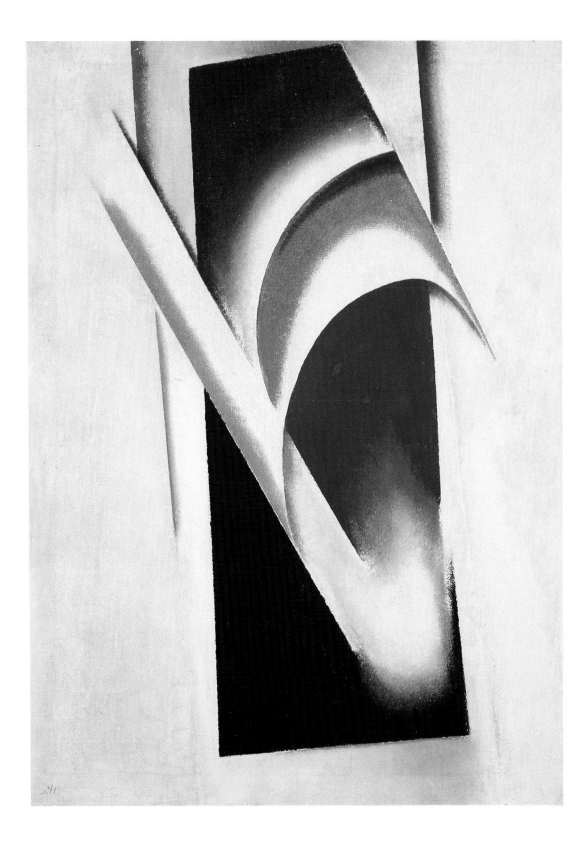

**Nonobjective:
Density and Weight** 1918

Oil on canvas

48 1/8 x 28 3/4 in.

122.0 x 73.0 cm

The State Tretyakov Gallery,
Moscow (9390)

In an era of industrial revolution
and optimism regarding the poss-
ibilities of modern technology, the
leaders of the avant-garde studied
certain aspects of the material
world, including durability, flex-
ibility, density, and weight, which
had previously not been included
in artistic considerations.

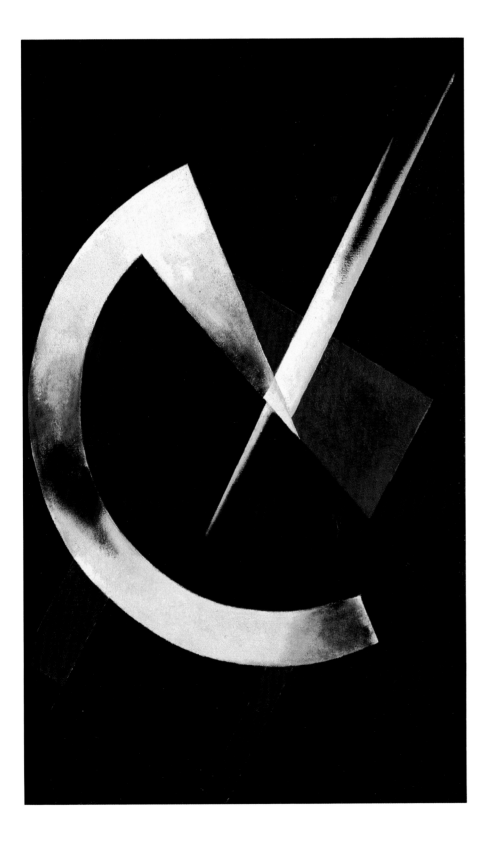

NICHOLAS STEPANOVICH ROERICH

Born 1874 Saint Petersburg—died 1947 India

Studied at the Saint Petersburg Academy of the Arts with Aarkhip Kuindzhi (1893–97) and with Ferdinand Cormon (Paris, 1901). Exhibited with the Union of Russian Artists (1903) and Mir iskusstva (1910) and at the Salon d'automne (1906). Headed the School of the Society for the Encouragement of the Arts (Saint Petersburg, 1906–18). Graduated from the Law School of Saint Petersburg University. Exhibited in Russia and abroad, including America (1920–23). Lived in Saint Petersburg, Finland, America, India (from 1923). Undertook a research trip to Central Asia (1925–28). Proposed the International Pact for Protecting Monuments of Culture (during World War II). Painted historical and mythological scenes and landscapes; designed stage designs; active as a journalist.

Guests from across the Sea 1902

Study for *Guests from across the Sea,* 1901 (State Tretyakov Gallery)

Oil on board

31 1/8 x 39 3/8 in.

79.0 x 100.0 cm

Signed and dated lower right: N. Roerich 1902

The State Russian Museum, Leningrad (Zh.-1974)

Acquired in 1927 from the State Museum Collection

While still a student Roerich planned a monumental series tracing the origins of his country. The painting *Guests from across the Sea* is part of this series. It depicts a flotilla of Vikings sailing in brightly painted boats to Constantinople. The canvas incorporates elements of folk art, evident in the simplified forms and intense colors, and is one of Roerich's finest paintings.

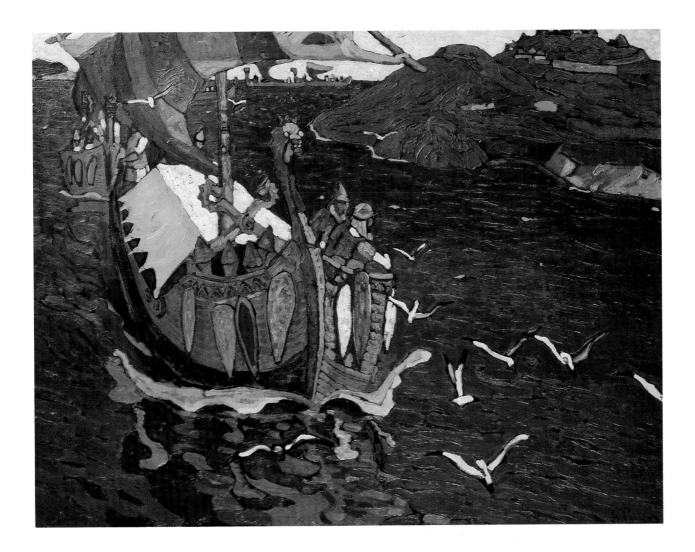

OLGA VLADIMIROVNA ROZANOVA

Born 1886 present-day Vladimir Oblast—died 1918 Moscow

Studied at the Bolshaov Art College with Konstantin Yuon, Stroganov Art School (Moscow, 1904–10), Zvantseva School of Art (Saint Petersburg, 1912–13). Secretary of the *Supremus* editorial board. Illustrated and designed Futurist books and almanacs (from 1912). Exhibited with the groups the Union of Youth (Saint Petersburg, 1912–14) and Jack of Diamonds (Moscow). Contributed to the *International Exhibition of Free Futurists* (Rome, 1914), *Tramway V* (Petrograd, 1915), *0.10* (Petrograd, 1915–16), *The Store* (Moscow, 1916). Designed decorations for the first-anniversary celebrations of the October Revolution (Moscow, 1918). Board member of Visual Arts Department of the People's Commissariat for Enlightenment (1918). Active as a painter, designer, poet, theorist.

Metronome 1915

Oil on canvas

18 1/8 x 13 in.

46.0 x 33.0 cm

The State Tretyakov Gallery, Moscow (11943)

Acquired in 1929 from the Museum of Artistic Culture

In this painting Rozanova re-combined elements of the metronome in a seemingly arbitrary arrangement. Conveying the measured, isolating rhythm of the pendulum was the artist's primary task. The dynamism of the form, which is subjected to this rhythm, is interrupted by the names of various countries.

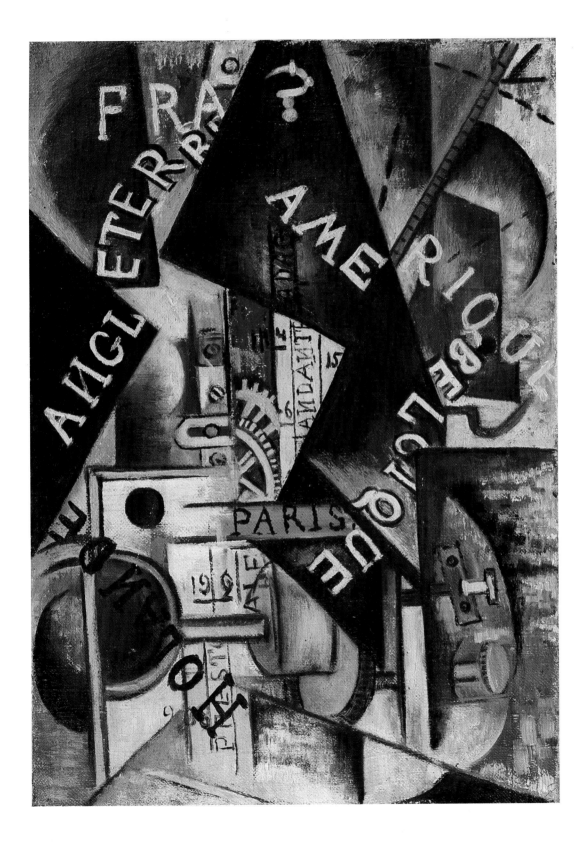

Sideboard with Dishes 1915

Oil on canvas

25 1/4 x 17 3/4 in.

64.0 x 45.0 cm

The State Tretyakov Gallery, Moscow (11941)

Acquired in 1929 from the Museum of Artistic Culture

Rozanova's depiction of tangible elements is not modified by her use of simplified forms and decorative distribution of images. The painting recalls trompe l'oeil canvases in which various objects, usually fastened to a board or door, are depicted with great realism to deceive the viewer.

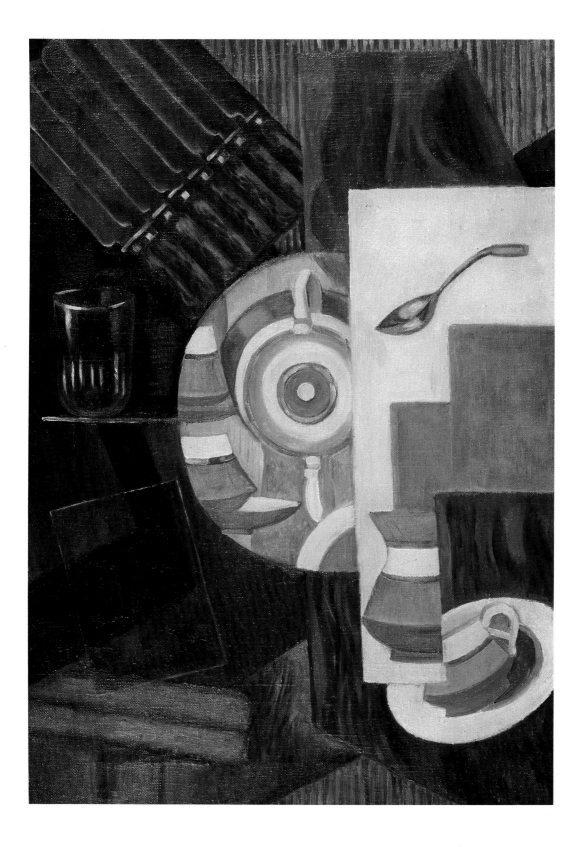

**Four Aces: Simultaneous
Composition** 1915–16

From the series Playing Cards

Oil on canvas

33 1/2 x 26 5/8 in.

85.0 x 67.5 cm

The State Russian Museum,
Leningrad (Zh.B.-1455)

Acquired in 1926 from the
Museum of Artistic Culture

According to the catalog of
Rozanova's posthumous exhibi-
tion, the series Playing Cards
included no less than twelve
paintings. *Four Aces* expresses
Rozanova's individualistic
interpretation of Suprematist
principles. Unlike other Suprema-
tists, Rozanova often included
concrete objects and symbols in
her compositions. The playing
cards, a traditional motif for
Romantic artists, here served as a
starting point for the artist's
creation of a "new reality," a
universe of detached harmony
imbued with an inner dynamism.

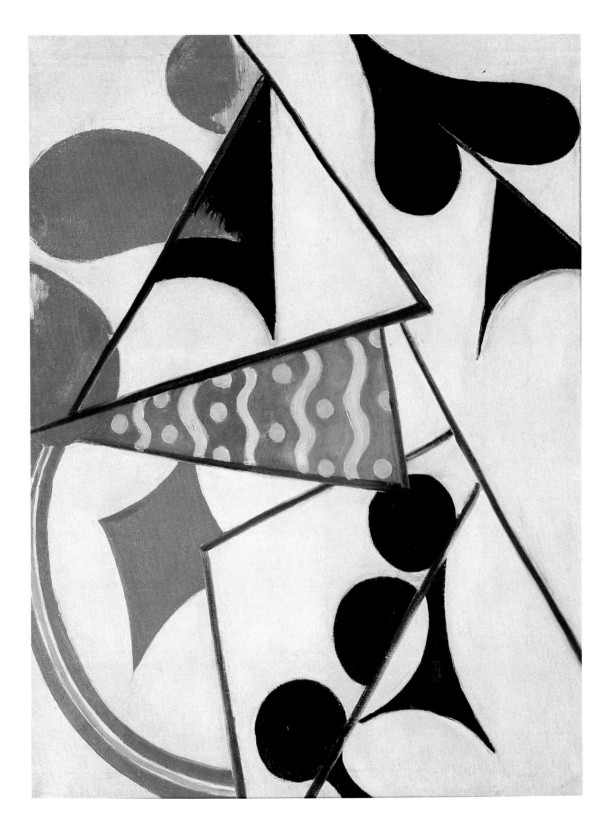

VASILII VASILIEVICH ROZHDESTVENSKY

Born 1884 Tula—died 1963 Moscow

Studied at Moscow School of Painting, Sculpture, and Architecture with Konstantin Korovin and Valentin Serov (1900–1910). Visited Austria and Italy (1912). Exhibited with the groups the Jack of Diamonds (Moscow), World of Art (1917–22), AKhRR (1926), Society of Artists (Moscow, 1927–29). Taught at Vkhutemas (1920) and in Udomlya. Painted landscapes, portraits, still lifes.

Still Life with Liqueur 1913

Oil on canvas

33 1/2 x 25 5/8 in.

85.0 x 65.0 cm

Signed and dated lower left:
V. Rozhdestvensky 1913

The State Tretyakov Gallery, Moscow (17380)

Acquired in 1928 from the Museum of Artistic Culture

Like other artists of the group the Jack of Diamonds, Rozhdestvensky paid tribute to still-life painting. For followers of Cézanne, this genre was especially important because it permitted them to concentrate on the image itself and the purely painting problems associated with it—color, form, composition, and texture.

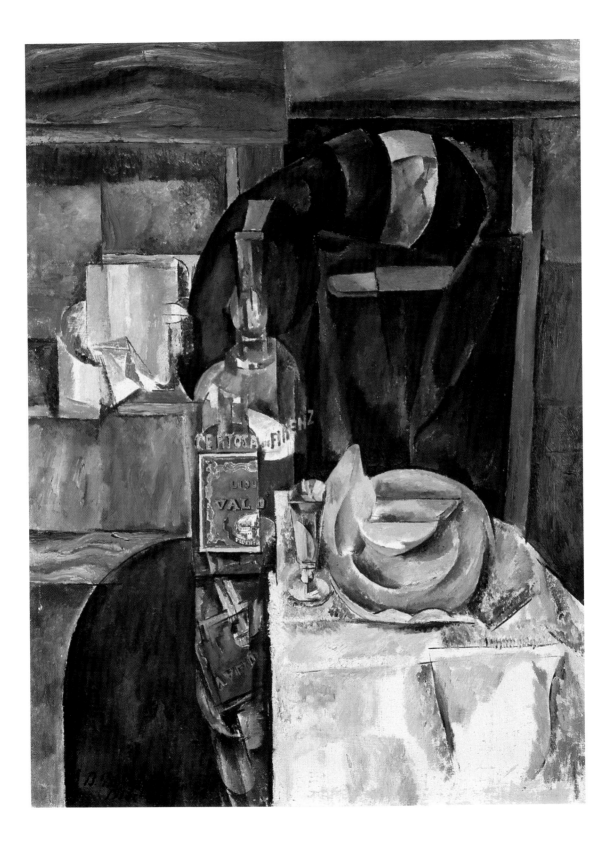

MARTIROS SERGEEVICH SARIAN

Born 1880 Nakhichevan-on-the-Don—died 1972 Yerevan

Studied at Moscow School of Painting, Sculpture, and Architecture with Konstantin Korovin and Valentin Serov (1897–1904). Exhibited with the groups the Blue Rose (1907), Golden Fleece (Moscow, 1907–9), World of Art (1910–16), Union of Russian Artists (1910–11), Four Arts Society (1925–28). Lived and worked in Nakhichevan-on-the-Don, Moscow, Tbilisi (1915), Yerevan (from 1921). Cofounded the Armenian Technical School of Arts and Museum (1920s). Contributed to a major exhibition of Russian and Soviet art (Berlin, 1922). Hero of Socialist Labor, People's Artist of the USSR, member of the Academy of the Arts. Awarded the Lenin Prize and USSR State Prize. Painted landscapes, still lifes, portraits.

The Old and the Newest 1929

Oil on canvas

25 1/2 x 63 7/8 in.

64.5 x 162.0 cm

Signed and dated lower right:
M. Sarian 1929

Inscribed verso: M. Sarian 1929.
The Old and the Newest.

The State Russian Museum,
Leningrad (Zh.-2001)

Acquired in the 1930s from the artist

The Old and the Newest is one of Sarian's many landscapes dating to the 1920s and 1930s, depicting, with particular warmth and love, the nooks and crannies, picturesque streets and yards of old Yerevan, an Armenian village. The composition is broken up into individual narratives that describe a single theme. The old, clinging to traditional ways of life, is compared with the new, symbolized by a group of Young Pioneers on the march.

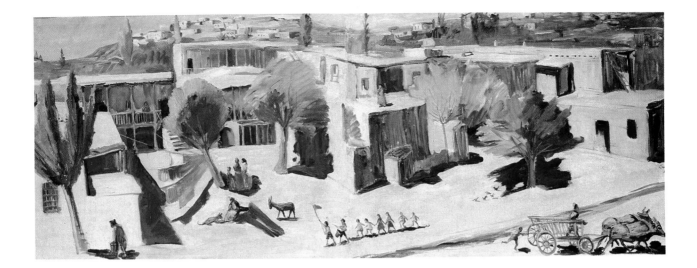

ZINAIDA EVGENYEVNA SEREBRIAKOVA

Born 1884 near Kharkov—died 1967 Paris

Studied in Saint Petersburg (1903–5) and Paris (1905). Exhibited with the Union of Russian Artists (1910) and World of Art (1910, 1912–13, 1915–16). Contributed to the exhibitions *The Modern Female Portrait* (1910), *Soviet Art* (Tokyo, 1926–27), *Russian Art from Antiquity to the Present* (Brussels, 1928). Lived in Saint Petersburg, Kharkov (1918–20), Paris (from 1924). Painted decorative panels, genre scenes, landscapes, portraits, still lifes.

Bath House 1912

Study for *Bath House,* 1913 (State Russian Museum)

Oil on canvas

40 1/4 x 32 1/2 in.

102.0 x 82.5 cm

Signed and dated lower left: 1912 Serebriakova

The State Russian Museum, Leningrad (Zh.-1909)

Acquired in 1946 from E. B. Serebriakov, the artist's son

Serebriakova was interested in evoking the plasticity of the female body, capturing its varied postures and movements. In this sketch the artist displays painstaking attention to chiaroscuro and the rendering of smooth, curved lines. The work captivates with its poetic imagery, careful depiction, harmonious imagery, and classic clarity.

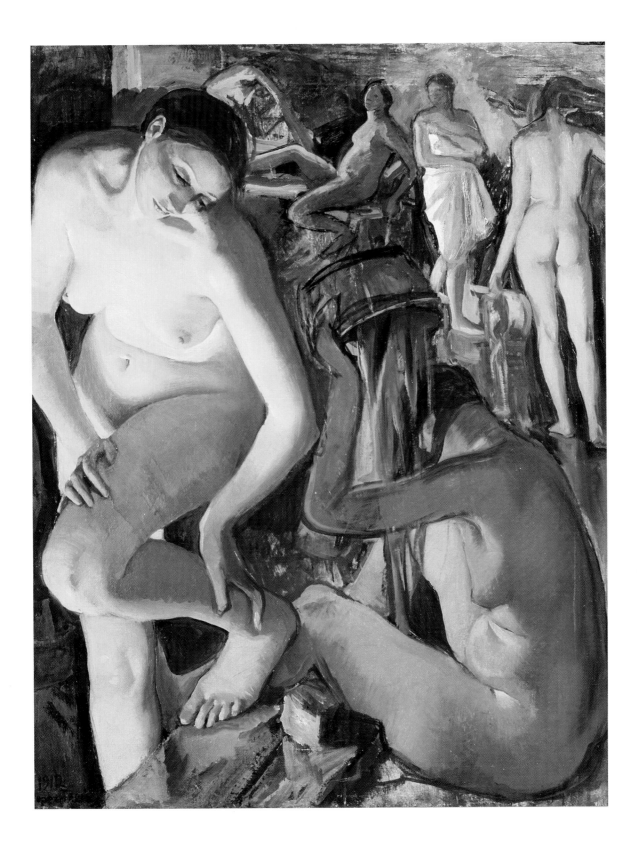

ALEXANDR VASILIEVICH SHEVCHENKO

Born 1883 Kharkov—died 1948 Moscow

Studied in Kharkov (1890s) and at the Stroganov Art School with Konstantin Korovin and Mikhail Vrubel (Moscow, 1899–1905), Académie Julien (Paris, 1905–6), Moscow School of Painting, Sculpture, and Architecture (1907–10). Exhibited with the groups the World of Art (1904–13, 1917, 1921), Moscow Cooperative of Artists (1908–16), Donkey's Tail (Moscow, 1912), Union of Youth (Saint Petersburg, 1912), Makovets (1922, 1925), Painters' Guild (1926, 1930), Society of Moscow Artists (1928–29). Contributed to the exhibitions *The Target* (Moscow, 1913) and *No. 4* (Moscow, 1914). Taught at Svomas, Vkhutemas, Vkhutein (Moscow, 1918–29), Ukrainian Academy of Arts (1921), Proletarian Arts Institute (Leningrad, 1930), Stroganov Art School (Moscow), Moscow Textile Institute (from 1940). Painted genre scenes, landscapes, portraits, still lifes.

Woman Ironing 1920

Oil on canvas

37 x 32 1/2 in.

94.0 x 82.5 cm

Signed and dated lower left:
ASh / 20

The State Russian Museum, Leningrad (Zh.-8225)

Acquired in 1966 from T. A. Shevchenko, the artist's daughter

Woman Ironing testifies to the strong influence on Shevchenko's work of the French school as well as traditional Russian art. In this painting Shevchenko created a stylized image evincing traits of monumentality to disclose the beauty and poetry of daily endeavors.

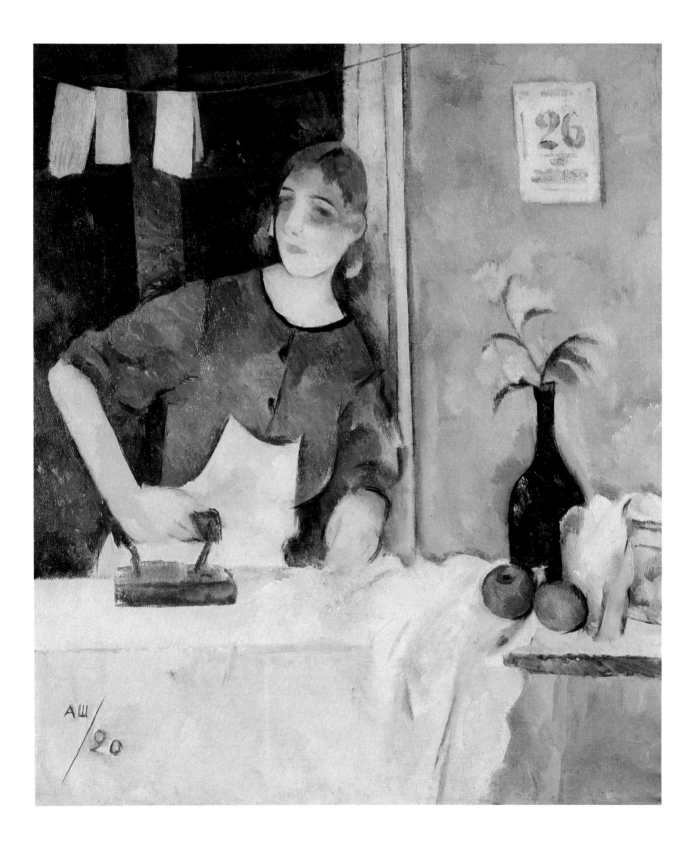

DAVID PETROVICH SHTERENBERG

Born 1881 Zhitomir—died 1948 Moscow

Studied in Paris (1906–12). Chief of the Visual Arts Department of the People's Commissariat for Enlightenment (1918–20). Organizer and chairman of OST (1925–30). Taught at Vkhutemas and Vkhutein (1929–30). With Natan Altman and Marc Chagall contributed to the *Exhibition of the Three*. Honored artist of the Russian Soviet Federated Socialist Republic.

Still Life with Herring 1918

Oil on wood

21 3/4 x 24 5/8 in.

55.0 x 62.5 cm

Signed lower left: D. Shterenberg

The State Tretyakov Gallery, Moscow (11920)

This painting is an expressive symbol of the period immediately after the Socialist Revolution. A loaf of bread and a pair of herring represent the scanty diet of the people during those difficult years. The tabletop and the objects placed upon it, torn from a typical interior, float on an abstract background. The objects thus focus all the attention on themselves, which increases their symbolic meaning.

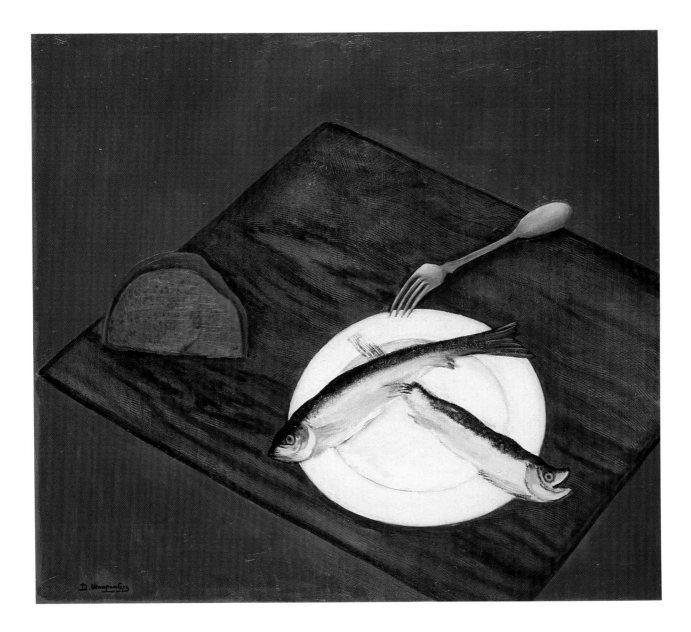

Still Life with Cherries 1919

Oil on canvas

26 3/8 x 26 3/8 in.

67.0 x 67.0 cm

Signed lower left: D. Shterenberg

The State Russian Museum,
Leningrad (Zh.B.-1540)

Still Life with Cherries is striking
for its simplicity and composi-
tional clarity. The table circumfer-
ence is cut off by the lower-right
corner of the painting, enhancing
the dynamic effect of the composi-
tional shift. Shterenberg concen-
trates on rendering the texture of
the objects. The artist's style
betrays a wide range of assimi-
lated traditions—from Neoprimi-
tivism (the dominant trend of the
time) to pictorial Constructivism
and the latest novelties of French
painting, absorbed and assimilated
to become organic to his art.

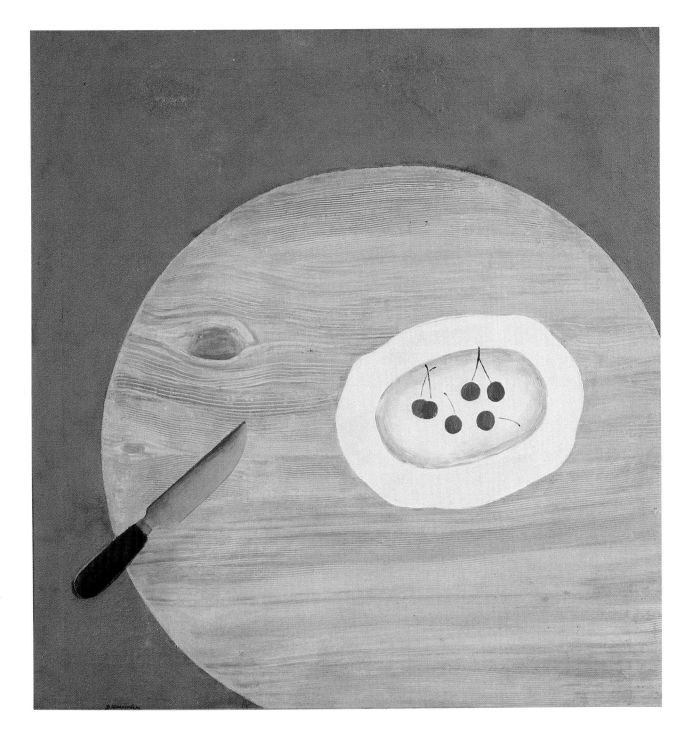

GEORGII AVGUSTOVICH STENBERG

Born 1900 Moscow—died 1933 Moscow

Studied at the Stroganov Art School (Moscow, 1912–17) and Svomas (Moscow, 1917–20). Exhibited with the Society of Young Artists (Moscow, 1919–21). Joined Inkhuk (1920). Co-founded the Constructivism Laboratory. Designed stage sets and costumes for Chamber Theater (Moscow, 1922–31). Contributed to the *Discussional Exhibition of Associations of Active Revolutionary Art* (Moscow, 1924). Awarded gold medal at the *Exposition internationale des arts décoratifs et industriels* (Paris, 1925) and prize at the Palace of the Soviets Architectural Project Competition (1932). Taught at the Architecture-Construction Institute (Moscow, 1929–32).

Crane 1920

Oil on canvas

28 x 35 1/8 in.

71.0 x 89.0 cm

Signed and dated lower right: Georgii Stenberg. 1920.

The State Russian Museum, Leningrad (Zh.B.-1440)

Acquired in 1926 from the Museum of Artistic Culture

The plastic treatment of the work exhibits Georgii's obsession with austere geometric forms. The schematic outlines of the figures and interior are integrated into a whole by his rigorous manipulation of color rhythms. The composition is imbued with an emotional intensity, achieved by the artist's talents as an original draftsman and colorist.

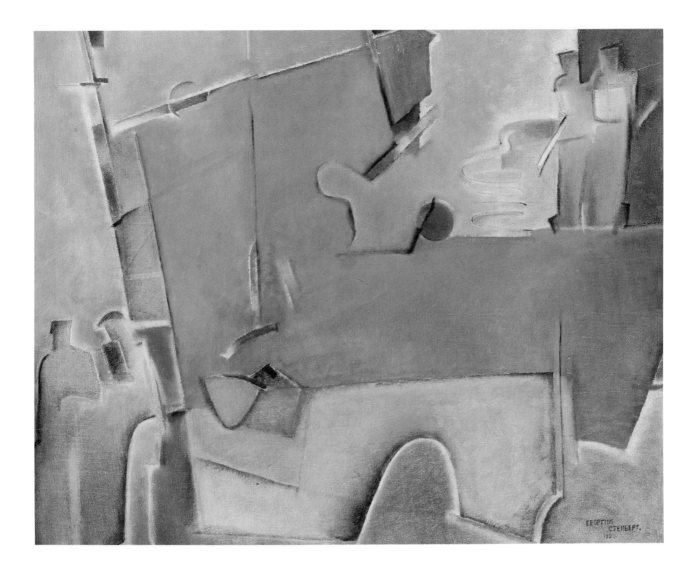

217

VLADIMIR AVGUSTOVICH STENBERG

Born 1899 Moscow—died 1982 Moscow

Studied at the Stroganov Art School (Moscow, 1912–17) and Svomas (Moscow, 1917–20). Exhibited with the Society of Young Artists (Moscow, 1919–21). Joined Inkhuk (1920). Cofounded the Constructivism Laboratory. Designed stage sets and costumes for Chamber Theater (Moscow, 1922–31). Contributed to the *Discussional Exhibition of Associations of Active Revolutionary Art* (Moscow, 1924). Awarded gold medal at the *Exposition internationale des arts décoratifs et industriels* (Paris, 1925) and prize at the Palace of the Soviets Architectural Project Competition (1932). Taught at the Architecture-Construction Institute (Moscow, 1929–32). Prepared decorations for the first-anniversary celebration of the October Revolution (Moscow, 1918) and designed railway and subway cars.

Color Construction #4 1920

Oil on canvas

29 5/8 x 15 1/4 in.

75.0 x 38.5 cm

Inscribed verso: V. Stenberg. 1920. *Color Construction #4 / 17 x 9*

The State Russian Museum, Leningrad (Zh.B.-1645)

Acquired in 1926 from the Museum of Artistic Culture

The easel paintings of Georgii and Vladimir Stenberg interpret in aesthetic terms architectural structures and technological forms. *Color Construction #4* faintly resembles a blueprint or map. Vladimir's experimental approach is expressed in the asymmetric composition, color dominants, and highly sophisticated brushwork.

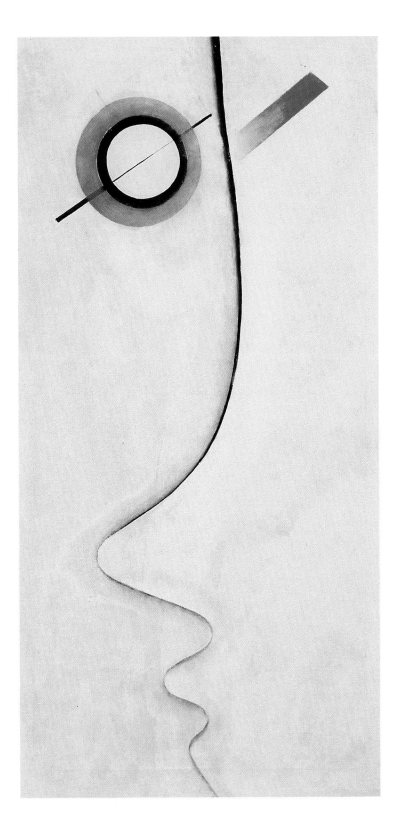

SERGEI YAKOVLEVICH SVETLOV

Born 1900 Moscow—died 1966 Moscow

Studied at the Central School of Technical Drawing (Moscow, 1911–18) and Svomas with Georgii Yakulov (1918–20). Taught at the Perslavl-Zalesski Art School, Mstera Artistic-Technical School, Architecture-Construction Institute (Moscow). Exhibited with the Society of Young Artists (Moscow, 1919–22). Active as a painter and designer.

Bridge 1921

Oil on canvas

27 1/4 x 39 1/2 in.

69.0 x 100.0 cm

Inscribed verso: Svetlov *Bridge*

The State Russian Museum, Leningrad (Zh.B.-1460)

Acquired in 1926 from the Museum of Artistic Culture

This work is imbued with symbolism: the emerging volcano represents liberation, the nude male signifies the strength of the new society, and the bridge—the contours of which emerge in the interconnected geometric planes—embodies the revolution as the link between the present and the future.

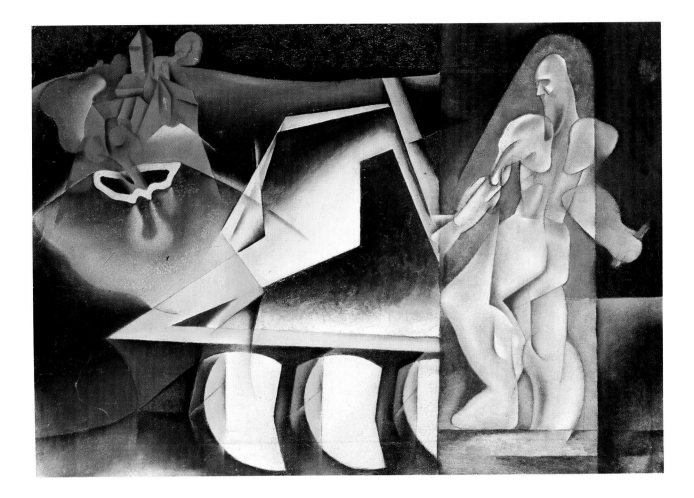

NIKOLAI BORISOVICH TERPSIKHOROV

Born 1890 Saint Petersburg—died 1960 Moscow

Studied with Konstantin Yuon (Moscow) and Vasilii Meshkov (1907–10) and at Moscow School of Painting, Sculpture, and Architecture with Konstantin Korovin (1911–17). Joined AKhRR (1922). Honored artist of the Russian Soviet Federated Socialist Republic.

The First Slogan 1924

Oil on canvas

34 3/4 x 40 5/8 in.

88.0 x 103.0 cm

Signed and dated lower left:
N. Terpsikhorov 24

The State Tretyakov Gallery,
Moscow (17366)

Acquired in 1934 from the artist

The painting depicts the Moscow studio of A. D. Korin. The ideological content and imagery of the work are much more powerful than that of traditional depictions of an artist's studio. *The First Slogan* is both monumental and lyrical, its narrative reverberating with the effects of revolutionary change. Standing among casts of classical sculptures, the artist is portrayed committing himself to the social struggle of his time.

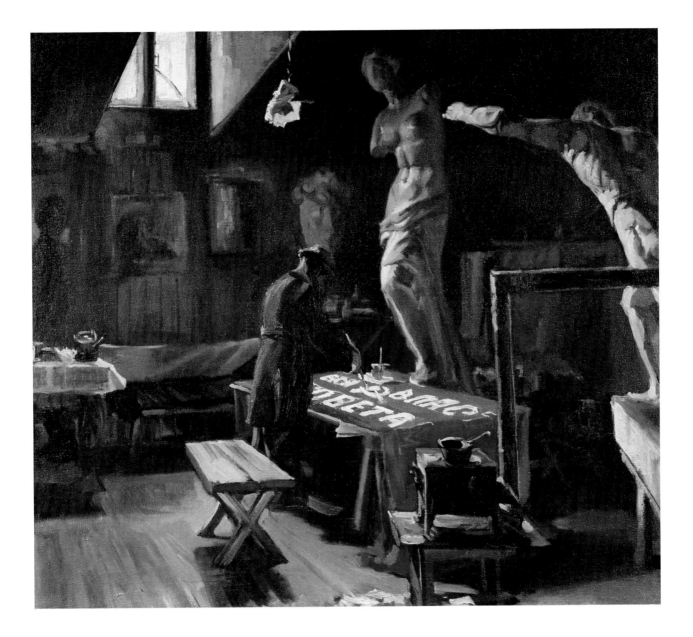

NADEZHDA ANDREEVNA UDALTSOVA

Born 1886 Orel—died 1961 Moscow

Studied with Konstantin Yuon (Moscow) and at Jean Metzinger's studio La Palette with Henri LeFauconnier and with Andre Dunoyer de Segonzac (Paris, 1912–13). Worked with Vladimir Tatlin. Member of the Visual Arts Department of the People's Commissariat for Enlightenment (1918) and Inkhuk. Taught at Svomas (1918), Vkhutemas, Vkhutein (1921–30).

Table at a Restaurant 1915

Study for *Restaurant,* 1915 (State Russian Museum)

Oil on canvas

28 x 20 7/8 in.

71.0 x 53.0 cm

The State Tretyakov Gallery, Moscow (11930)

Acquired in 1929 from the Museum of Artistic Culture

The early paintings of Udaltsova are in the mainstream of European Cubism. Although she freely restructured images on the canvas plane, the artist nevertheless retained representational elements in her work.

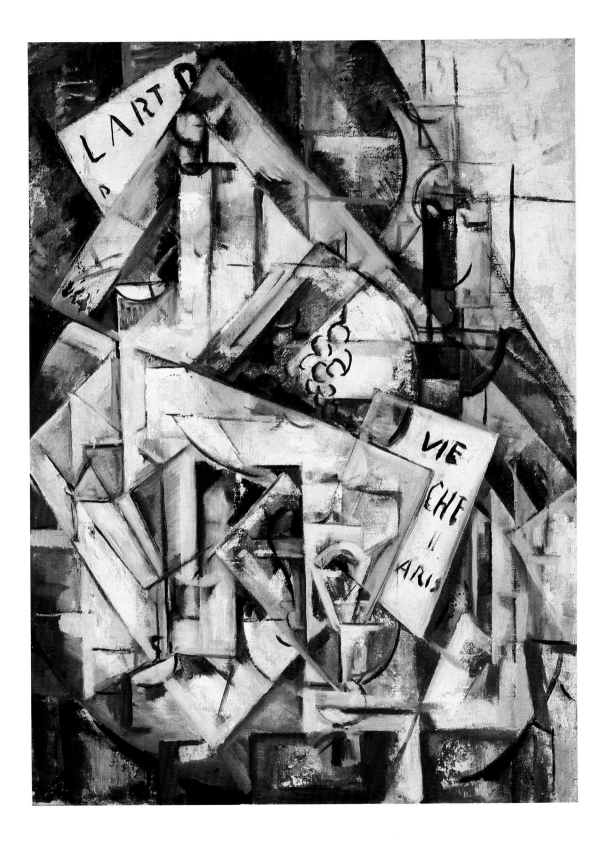

NIKOLAI PAVLOVICH ULIANOV

Born 1875 Ylets—died 1949 Moscow

Studied with Vasilii Meshkov (Moscow, 1888–89); at Moscow School of Painting, Sculpture, and Architecture (1889–1900); with Nikolai Ge and Valentin Serov (1899–1902). Taught at the Zvantseva School of Art (Saint Petersburg, 1901–7), Stroganov Art School (Moscow, 1915–18), Vkhutemas (1920–22), Moscow Art Institute (1942–45). Exhibited with the groups the Blue Rose (1907), World of Art, Four Arts Society. Honored artist of the Russian Soviet Federated Socialist Republic and corresponding member of the USSR Academy of Arts.

**Self-Portrait
with a Barber** 1914–23

Oil on canvas

40 5/8 x 57 7/8 in.

103.0 x 147.0 cm

Signed and dated lower left:
N. Ulian 1914–23

The State Tretyakov Gallery,
Moscow (Zh.S.-665)

Acquired in 1967 from
V. E. Ulianova

This self-portrait was painted when Ulianov was deeply influenced by Romanticism (at the time he was also illustrating the works of the German Romantic composer and writer E. T. A. Hoffmann). The artist was attracted by the effects of multiple reflections in a mirror and here described them in an enigmatic play of forms.

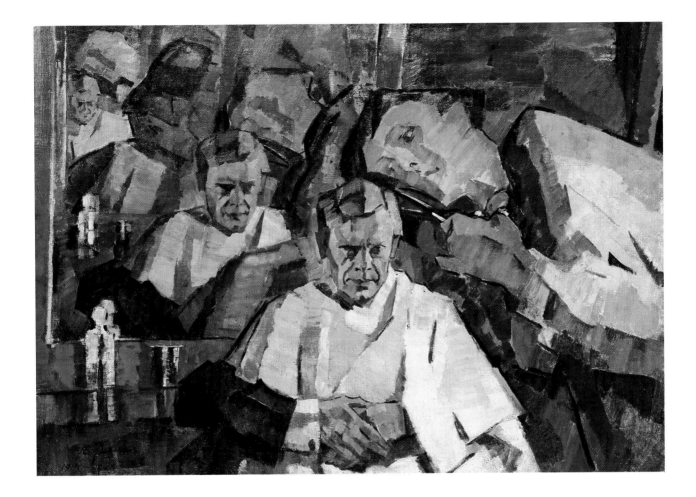

KONSTANTIN ALEXANDROVICH VIALOV

Born 1900 Moscow—died 1976 Moscow

Studied at the Stroganov Art School (Moscow, 1914–17), Svomas (1918–19), Vkhutemas with Vasilii Kandinsky and Alexei Morgunov (1920–24). Member of OST (1925–31). Honored Artist of the Russian Soviet Federated Socialist Republic.

A Militiaman 1923

Oil on canvas

42 1/8 x 34 7/8 in.

106.9 x 88.5 cm

The State Tretyakov Gallery, Moscow (20842)

Acquired in 1934 from the artist

The principal creative purpose for many representatives of the Association of Easel Painters (OST) was to memorialize the new Soviet way of life. Vialov's picture captures the image of a worker of the people's militia standing at his post.

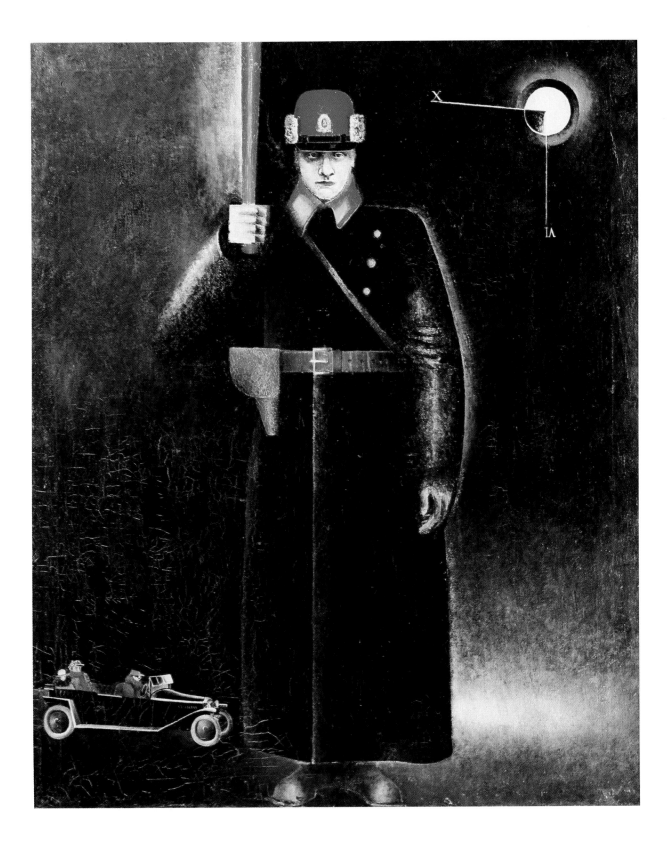

GEORGII BOGDANOVICH YAKULOV

Born 1882 Tbilisi—died 1928 Yerevan

Studied at Moscow School of Painting, Sculpture, and Architecture (1900–1902). Exhibited with the Society of Artists (Moscow, 1906–7, 1911), Wreath (1908), Union of Russian Artists (1908–9), World of Art (1911–17), Der Sturm (Berlin, 1913), Society of Young Artists (Moscow, 1919, 1921), Blue Rose (Moscow, 1925) and with the Secessionists (Vienna, 1909). Visited Italy (1910) and Paris (1913). Signed Futurist manifesto (1914). Staged performances for Chamber Theater (Moscow) and First State Theater (Yerevan, 1918). Taught at Svomas (1918–19). A juror of the *Exposition internationale des arts décoratifs et industriels modernes* (Paris, 1925). Performed in Sergei Prokofiev's ballet "The Steel Step" produced by Sergei Diaghilev (Paris, 1927). Painted genre scenes, landscapes, portraits; designed stage sets.

Bar 1910

Oil on canvas

26 x 39 7/8 in.

66.0 x 101.0 cm

The State Tretyakov Gallery, Moscow (10939)

Acquired in 1928 from the Museum of Artistic Culture

Like many of Yakulov's paintings, *Bar* brings to mind a flowery Eastern carpet. For the artist decorativeness and an "absence of a sensation of property, of the material nature of things" were organic to Eastern culture, to which he belonged by birth, while European realism and naturalism were alien to him as a "son of the East." He was, however, aware of the influences of contemporary French painting on his art but noted: "I moved from east to west, the Europeans are going from west to east, I from an ornamental tapestry toward the material expression of life, the Europeans from illustrative form toward the nonobjective and ornamental."

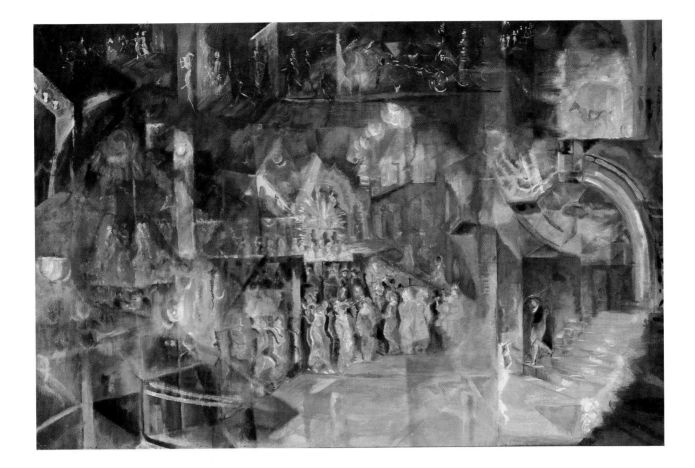

SELECT BIBLIOGRAPHY

Alpatov, Mikhail V. *Russian Impact on Art.* Edited by
 Martin L. Wolf. New York: Philosophical Library, 1950.
_____. *Art Treasures of Russia.* New York: Abrams, 1967.
_____. *Über westeuropäische und russische Kunst.* Dresden:
 VEB Verlag der Kunst, 1982.
Andersen, Troels. *Moderne Russisk Kunst, 1910–1930.*
 Copenhagen: Borgen, 1967.
An Exhibition of Works by Russian and Soviet Artists. Exh.
 cat. London: Royal Academy of Arts, 1959.
Art in Revolution: Soviet Art and Design since 1917. Exh.
 cat. London: Arts Council/Hayward Gallery, 1971.
*Art Treasures in Russia: Monuments, Masterpieces, Commis-
 sions, and Collections.* Introduction by Dmitri
 Obolensky. New York: McGraw-Hill, 1970.
The Avant-garde in Russia, 1910–1930: New Perspectives.
 Exh. cat. Edited by Stephanie Barron and Maurice
 Tuchman. Los Angeles: Los Angeles County Museum
 of Art, 1980.
Bakst Centenary, 1876–1976. Exh. cat. London: Fine Art
 Society, 1976.
Billington, James H. *The Icon and the Axe: An Interpretive
 History of Russian Culture.* New York: Knopf, 1966.
Bird, Alan. *A History of Russian Painting.* Oxford:
 Phaidon, 1987.
Bojko, Szymon. *New Graphic Design in Revolutionary
 Russia.* New York: Praeger, 1972.
Bowlt, John E. "Alexandra Exter: A Veritable Amazon of the
 Russian Avant-garde." *Artnews* 73 (September 1974):
 41–43.
_____. "From Surface to Space: The Art of Liubov Popova."
 The Structurist 15–16 (1975–76): 80–88.
_____. *Russian Art, 1875–1975: A Collection of Essays.*
 New York: Manuscript Information Company, 1976.
_____. *The Silver Age: Russian Art of the Early Twentieth
 Century and the 'World of Art' Group.* Newtonville,
 Mass.: Oriental Research Partners, 1979.
Bowlt, John E., and Rose-Carol Washton Long. *The Life of
 Vasilii Kandinsky in Russian Art: A Study of "On the
 Spiritual in Art."* Newtonville, Mass.: Oriental Re-
 search Partners, 1980.

Chamot, Mary. *Russian Painting and Sculpture*. Oxford and London: Pergamon, 1963.

Chan-Magomedow, S. *Pioniere der sowjetischen Architektura*. Dresden: VEB Verlag der Kunst, 1983.

Companion to Russian Studies: An Introduction to Russian Art and Architecture. Edited by Robert Auty and Dmitri Obolensky. Cambridge: Cambridge University Press, 1980.

Compton, Susan. *The World Backwards: Russian Futurist Books, 1912–16*. London: British Library, 1978.

"Constructivism and the Geometric Tradition." *Nelson-Atkins Museum of Art Bulletin* 5 (October 1982). Special issue edited by Ellen R. Goheen.

David Burliuk: Fifty-five Years of Painting. Exh. cat. Long Beach, Calif.: Lido Galleries, 1962.

Die Kunstismen in Russland, 1907–30/The Isms of Art in Russia 1907–30. Exh. cat. Introduction and biographies by John E. Bowlt. Cologne: Galerie Gmurzynska, 1977.

Doria, Charles. *Russian Samizdat Art*. New York: Willis Locker & Owens, 1986.

Douglas, Charlotte. "Colors without Objects: Russian Color Theories (1908–1932)." *The Structurist* 13–14 (1973–74): 30–41.

Elliott, David. *New Worlds: Russian Art and Society, 1900–1937*. London: Thames & Hudson, 1986.

Gassner, Hubertus, and Gillen Eckhart. *Zwischen Revolutionskunst und sozialistischen Realismus: Dokumenta und Kommentare. Kunstdebatten in der Sowjetunion von 1917 bis 1934*. Cologne: DuMont, 1979.

Gray, Camilla. *The Russian Experiment in Art, 1863–1922*. London: Thames & Hudson, 1970. Originally published as *The Great Experiment: Russian Art, 1863–1922*. New York: Abrams, 1962.

Guerman, Mikhail, comp. *Art of the October Revolution*. Translated by W. Freeman, D. Saunders, and C. Binns. New York: Abrams, 1979.

Hamilton, George Heard. *The Art and Architecture of Russia*. 2d ed. Baltimore: Penguin, 1977.

Harrison, Gail. *Constructivism & Futurism: Russian & Other: Ex Libris 6*. New York: T. J. Art, 1977.

Hilton, Alison. "The Revolutionary Theme in Russian Realism." In *Art and Architecture in the Service of Politics.* Edited by Henry Millon and Linda Nochlin. Cambridge, Mass.: MIT Press, 1978.

Ivan Vasilievich Kliun, Sketchbook, circa 1916–1927. Exh. cat. New York: Matignon Gallery, 1983.

James, C. V. *Soviet Socialist Realism: Origins and Theory.* London: Macmillan, 1973.

Janecek, Gerald. *The Look of Russian Literature: Avant-garde Experiments, 1900–1930.* Princeton: Princeton University Press, 1984.

The Journal of Decorative and Propaganda Arts 5 (1987). Special issue devoted to Russian design, 1880–1980, edited by John E. Bowlt.

Journey into Non-Objectivity: The Graphic Work of Kazimir Malevich and Other Members of the Russian Avant-garde. Exh. cat. Dallas: Dallas Museum of Fine Arts, 1980.

Kean, Beverly Whitney. *All the Empty Palaces: The Merchant Patrons of Modern Art in Pre-Revolutionary Russia.* New York: Universe, 1983.

Kennedy, Janet. *The "Mir iskusstva" Group and Russian Art, 1898–1912.* New York: Garland, 1977.

Khan-Magomedov, Selim O. *Rodchenko: The Complete Work.* Cambridge: MIT Press, 1987.

Korotkevich, E. Yu., and E. A. Uspenskaia. *Russian and Soviet Painting.* Exh. cat. Introduction by Dmitrii Vladimirovich Sarabianov. Translated by John E. Bowlt. New York: Metropolitan Museum of Art, 1977.

Künstlerinnen der russischen Avantgarde, 1910–1930/Russian Women-Artists of the Avantgarde, 1910–1930. Exh. cat. Cologne: Galerie Gmurzynska, 1979.

Larionov-Gontcharova Retrospective. Exh. cat. Brussels: Musée d'Ixelles, 1976.

Livshits, Benedikt. *The One and a Half-Eyed Archer.* Newtonville, Mass.: Oriental Research Partners, 1977.

Lodder, Christina A. *Russian Constructivism.* New Haven: Yale University Press, 1983.

Malevitch. Exh. cat. Paris: Centre Georges Pompidou, 1978.

Marcadé, Valentine. *Le renouveau de l'art pictural russe.* Lausanne: L'Age d'homme, 1971.

Marc Chagall: Retrospective de l'oeuvre peint. Exh. cat. Saint-Paul-de-Vence: Fondation Maeght, 1984.

Markov, Vladimir. *Russian Futurism: A History.* Berkeley: University of California Press, 1968.

Martiros Saryan: Paintings, Watercolors, Drawings, Book Illustrations, Theatrical Design. Leningrad: Aurora Art Publishers, 1988.

Massie, Suzanne. *Land of the Firebird: The Beauty of Old Russia.* New York: Simon & Schuster, 1980.

Milner, John. *Russian Revolutionary Art.* London: Oresko, 1979.

_____. *Vladimir Tatlin and the Russian Avant-garde.* New Haven: Yale University Press, 1983.

Misler, Nicoletta. *Pavel Florenskij: La prospettiva rovesciata e altri scritti.* Rome: Casa del libro, 1983.

Misler, Nicoletta, and John E. Bowlt. *Pavel Filonov: A Hero and His Fate.* Austin: Silvergirl, 1984.

Mudrak, Myroslava. *The New Generation and Artistic Modernism in the Ukraine.* Ann Arbor, Mich.: UMI, 1986

Nakov, Andrei B. *Russian Pioneers: At the Origins of Non-Objective Art.* Exh. cat. London: Annely Juda Fine Art, 1976.

_____. *Abstrait/Concret: Art Non-Objectif Russe et Polonais.* Paris: Minuit, 1981.

_____. *L'Avant-garde Russe.* Paris: Hazan, 1984.

Notes et documents edites par la société des Amis Georges Yakoulov. Paris: Société des amis de Georges Yakoulov, 1967.

"On Russian Art." *Transactions of the Association of Russian-American Scholars in USA* 15 (1982). Special issue edited by N. Jernakoff.

Paris-Moscou, 1900–1930. Exh. cat. 2d rev. ed. Paris: Centre Georges Pompidou, 1979.

Revolution: Russian Avant-garde, 1912–1930. Exh. cat. New York: Museum of Modern Art, 1978.

Rice, Tamara Talbot. *A Concise History of Russian Art.* New York: Praeger, 1963.

Roerich, Nicholas. *Realm of Light.* New York: New Era Library, 1931.

Roethel, Hans K., and Jean K. Benjamin. *Kandinsky: Catalogue Raisonné of the Oil Paintings.* Ithaca, N.Y.: Cornell University Press, 1982.

Rowell, Margit, and Angelica Zander Rudenstine. *Art of the Avant-garde in Russia: Selections from the George Costakis Collection.* Exh. cat. New York: Solomon R. Guggenheim Museum, 1981.

Russia, the Land, the People: Russian Art, 1850–1910: From the Collections of the State Tretyakov Gallery, Moscow, and the State Russian Museum, Leningrad. Exh. cat. Washington, D.C.: Smithsonian Institution Traveling Exhibition Service, 1986.

"Russian Art, 1900–1930." *Art vivant* 7–8 (1982). Special issue edited by T. Omuka.

Russian Art of the Avant-garde: Theory and Criticism, 1902–1934. Edited by John E. Bowlt. New York: Viking, 1976.

Russian Art of the Revolution. Exh. cat. Ithaca, N.Y.: Cornell University Press, 1970.

"Russian Avant-garde: Art and Architecture." *Architectural Design 53* (1983). Special issue edited by C. Cooke.

Russian Avant-garde Art: The George Costakis Collection. Edited by Angelica Zander Rudenstine with an introduction by S. Frederick Starr. New York: Abrams, 1981.

Russian Avant-garde, 1908–1922. Exh. cat. Essays by S. Frederick Starr and John E. Bowlt. New York: Leonard Hutton Galleries, 1971.

Russian Modernism: Culture and the Avant-garde, 1900–1930. Edited by George Gibian and J. W. Tjalsma. Ithaca, N.Y.: Cornell University Press, 1976.

Sarabianov, Dmitrii Vladimirovich. *Russian Painters of the Early Twentieth Century (New Trends).* Leningrad: Aurora Art Publishers, 1973.

Sieben Moskauer Künstler, 1910–1930/Seven Moscow Artists, 1910–1930. Exh. cat. Cologne: Galerie Gmurzynska, 1974.

Sieg über die sonne: Aspekte russischer Kunst zu Beginn des 20. Jahrhunderts. Edited by Christiane Bauermeister and Nele Hertling. West Berlin: Frolich & Kaufmann, 1983.

"Soviet Art of the 1920s." *Soviet Union 7* (1980). Special issue edited by John E. Bowlt.

"Soviet Constructivism." *Soviet Union* 3 (1976). Special issue edited by John E. Bowlt.

Stapanian, Juliette. *Mayakovsky's Cubo-Futurist Vision.* Houston: Rice University Press, 1986.

Tatlin's Dream: Russian Suprematist and Constructivist Art, 1910–1923. Exh. cat. London: Fischer Fine Art Limited, 1973.

Two Decades of Experiment in Russian Art, 1902–1922. Exh. cat. London: Grosvenor Gallery, 1962.

2 Stenberg 2. Exh. cat. Paris: Galerie Jean Chauvelin, 1975.

Umanskij, Konstantin. *Neue Kunst in Russland, 1914–1919.* Potsdam: G. Kiepenheuer, 1920.

Valkenier, Elizabeth. *Russian Realist Art, the State and Society: The Peredvizhniki and Their Tradition.* Ann Arbor, Mich.: Ardis, 1977.

Von der Flaeche zum Raum Russland, 1916–24/From Surface to Space Russia, 1916–24. Exh. cat. Cologne: Galerie Gmurzynska, 1974.

Williams, Robert C. *Artists in Revolution: Portraits of the Russian Avant-garde, 1904–1925.* Bloomington: Indiana University Press, 1977.

_____. *Russian Art and American Money.* Cambridge, Mass.: Harvard University Press, 1980.

Zhadova, Larissa A. *Malevich: Suprematism and Revolution in Russian Art, 1910–1930.* London: Thames & Hudson, 1982.